Radiator Springs on U.S. 66

CADILLAC RANGE

TOWN COURT HOUSE
RADIATOR SPRINGS

RADIATOR SPRINGS

Luigis

LEANING TOWER OF TIRES

RAMONES

House of Body Art

Radiator Springs

Ramones on U.S. 66

ORNAMENT VALLEY

RADIATOR SPRINGS

What a Butte

WILLYS BUTTE

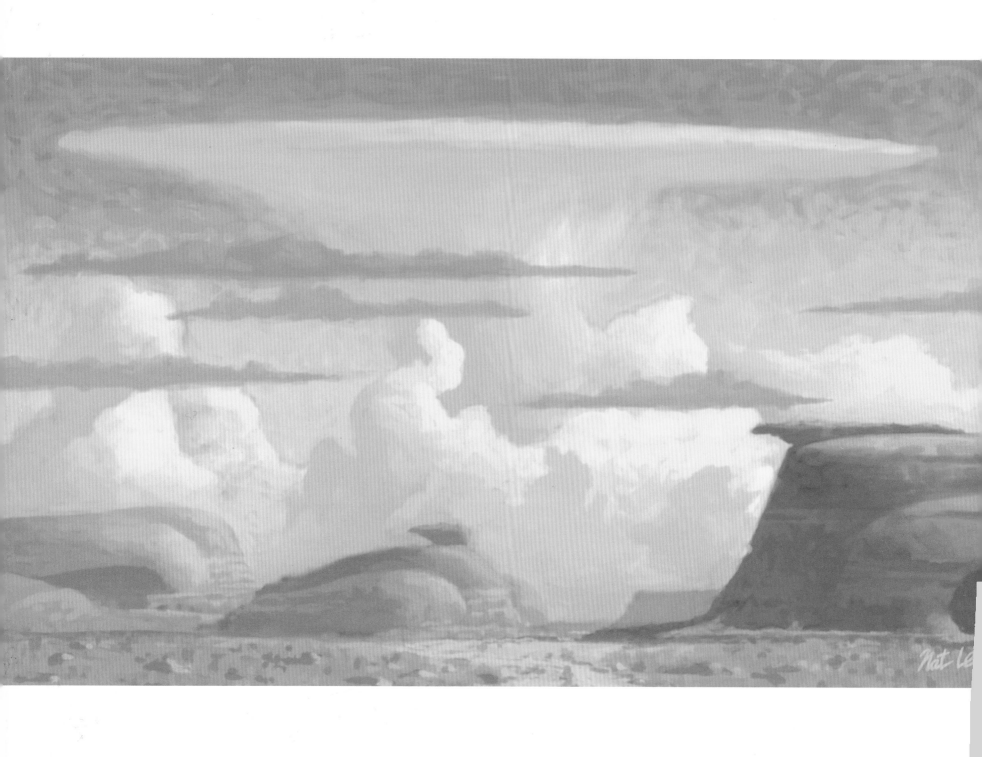

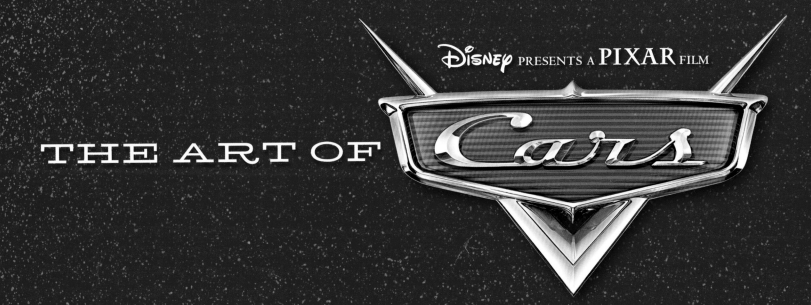

THE ART OF

DISNEY PRESENTS A PIXAR FILM

By **Michael Wallis** with **Suzanne Fitzgerald Wallis**
Foreword by Pixar's **John Lasseter**

CHRONICLE BOOKS
SAN FRANCISCO

To the Pixar Pit Crew. *Dadgum!*

— John Lasseter, Director

— Darla K. Anderson, Producer

© COPYRIGHT © 2006 BY DISNEY ENTERPRISES, INC./PIXAR ANIMATION STUDIOS. ALL RIGHTS RESERVED.

★ NO PART OF THIS BOOK MAY BE REPRODUCED IN ANY FORM WITHOUT WRITTEN PERMISSION FROM THE PUBLISHER.

✎ Library of Congress Cataloging-in-Publication Data:

Wallis, Michael, 1945–

The Art of Cars / By Michael Wallis with Suzanne Fitzgerald Wallis; foreword by John Lasseter.

p. cm.

ISBN 0-8118-4900-7

1. Cars (Motion picture)—Illustrations. 2. Animated films—United States. 3. Pixar Animation Studios. I. Wallis, Suzanne Fitzgerald, 1943– II. Title.

NC1766.U53C378 2005
791.43'72—dc22
2004027692

Manufactured in China
Designed by Public, San Francisco

Distributed in Canada by Raincoast Books
9050 Shaughnessy Street
Vancouver, British Columbia V6P 6E5

10 9 8 7 6 5 4 3 2 1

Chronicle Books LLC
85 Second Street
San Francisco, California 94105
www.chroniclebooks.com

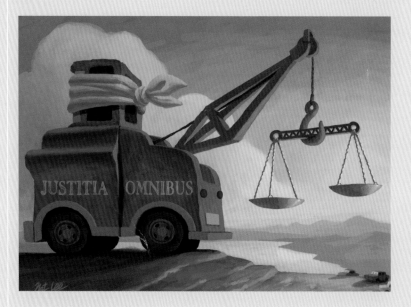

Dodge is a trademark of DaimlerChrysler; Hudson Hornet is a trademark of DaimlerChrysler; Volkswagen trademarks, design patents, and copyrights are used with the approval of the owner Volkswagen AG; Model T is a registered trademark of Ford Motor Company; Fiat is a trademark of Fiat S.p.A.; Mack is a registered trademark of Mack Trucks, Inc.; Mazda Miata is a registered trademark of Mazda Motor Corporation; Kenworth is a trademark of Paccar, Inc.; Chevrolet Impala is a trademark of General Motors; Porsche is a trademark of Porsche; Jeep is a registered trademark of DaimlerChrysler; Mercury is a registered trademark of Ford Motor Company; Plymouth Superbird is a trademark of DaimlerChrysler; Cadillac Coupe de Ville is a trademark of General Motors. The Name, Image, and Likeness of Elvis Presley appears courtesy of Elvis Presley Enterprises, Inc. Some elements of Cadillac Range inspired by Cadillac Ranch by Ant Farm (Lord, Michels, and Marquez) © 1974.

Travel Stickers: (Endpapers) Craig Foster, Digital, 2005. **Radiator Springs Postcard:** (Page 1) Paul Topolos [paint], Bud Luckey [layout], and Andy Dreyfus [graphics], Digital, 2004. **Courthouse Painting:** (Page 2) John Lee [paint] and Nat McLaughlin [layout], Digital, 2005. **Cars Logo:** (Page 3) Andy Dreyfus and Bob Pauley [layout], Andrew Schmidt [model], Thomas Jordan and Bob Moyer [shading], and Jean-Claude Kalache [lighting], Digital, 2004. **Red Metal Flake Background:** (Page 3) Colin Thompson, Digital, 2004. **Courthouse Painting:** John Lee [paint] and Nat McLaughlin [layout], Digital, 2005.

Contents

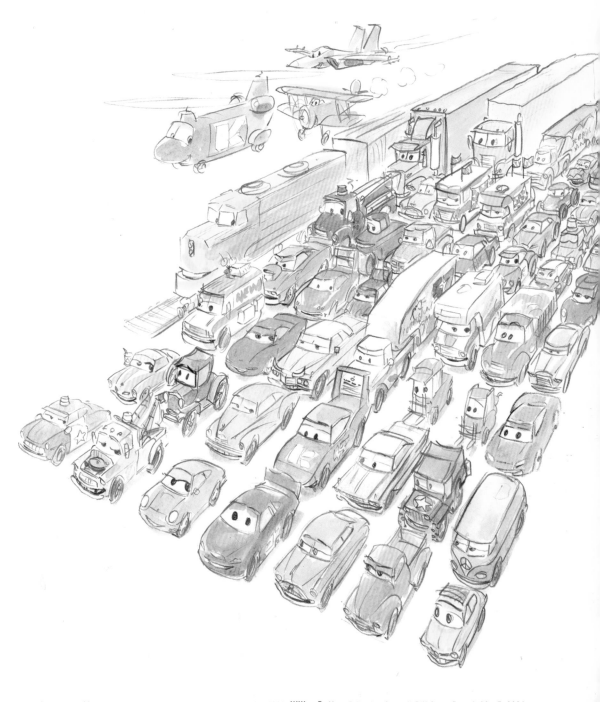

Early Character Lineup: Bob Pauley, Pencil/Marker, 10.75 x 10.25, 2002. **Willys Butte:** (Following Spread) Bill Cone, Pastel, 16 x 7, 2004.

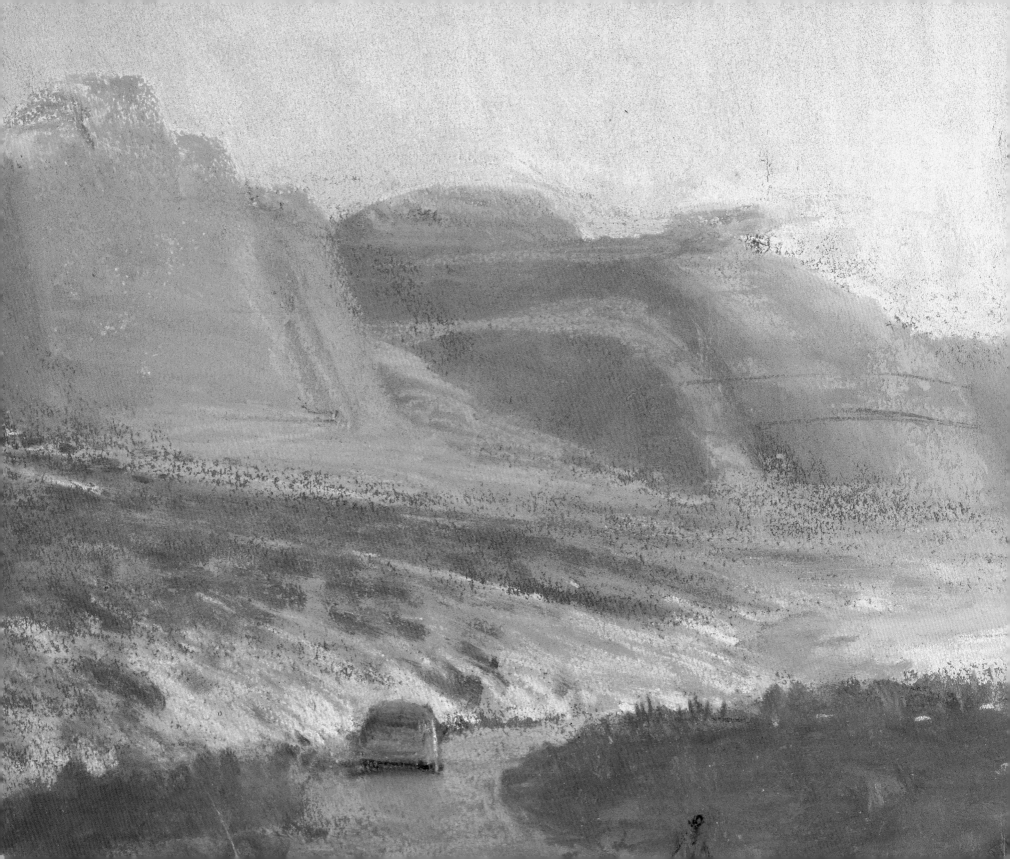

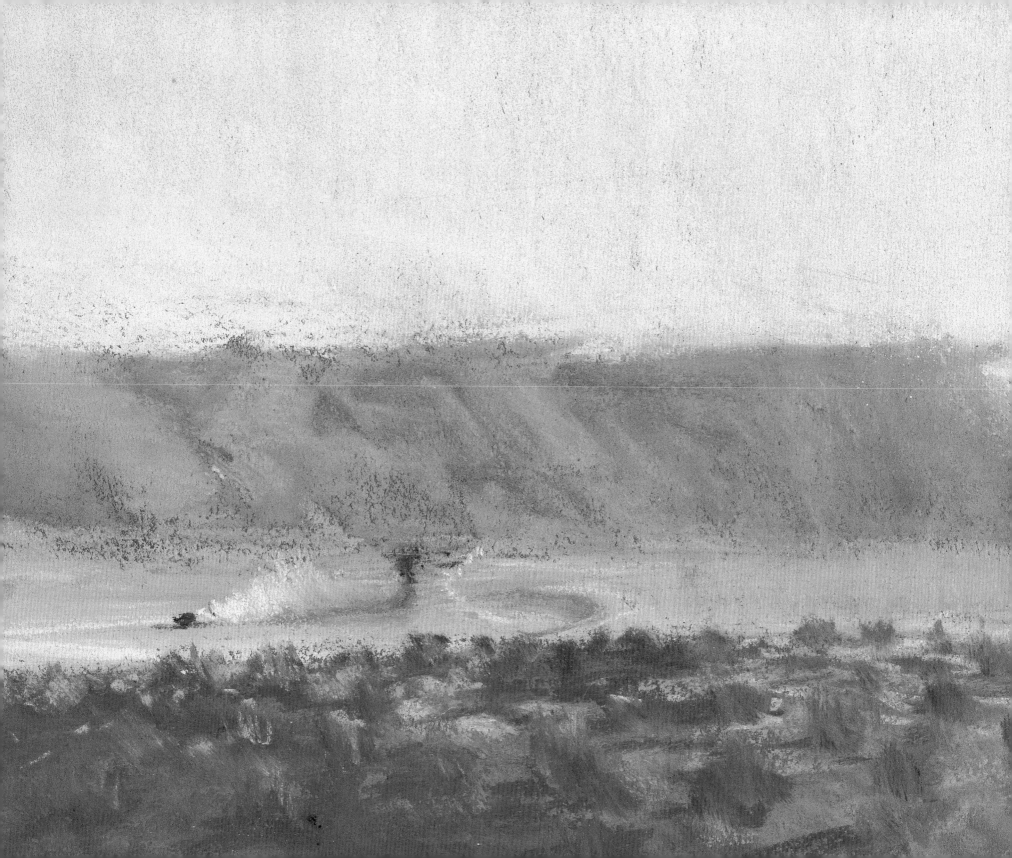

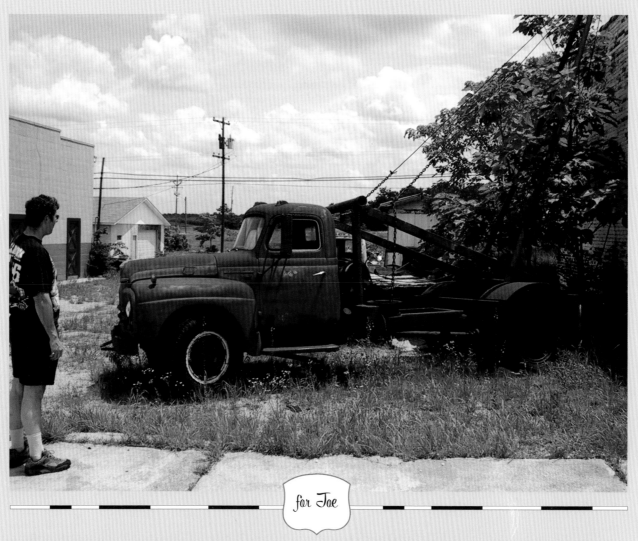

for Joe

In Galena, Kansas, we found a lonely old tow truck that most folks would pass by without a second glance. Our Head of Story Joe Ranft, however, saw beyond its rust and broken-down parts—he saw the inspiration for the character Mater. They soon became kindred spirits. Joe gave Mater his warmth, his sense of fun, his humble and generous spirit, and his capacity to see—and bring out—the best in others.

There's a piece of Joe in every movie Pixar has ever made. But Joe was truly the heart of *Cars.*

Foreword

One of the things that first drew me to computer animation was its potential to create worlds that don't actually exist—but boy, they sure look real. The more I worked with it, the more I realized that to take full advantage of the medium, you have to pay as much attention to the believable as you do to the unbelievable.

Doing research on the subjects of our films has become a matter of principle for us. We care about all the little details. It comes out of respect not only for our medium but for our subject matter and for the people who watch our movies. We spend years on each film, and we want everyone in the audience to love and believe in the world we're creating as much as we do—especially the people who are already passionate about the subject. They're the ones who will know immediately when it's not right.

When we started working on *Cars*, I knew that researching and getting the details right would be essential to the story. What surprised me was just how essential it turned out to be. The first time I drove on Route 66, what immediately jumped out at me was the way you could see the story of each town—its rich history and the way that the modern world had bypassed it in order to save a few minutes of driving time. No movie set along the Mother Road could ignore that sense of history without completely robbing the setting of its soul. The spirit of Route 66 is in the details: every scratch on a fender, every curl of paint on a weathered billboard, every blade of grass growing up through a cracked street. Those details don't come for free in the computer—you have to create every single one. So you really have to pay attention and do your homework.

We ended up doing more research for *Cars* than we'd done for any other project here at Pixar. What we learned helped us to create our movie. It permeated everything—the setting, the characters, and even the story. But it also became a journey with its own reward, one we wanted to share with you in this book.

John Lasseter

—Director

Approval Stamp: Joey Tague [John Lasseter's stepson], Rubber Stamp, 2 x 2, 1987.

Introduction:

California Dreaming

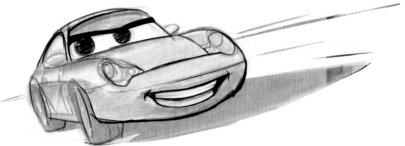

John Lasseter, the Academy Award®–winning director of *Cars* and one of the founders of Pixar Animation Studios, was just a little boy growing up in Southern California when he fell hopelessly in love with the art of animation.

"I absolutely adored the animation cartoons, but you have to remember that when I was a little guy there were no home video or cable channels. I got my big doses of animation in front of our TV on Saturday mornings or after school. I'd get up at the crack of dawn, get a bowl of cereal, and watch cartoons." As he fed his appetite for animated art, John also developed what would become a lifelong fascination with cars and all things automotive.

"Slice open one of my veins and cartoons will pour out, and then open another vein and you'll get a flood of motor oil," is how he explains it.

These twin obsessions—animation and cars—were planted as a single seed in the youngster's fertile imagination. They took root, and decades later they blossomed as Pixar's feature film *Cars.* Those of us fortunate enough to know John are not at all surprised. An animated film starring only automobiles has always been one of John's creative dreams.

Born in Hollywood in 1957—the year that gave us Jack Kerouac's novel *On the Road* as well as the now classic '57 Chevy Bel Air—John was raised with his brother and sister in the suburban community of Whittier, east of Los Angeles. Chevrolet's advertisement for their latest model boasted, "You get more to be proud of in a Chevy!" The Lasseter family already knew all about Chevys since John's father, Paul, worked as a parts manager at Chevrolet dealerships in Whittier and nearby La Habra. John inherited his Dad's car consciousness and as a teen held a part-time job at a dealership.

When he wasn't watching customized muscle cars, hot rods, and lowriders strut their stuff on Whittier Boulevard—prime cruising in Los Angeles—John focused on other passions. With the help of his mother, Jewell, a high school art teacher for thirty-eight years, he fed his artistic side.

"My mom always brought home extra paints, paper, and markers," recalls John, "so I was constantly creating little art projects. I was really blessed to be in a family that loved and supported the arts, including the art of animation." At the tender age of five, John received a $15 cash award from the Model Grocery Market in Whittier for a crayon drawing he had made of the Headless Horseman.

As a high school freshman, John discovered Bob Thomas's book, *The Art of Animation,* a behind-the-scenes look at Disney's making of *Sleeping Beauty.* He instantly devoured the

Sally: Bob Pauley, Pencil/Marker, 17 x 11, 2002.

book and realized that people actually made a living doing animation. He had found his calling.

While still in high school, John became even more serious about studying art and drawing techniques. In his senior year he began corresponding with the Walt Disney Studios and learned that they were establishing an animation program with the California Institute of the Arts (CalArts). John applied and became the second student to be accepted into the start-up program. After four years of intense study with the masters of the medium at CalArts, he joined Disney for a successful five-year stint in the feature animation department. After leaving Disney in 1983, John joined a small computer graphics division of Lucasfilm, which was exploring making cartoons with the new technologies they were developing. In 1986, this group was sold and Pixar Animation Studios was born. John was the studio's first animator.

During the production of *Toy Story,* John would commute each day from his home south of the

San Francisco Bay Area to the studio in Point Richmond, often carpooling with Bob Pauley, a Pixar production designer. John soon discovered that Bob—a Detroit native whose father worked as an engineer for Ford—was also an avowed car fanatic. During the long drives to and from the studio the two men talked almost exclusively about cars.

"I still can see Bob and John coming into our office after arriving at the studio, and John saying, 'One of these days we'll make a car movie,'" recalls Bill Cone, another Pixar production designer.

"I knew we had to do it, but I was also aware that making a car feature would be challenging," says John. "But then, so is every subject we tackle at Pixar."

Many of John's experiences provided inspiration for the film *Cars.* The event that ultimately turned John's dream into reality came in 1999 after the wrap-up of *Toy Story 2.* Needing a

break after nine straight years directing Pixar's first three feature films, John and his wife, Nancy, loaded their five sons into a recreational vehicle and took off on the open road.

"It was a very long journey. I took off for two months and we just drove. We made no plans and no reservations. We put our feet in the Pacific Ocean just north of the Golden Gate Bridge and headed east. Our only plan was to eventually dip our feet in the Atlantic. We just traveled across the country from coast to coast and took in everything. It was such a great adventure, but the true epiphany came in North Carolina one afternoon when I was about halfway through a rather bland taco at some chain restaurant. I suddenly realized that I could be anywhere in America and here I am

Cars **Production Office Sign:** Andy Dreyfus, Bill Cone [graphics] and Japeth Pieper [paint], Digital, 2004.

eating a taco in North Carolina, when there's plenty of genuine barbecue all around us! Why eat Mexican food in barbecue country? We left immediately in search of a hometown eatery where the folks go to feast on a local staple—great barbecue."

It was a turning point for John. He had experienced firsthand how America had become overrun with predictable, homogenous franchises. Now, after enjoying regional cuisine, he found himself searching for those special places that still offered the real thing. John also discovered that the trip was having an enormous impact on his family. "I realized that I had been working long hours and was beginning to lose touch with my children. My wife had warned me that one day I'd wake up and my kids would be off to college and I would have missed it. Being with each other on this road trip brought us closer together."

All the way back to California, John thought

about the movie he wanted to make. This time, when he walked into the studio, instead of saying, "One of these days . . ." John smiled and simply said, "Let's make our car movie."

Inspired by his revelation in barbecue country with his family, John decided to make a film with cars as characters who experience the expected along the nation's superhighways, experience the unexpected along the back roads, and learn that the "journey in life is the reward." The film's concept was slowly coming together.

At Pixar, research is a chief ingredient in every creative concoction. Each project presents its own challenges, but the extent of the research process—planning, questioning, gathering, sorting, sifting, synthesizing, and evaluating—never varies. So whether a film is about toys, bugs, monsters, or fish, it takes curious people to gather knowledge and then interpret it. In *Cars,* the main subject proved to be as

broad as the themes of previous Pixar films. Although John and the Pixar team knew a lot about cars, they also knew that making a feature film about them would require plenty of research.

"John is an absolute stickler for research," explains Production Manager Jonas Rivera. "It is really our bottom line—a key part of every film we do. Research is vital and really never ends."

This film would be no exception. The Pixar team traveled the nation and watched every video and documentary they could find about cars and highways. In this book, you will see how the research they gathered at manufacturing plants, speedways, and automotive museums, and on historic Route 66 itself, inspired the filmmakers and influenced the early visual development of the film.

Highway Signs: Ellen Moon Lee, Digital, 2005.

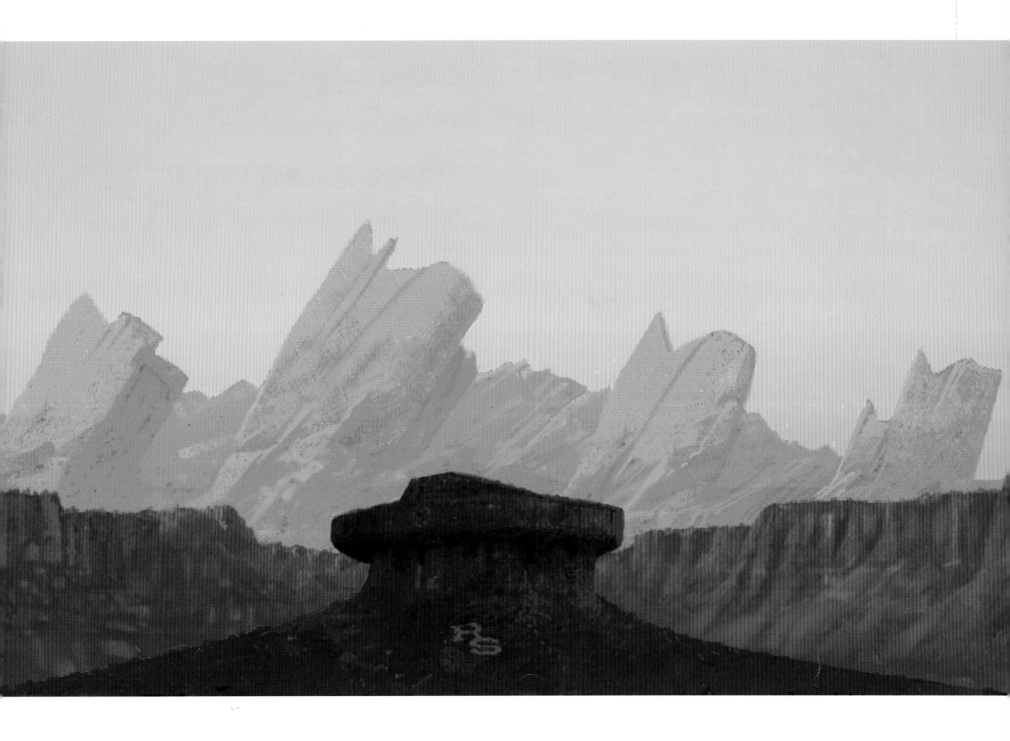

Sunrise in Radiator Springs: Bill Cone, Pastel/Digital, 2005.

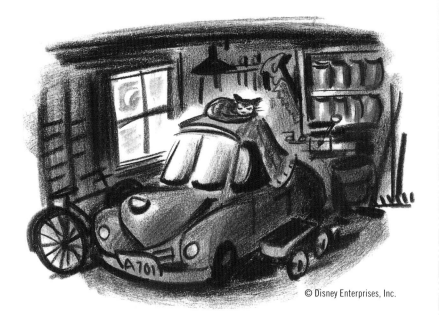

© Disney Enterprises, Inc.

PIT STOP Inspiration

Like all of Pixar's films, the story of *Cars* comes from the heart of its director. On June 6, 1952, Walt Disney Studios released a short animated film called *Susie, the Little Blue Coupe*. Its running time was just seven minutes and thirty-six seconds. Many years later, John Lasseter, a budding young animation artist who wasn't even born until five years after *Susie*'s debut, saw the film on a television rerun and was so taken with it that it would stay with him forever.

Like most good yarns, the movie's plot is simple. The film follows the life of a small powder-blue car named Susie. We see Susie come off the assembly line and go to the showroom. We follow her and her owner and their happy relationship, which ends when he decides to trade Susie in for a younger model. Then we see Susie discarded at a second-hand lot and ultimately Skid Row and the junkyard. There she stays until her glorious rebirth when a youngster resurrects the forlorn Susie and transforms her into a snappy hot rod. It is the ultimate automotive rags-to-riches story.

Crafted by legendary Disney story artist Bill Peet, directed by Clyde Geronimi, animated by Frank Thomas and Ollie Johnston, and narrated by the incomparable Sterling Holloway, this short film—a skillful blend of humor and pathos—illustrates Disney's expertise at giving sympathetic life to an inanimate object. Susie, her friendly eyes blinking from her windshield, lives on as one of the warmest anthropomorphic machine cartoons on screen. John Lasseter, who had first watched *Susie* in reruns on television and later studied the film as an apprentice animator, absorbed every moment.

Decades later, during the production of *A Bug's Life,* a distinctive automobile story would emerge and serve as inspiration in the early stages of *Cars*'s development. Called *The Yellow Car*, this first attempt at an automotive story was developed by Pixarian Jorgen Klubien, a skillful artist and popular singer in his homeland of Denmark. The story followed a little yellow electric car living in a small town. Because of its differences, this character was disliked by the town's other cars, who were portrayed as suspicious and prejudiced.

Susie, the Little Blue Coupe: Bill Peet, Pencil, 5 x 3.5, film release 1952.

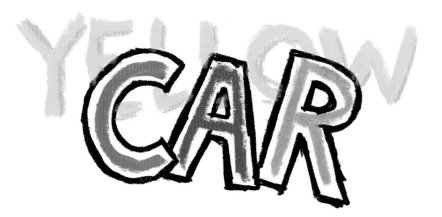

CAR

"In Denmark there has never been car production because the country is too small," says Jorgen. "Yet in the 1980s some enthusiastic folks got the idea of making a three-wheeled one-person car that ran on electricity. They put it into production and it worked great in the city, but out on the highway it was too slow. People also thought the car was ugly. I thought the electric car was ahead of its time, and it struck me as odd that my fellow Danes didn't agree. It reminded me of *The Ugly Duckling* by Hans Christian Andersen. This famous Danish character wasn't accepted at first, but in the end it proved to be right on the money."

The Yellow Car was never produced. It proved to be too slim a story to wrap a Pixar feature film around, yet the concept remained a true inspiration for what was to follow—most notably the idea of a small-town setting and the characters of Fillmore and Sarge.

Yellow Car Storyboards: Jorgen Klubien, Pencil, 11 x 8.5 each, 1997.

1 *Fast Lane*

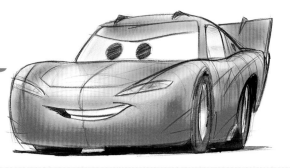

From the beginning everyone at Pixar called the new film project *Cars.* That was the name that would stick. It was an obvious choice, since all the film characters were to be automobiles. Naturally, of major concern to the creative team was what kinds of cars to choose for the character roles.

Given that the race car has become the ultimate symbol of our passion for speed, power, and uncompromising individuality, Lasseter felt that a hotshot racing car would be an ideal candidate for the main character. Although the film would ultimately end up including a large assortment of automobile makes, models, and types, the Pixar team made race-car research a top priority.

"I told my wife I had to go to race after race for the good of Pixar," John jokes. "Even though we were creating an animated film, I wanted it to be authentic in every single detail," he explains. "We had to have exact model cars, the real

sounds of the engines and crowds, and the look and feel of the racing world. We couldn't play fast and loose with the facts. We had to do our homework."

And so the Pixar team took to the fast lane. They made a beeline for the nation's leading racetracks and got behind the scenes. They went to see how the cars are built by hand, learn about the sport's evolution, and meet daredevil drivers, pit crews, and die-hard fans. They went to the tracks to hear the rumble and roar of powerful engines and the din of the crowd cheering in the bleachers. They went to smell burning rubber and spilled fuel and the smoke from a thousand tailgate grills.

The team soon learned that car racing is a dangerous sport—perhaps the most dangerous. They watched fearless drivers climb into three-thousand-pound race cars and reach track speeds of more than two hundred miles an hour. They witnessed huge crashes and the

smaller mishaps that occur when cars race only inches apart in tightly packed groups. The team journeyed to racetracks in Las Vegas, Nevada; Sonoma, California; Bristol, Tennessee; and elsewhere. They went to Lowe's Motor Speedway in Charlotte, North Carolina—considered in most racing circles the mother of all stock-car tracks.

They met Richard Petty, the leader of a four-generation racing family who gave the sport thirty-five years of competitive racing before retiring in 1992. Petty's record of two hundred victories and seven championships stands as a tribute to the man known by his many fans as "The King."

Not only did Petty prove to be an invaluable resource, but he provided voice talent for *Cars* as well. His character, a sleek 1970 Plymouth Superbird appropriately named "The King," is a role model for young upstart racers. Even though he has won more races than any other car in history, The King is still a down-home guy

Lightning McQueen: Bob Pauley, Pencil/Marker, 10.25 x 6, 2003.

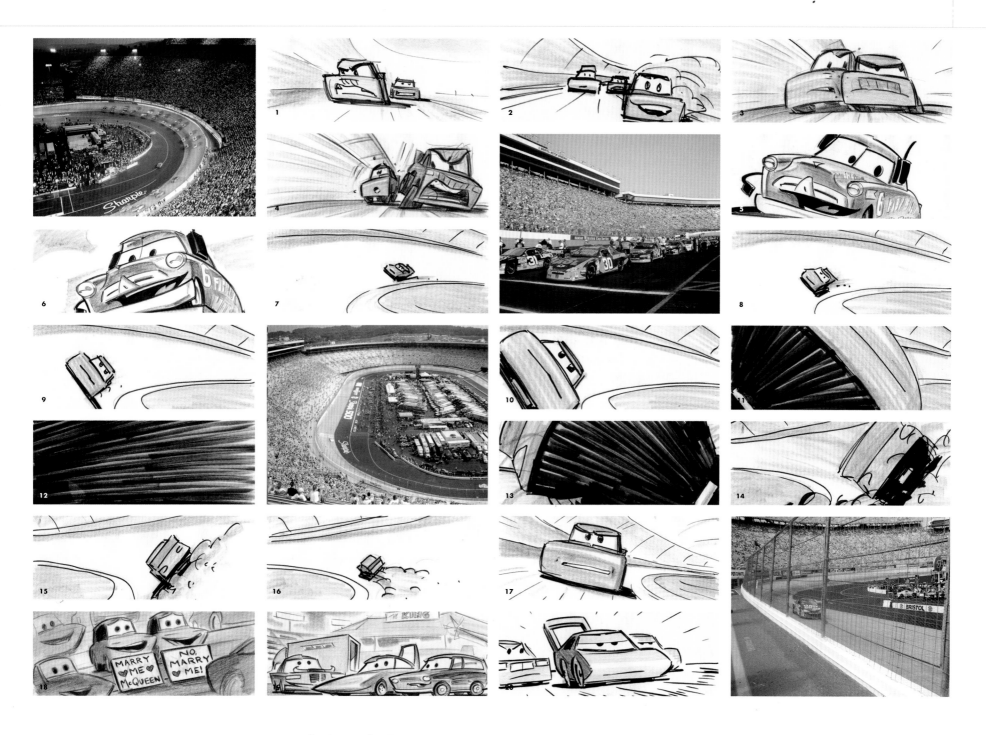

Opening Race Storyboards: (1), (2), (3), (4), (7), (8), (9), (10), (11), (12), (13), (14), (15), (16), (17) Garett Sheldrew, Marker/Pencil, 9 x 5, 2003–04. (5), (6), (19) Steve Purcell, Marker/Pencil, 9 x 5, 2004. (18) Rob Gibbs, Marker/Pencil, 9 x 5, 2004. (20) Brian Fee, Marker/Pencil, 9 x 5, 2003. **Track Reference Photographs:** John Lasseter, 2001.

who knows that it takes more than trophies to make a true champion.

The dedicated community of racing fans left an indelible impression on the *Cars* production team. These are people who consider car racing a sacred weekend ritual. They drive lumbering RVs down boring interstate highways for days, sleep in tents, eat from ice chests, and sit in uncomfortable grandstand seats under a scorching sun just to see their favorite driver make the rounds on Sunday afternoon. In the infield of the Lowe's Motor Speedway in Charlotte, the team met with two such devoted fans, named Mater and Larry, atop a small rise known as "Redneck Hill." Mater, the self-appointed mayor of Redneck Hill, and Larry gave the team an inside look at the fan world of racing. In fact, the team was so taken with these two that they included them in the film, in a cameo appearance as motor-home fans. Mater's name was also borrowed for another character, the lovable rusty tow truck who befriends McQueen.

"What an education!" explains story artist Steve Purcell. "Rubbing elbows with the die-hard race fans helped us a lot. Just walking on the track, hearing the power of the engines, looking over the shoulders of the pit crews was so important. We even went to hockey and pro football games, not for the games but to get a feel for the intensity of the screaming fans. Experiencing the racing world firsthand added so much to this film's authenticity." Also, research gathered at the racetrack eventually led to the creation of the film's exhilarating opening scene built around the final race of the season—the Piston Cup Championship—complete with screaming fans and a photo finish.

Back in California, John Lasseter took racing lessons at Infineon Raceway from the expert instructors at the Jim Russell Racing School. He learned the basic techniques because he wanted to experience that special brand of exhilaration and adrenaline rush that only comes from motor sports, and he was striving for authenticity in

the animation. He needed to know just how it feels to live loud. This experience allowed John to provide spirited direction to Owen Wilson, the voice talent for Lightning McQueen, a hotshot race car who has only one thing on his mind—to be the fastest to the finish line.

Trailer Graphics: Craig Foster, Andy Dreyfus, and Ellen Moon Lee [graphics] and Bob Pauley and Jay Shuster [layout], Digital, 2005.

Racecar Graphics: Craig Foster, Andy Dreyfus, and Ellen Moon Lee [graphics] and Bob Pauley and Jay Shuster [layout], Digital, 2005.

FIRST RACE

@ NIGHT ON A TRACK
- A SMALL TIGHT
½ MILE OVAL
HUGE CROWD LITTLE TRACK
- LIKE A BULLFIGHT -

ANGLES FASTCUTS

BRIGHT VISUALS LOUD

IN TIGHT

CRASHES ARE CLOSE & TAKE
OUT A BUNCH... MORE CONGESTED

NEVER SEE SKY
IN A 'BOWL'

BIG RACE
CALIF SPEEDWAY

ITS HUGE — SCOPE IS
IMPORTANT — OLYMPIC SIZE
HIGHER SPEEDS
'BIGGER' CRASHES
YOU CAN SEE SKY —

TIGHT/RUNNING W/ THEM

ON THE BIG BANKS

THE LEAD GROUP - TRACKING
WITH

MOVING THROUGH PACK

C/U IN PITS TOO

'IN-YOUR-FACE'

LONG LENS
TIGHT
CLOSE UPS
DUTCH CAMERA ANGLES!
FAST/QUICK CUTS

DYNAMIC ANGLES
STAYING W/ THE 'HORSE RACE'
THE WORLD A BLUR.

Layout Studies: Bob Pauley, Pencil, (1) 8 x 9.5, (2) 8.75 x 8.75, (3) 8.25 x 10.25; 2004.

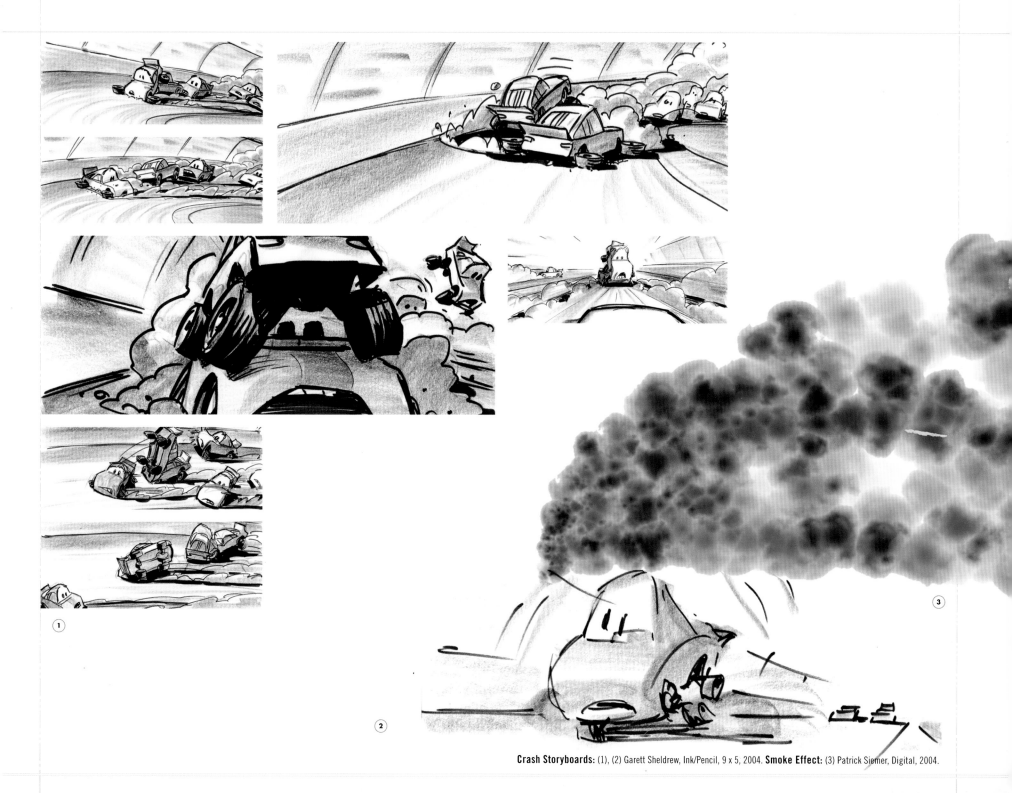

Crash Storyboards: (1), (2) Garett Sheldrew, Ink/Pencil, 9 x 5, 2004. **Smoke Effect:** (3) Patrick Siemer, Digital, 2004.

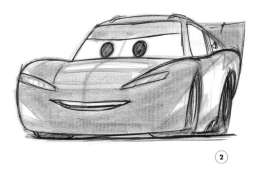

Lightning McQueen

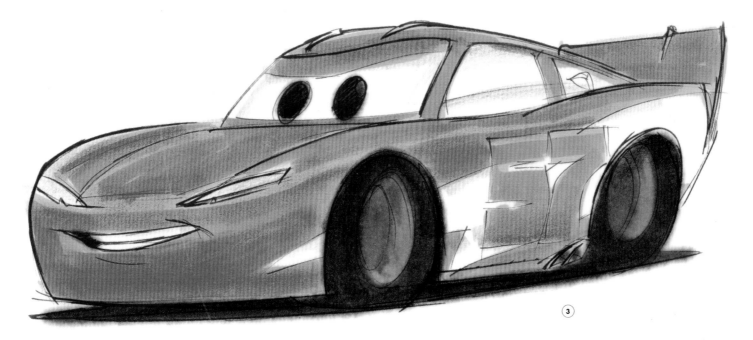

Bob Pauley, (1) Pencil, 17 x 11; (2) Pencil/Marker, 11.5 x 7.5; (3) Mixed Media, 17 x 11; 2003.

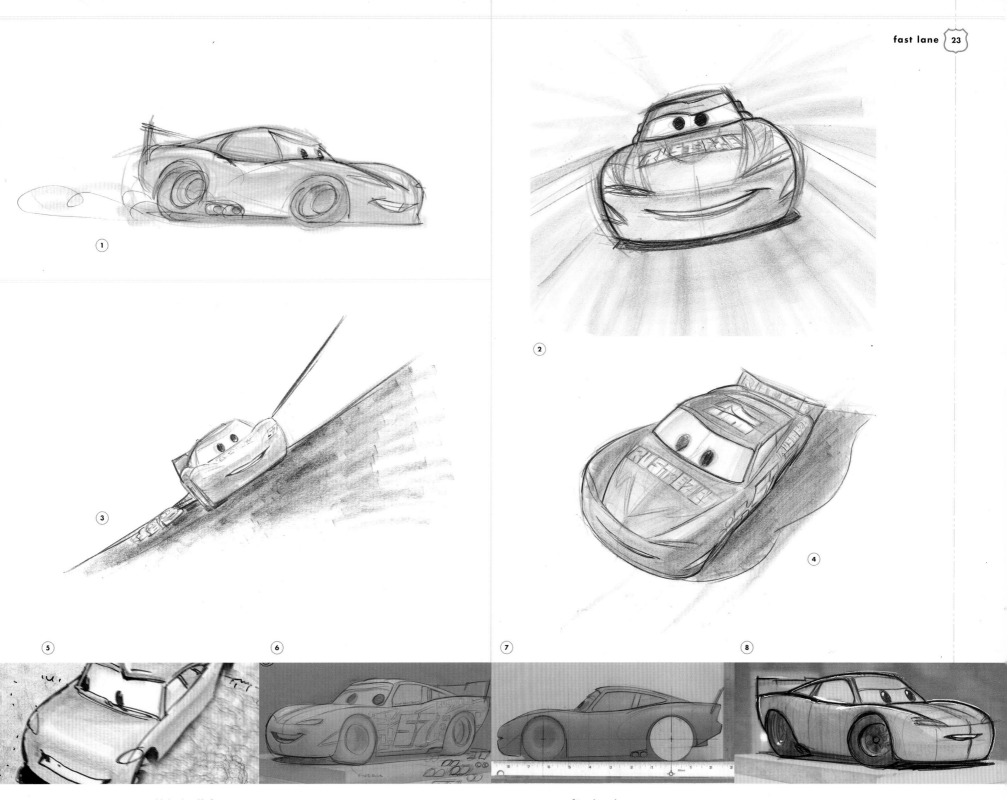

Lightning McQueen: Bob Pauley, Pencil, (1) 10.5 x 9, 2003; (2) 10.5 x 9, 2003; (3) 15.25 x 10, 2004; (4) 6 x 5, 2003. **Storyboard:** (5) Garett Sheldrew [art] and Patrick Siemer [effects], Marker/Pencil/Digital Effects, 2004.
Sculpt Development: Jerome Ranft [sculpt] and Bob Pauley [overlay], 17 x 11, Sculpt/Overlay, (6) 2003, (7) 2003, (8) 2004.

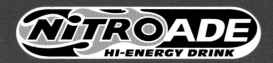
NiTROADE
HI-ENERGY DRINK

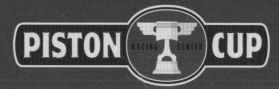
PISTON RACING SERIES CUP

RE-VOLTING
REBUILT ALTERNATORS

MOOD
SPRINGS

OCTANE GAIN
TURBO VITAMINS

Vitoline
FOR OLDER ACTIVE CARS

No Stall®

Creme Filled
Gask-its
The Racetrack Treat

HOOD ACHE RELIEF
GASPRIN

easy IDLE
A Warm Start To A Cold Morning

LIL' TORQUEY PISTONS

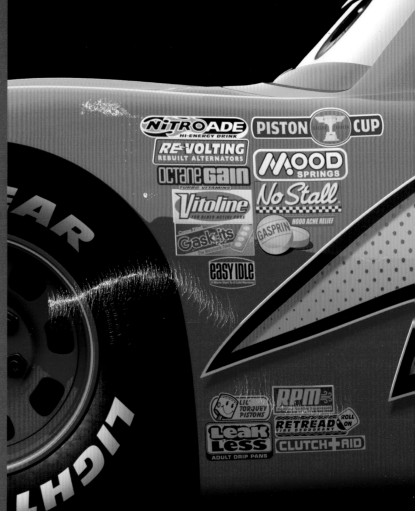

McQueen Graphics: (1) Andy Dreyfus, Ellen Moon Lee, and Craig Foster [graphics], Jay Shuster and Bob Pauley [layout], Digital, 2005.
McQueen: (2) Andrew Schmidt [model], Colin Thompson and Yvonne Herbst [shading/paint], Digital.

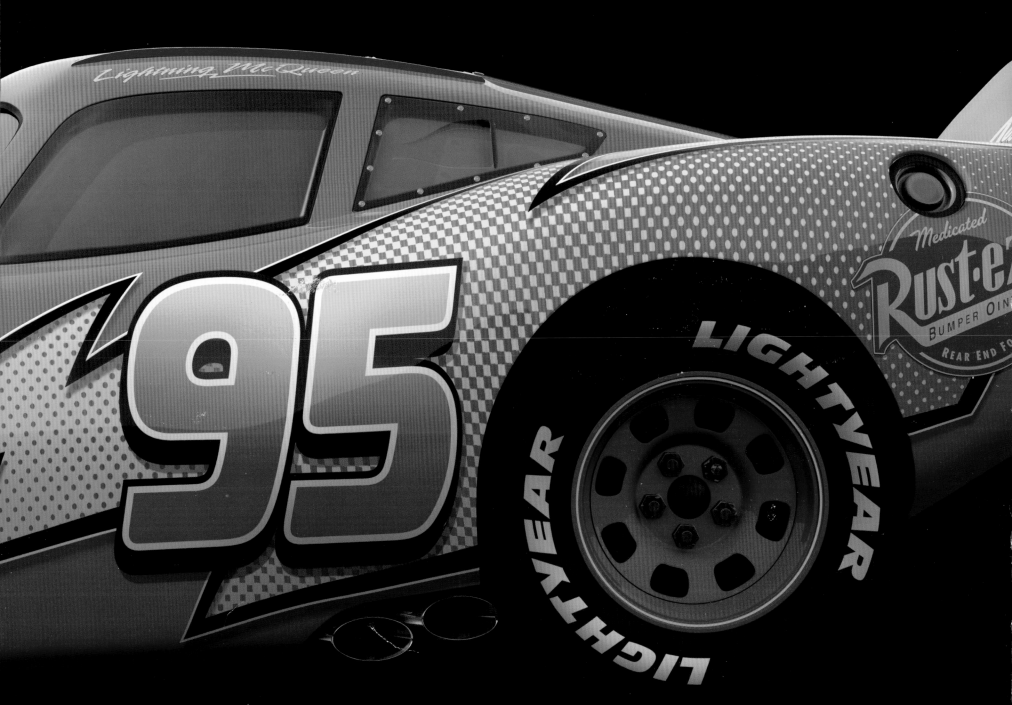

Mack

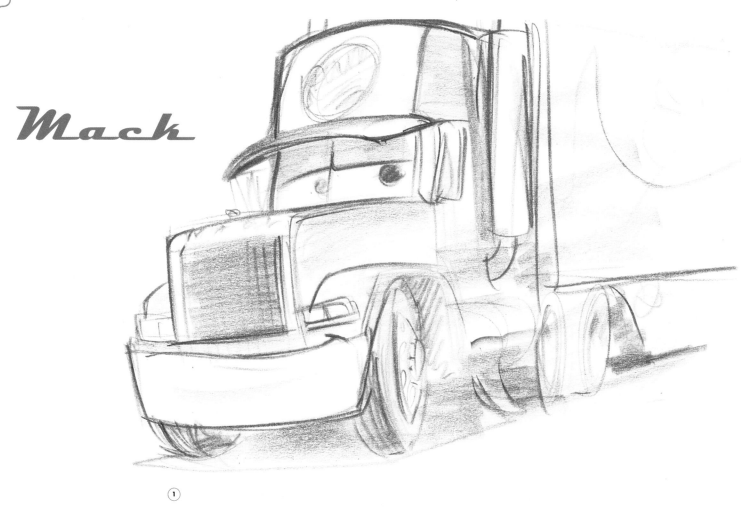

(1)

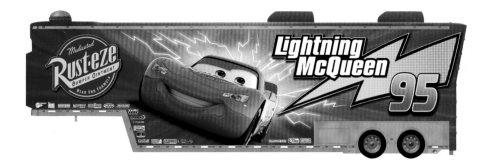

(2)

(3)

(1) Bob Pauley, Pencil, 17 x 11, 2004. **McQueen's Trailer:** (2) Bob Pauley, Andy Dreyfus, John Lee, Craig Foster, and Gary Schultz [model], Athena Xenakis [shading], Digital, 2005. **Mack and McQueen Storyboard:** (3) Dan Scanlon, Pencil, 9 x 5, 2004.

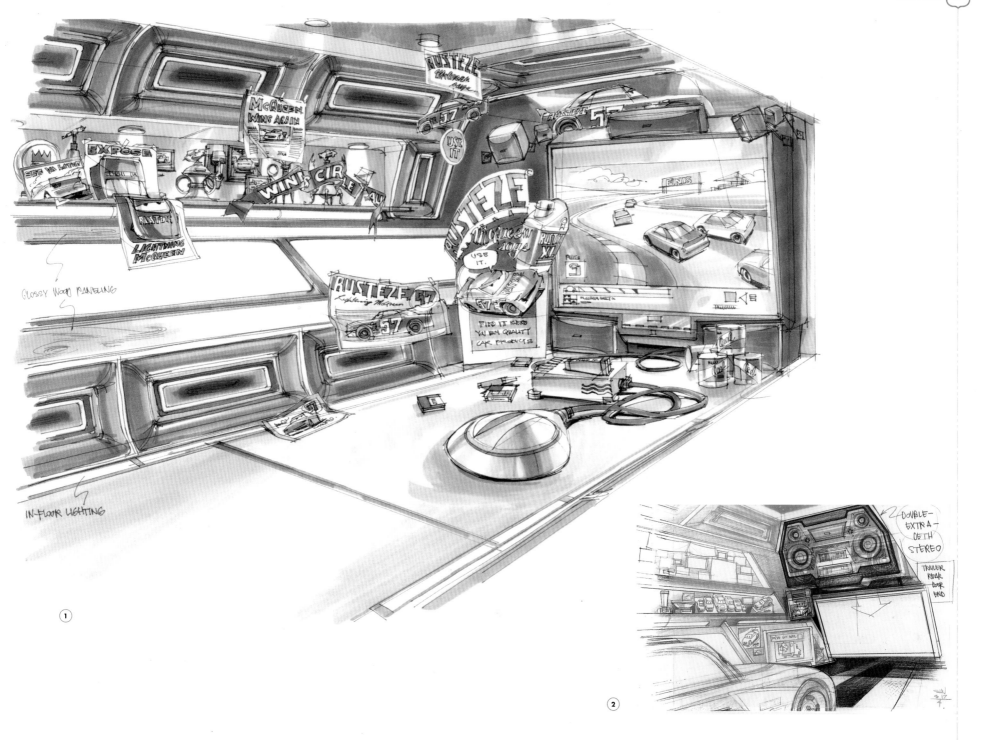

GLOSSY WOOD PANELING

IN-FLOOR LIGHTING

DOUBLE-
EXTRA-
DEPTH
STEREO

TRAILER
REAR
BACK
END

McQueen's Trailer: Jay Shuster, (1) Pen/Marker, 15.5 x 10.75, 2003; (2) Pencil, 16.75 x 12.25, 2004.

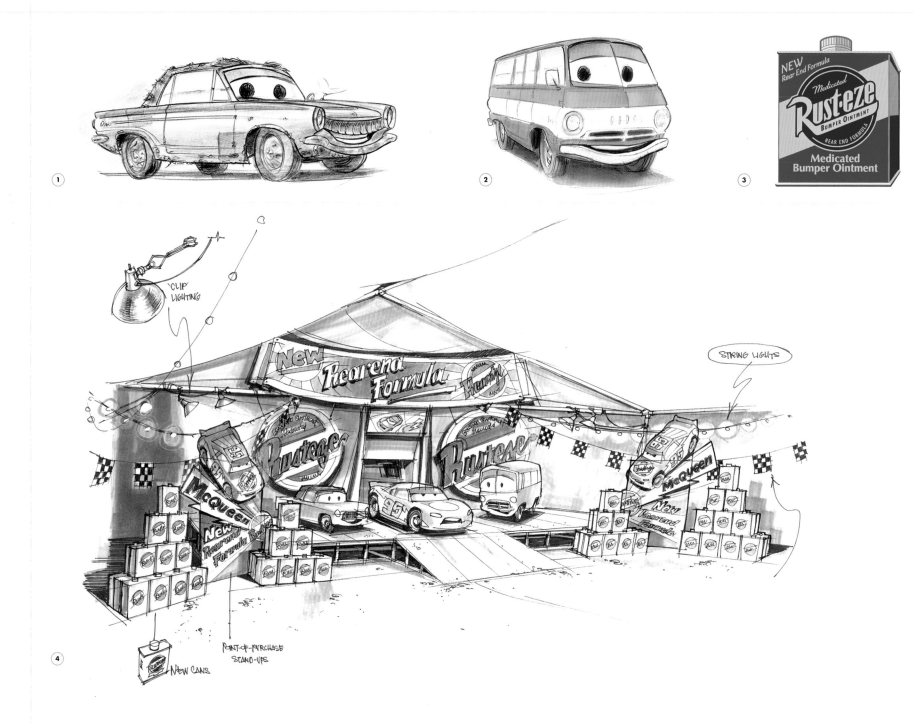

The Rust-eze Team: Bob Pauley, Pencil/Marker, (1) 8 x 3.75, (2) 10.25 x 8; 2003. (3) Craig Foster, Digital, 2005. (4) Jay Shuster, Pen/Marker, 17 x 11, 2004.

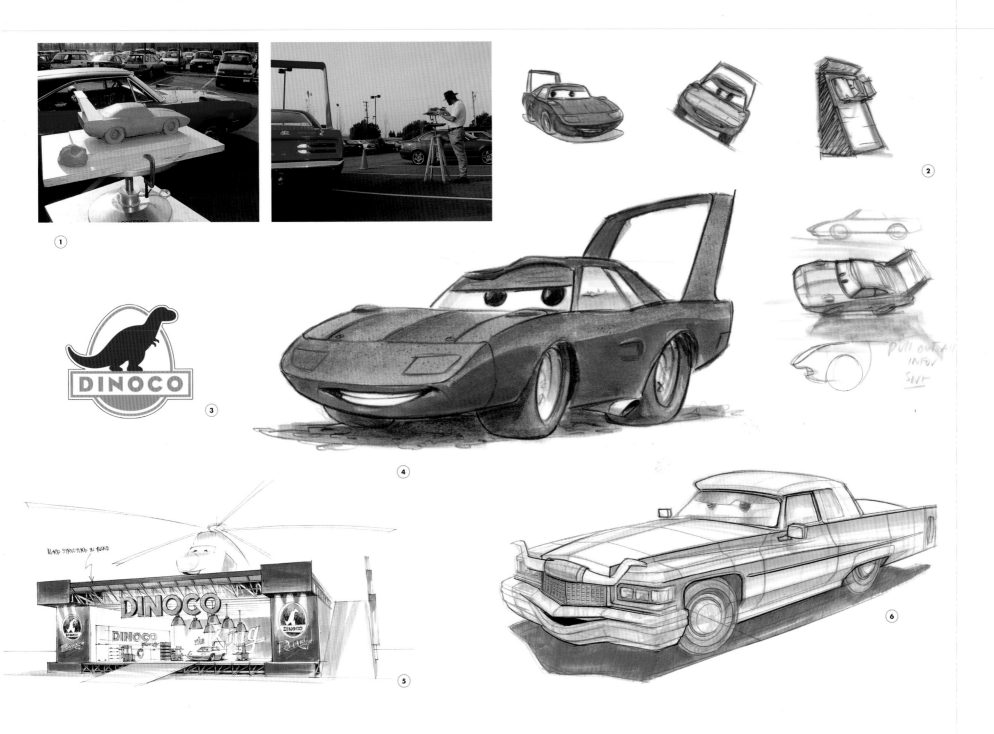

The Dinoco Team: (1) "The King." Jerome Ranft [sculpt] and Bob Pauley [photograph], 2003. (2) "The King." Bob Pauley, Pencil, 16.5 x 10.5, 2004. (3) Andy Dreyfus [graphics], Bill Cone and Bob Pauley [layout], Digital, 2004. (4) "The King." Bob Pauley, Pencil/Marker, 10.75 x 6, 2003. (5) Jay Shuster, Pen/Marker, 15.5 x 10, 2004. (6) "Tex." Jay Shuster, Pen/Marker, 11 x 6, 2003.

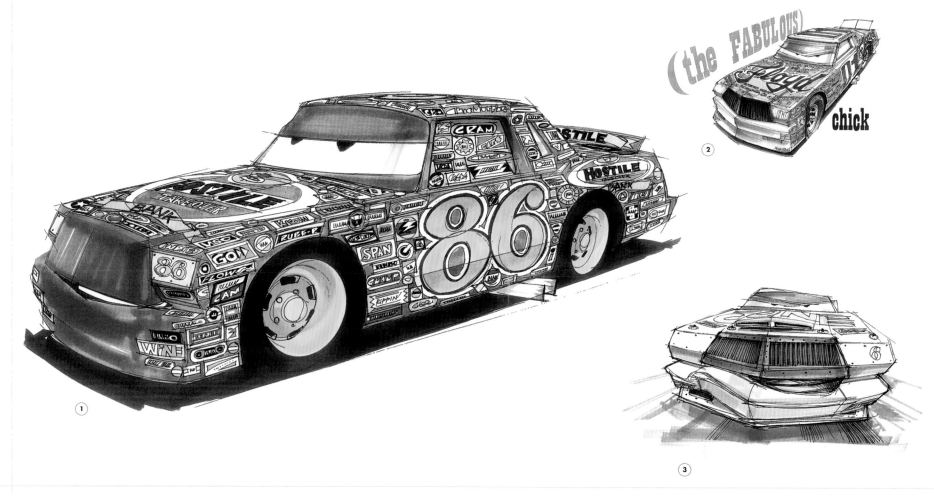

the FABULOUS) chick

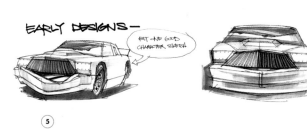

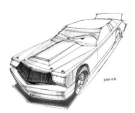

htB

hostile takeover Bank

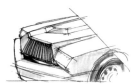

EARLY DESIGNS—

BUT ONE GOOD CHARACTER SKETCH

Chick Hicks: Jay Shuster, Pen/Marker, (1) 17.25 x 12.25, 2004; (2) 17 x 11, 2003; (3) 12.25 x 10, 2003; (5) 17 x 11 [detail], 2003. (4) Craig Foster, Digital, 2005.

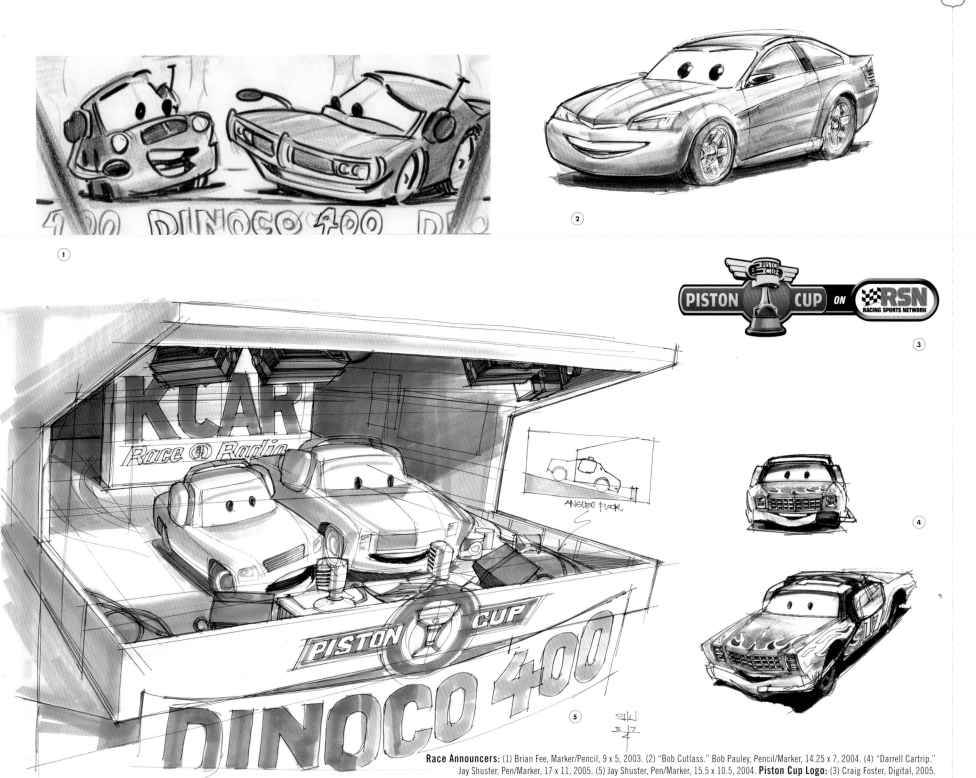

Race Announcers: (1) Brian Fee, Marker/Pencil, 9 x 5, 2003. (2) "Bob Cutlass." Bob Pauley, Pencil/Marker, 14.25 x 7, 2004. (4) "Darrell Cartrip."
Jay Shuster, Pen/Marker, 17 x 11, 2005. (5) Jay Shuster, Pen/Marker, 15.5 x 10.5, 2004. **Piston Cup Logo:** (3) Craig Foster, Digital, 2005.

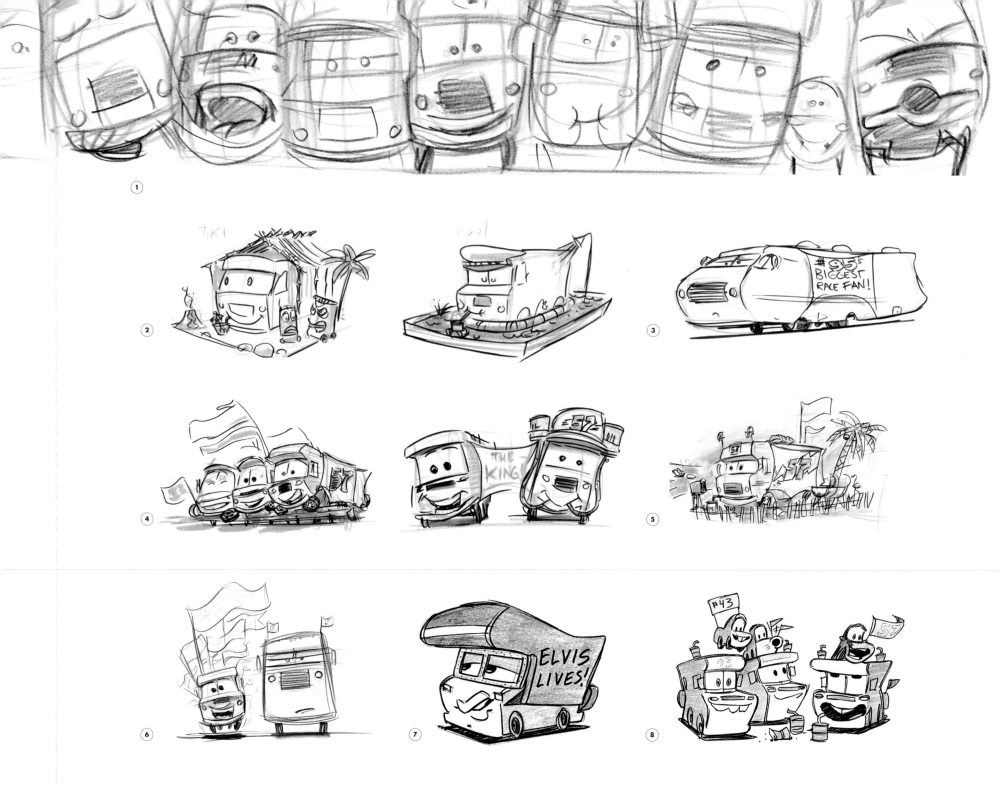

Motorhome Fans: Bob Pauley, Pencil, (1) 15.75 x 5.5, (6) 11 x 9.75; 2003. Bob Pauley, Pencil/Marker, (2) 14.5 x 9.5 [detail], (3) 17 x 11, (4) 16.5 x 7.5, (5) 12.5 x 8; 2003. Brian Fee, Marker/Pencil, (7) 11 x 8.5, (8) 11 x 8.5; 2004.

Mia and Tia: (1) Bob Pauley, Pencil/Marker, 9 x 5.25, 2002. **Fan Stickers:** (2) Craig Foster, Digital, 2004.

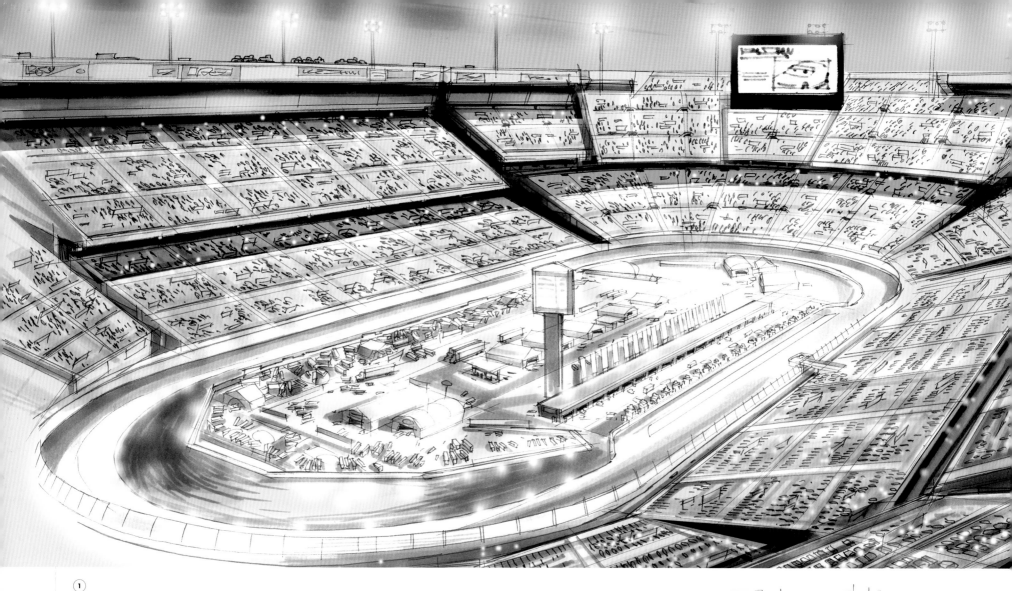

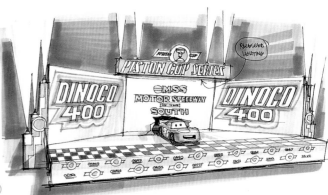

Motor Speedway of the South: Jay Shuster, (1) Pencil/Marker, 15.75 x 9.75; (3) Pen/Marker, 16.5 x 9.75; (4) Pen/Marker, 10.5 x 8.75; 2004. (2) Ellen Moon Lee and Bob Pauley, Digital, 2005.

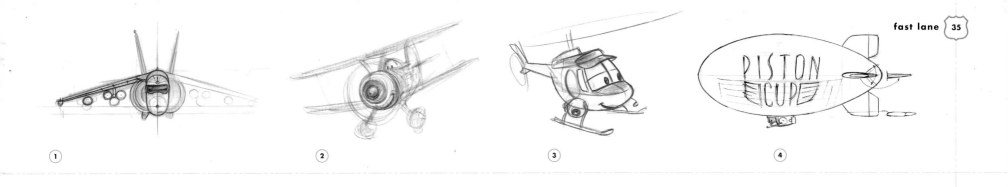

(1) (2) (3) (4)

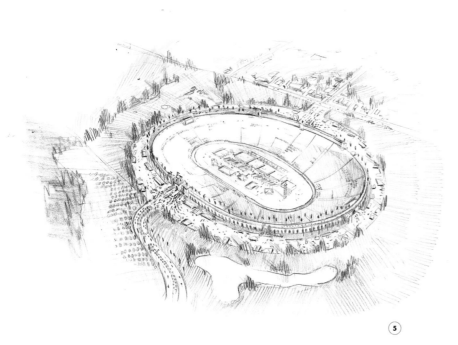

(5)

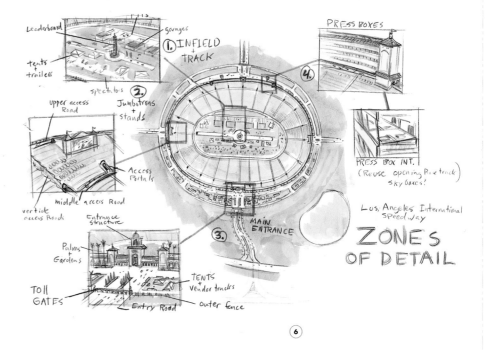

(6)

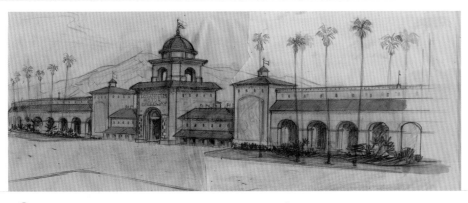

(7)

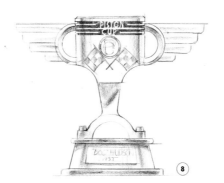

(8)

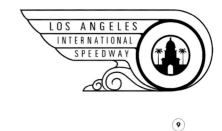

(9)

Los Angeles International Speedway: Bob Pauley, (1) Pencil, 15.5 x 6.75 [detail], 2004; (2) Pencil, 11.75 x 8.25, 2004; (3) Pencil, 17 x 11 [detail], 2003; (4) Pen/Marker, 11.5 x 7.5, 2003. Nat McLaughlin, (5) Pencil, 12.25 x 9.75, 2004; (6) Pencil/Marker, 14 x 10.5, 2004; (8) Pencil, 16.50 x 11, 2005. (7) Nat McLaughlin [overlay] and Gary Schultz [model], Pencil/Overlay, 17 x 11, 2005. (9) Ellen Moon Lee, Craig Foster, Digital, 2005.

"Automobile racing started when the second automobile was built."
—Richard Petty

PIT STOP
Thunder Road

Pixar's research about racing did not stop at the track. As the film team dove into the sport, they also reached into its history. The roots of stock-car racing are firmly anchored south of the Mason-Dixon line in the mountains of North Carolina and the hills and hollers of Appalachia. For more than two centuries many folks in that region supplemented their income by secretly making and peddling potent tax-free whiskey brewed by the light of the moon.

By the time of Prohibition in the 1920s and 1930s, the business of "running moonshine" had begun to boom. The runners, better known as bootleggers, who illegally hauled the hooch to a growing customer base, became adept at driving cars loaded with liquor. They thundered down twisting dark roads at breakneck speeds—the headlights off to avoid detection—with law officers or "revenuers" in hot pursuit.

On Sunday afternoons, the daredevil drivers started racing each other just for fun. They would take their souped-up standard coupes—modified to make them as speedy as possible—to cow pastures to see who had the fastest car. Wagers were made and a purse awarded to the winner. Large numbers of people started turning out to see the moonshine cars in action, and a new sport was born—stock-car racing.

Once considered exclusively a Southern tradition, this popular motor sport has gone national. Today speedways filled with fervent fans from every walk of life dot the nation, from California to New England, and sleek high-tech cars consistently break new records. Pixar took in the rich history of stock-car racing and paid homage to it in the film by featuring models of actual cars from various eras racing side by side.

(1)

Doc Hudson: Bob Pauley, Pencil, (1) 10.5 x 7.5 [detail], 2003; (2) 10.5 x 7.5 [detail], 2003; (3) 15 x 9.75 [detail], 2004. **Doc Crew Chief Storyboards:** (4) Steve Purcell, Marker/Pencil, 9 x 5, 2004. (5) Garett Sheldrew, Ink/Pencil, 9 x 5, 2003. (6) Brian Fee, Marker/Pencil, 9 x 5, 2004. **Doc Hudson Racing:** (Following Spread) Bill Cone, Pastel, 18 x 8, 2004.

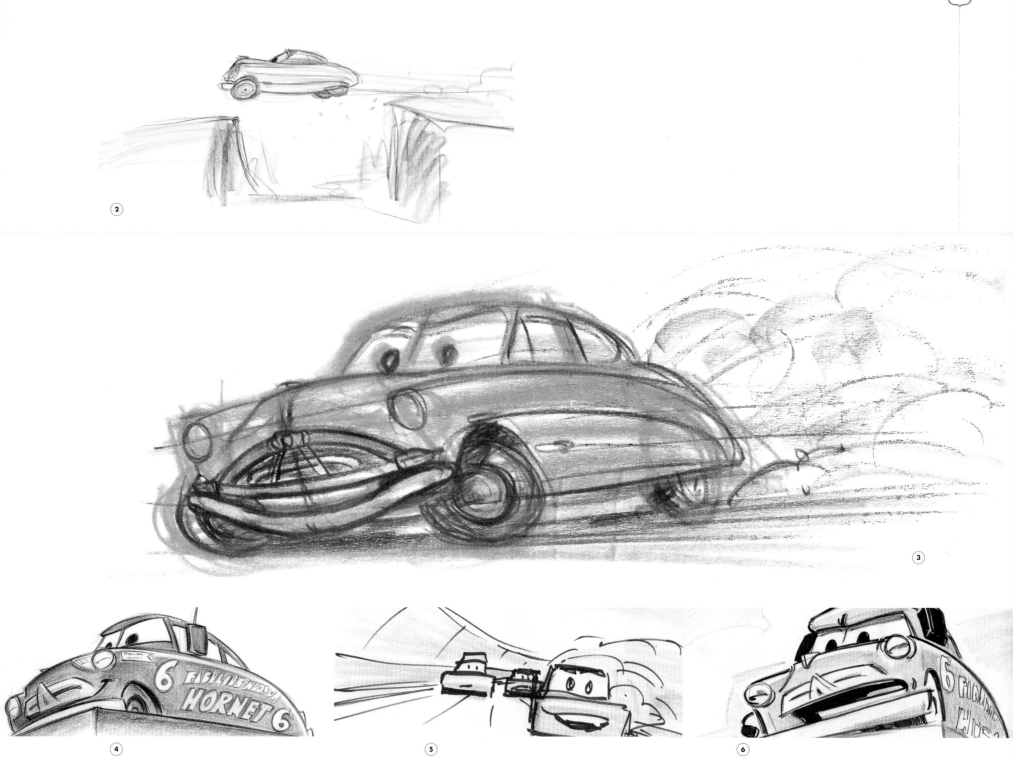

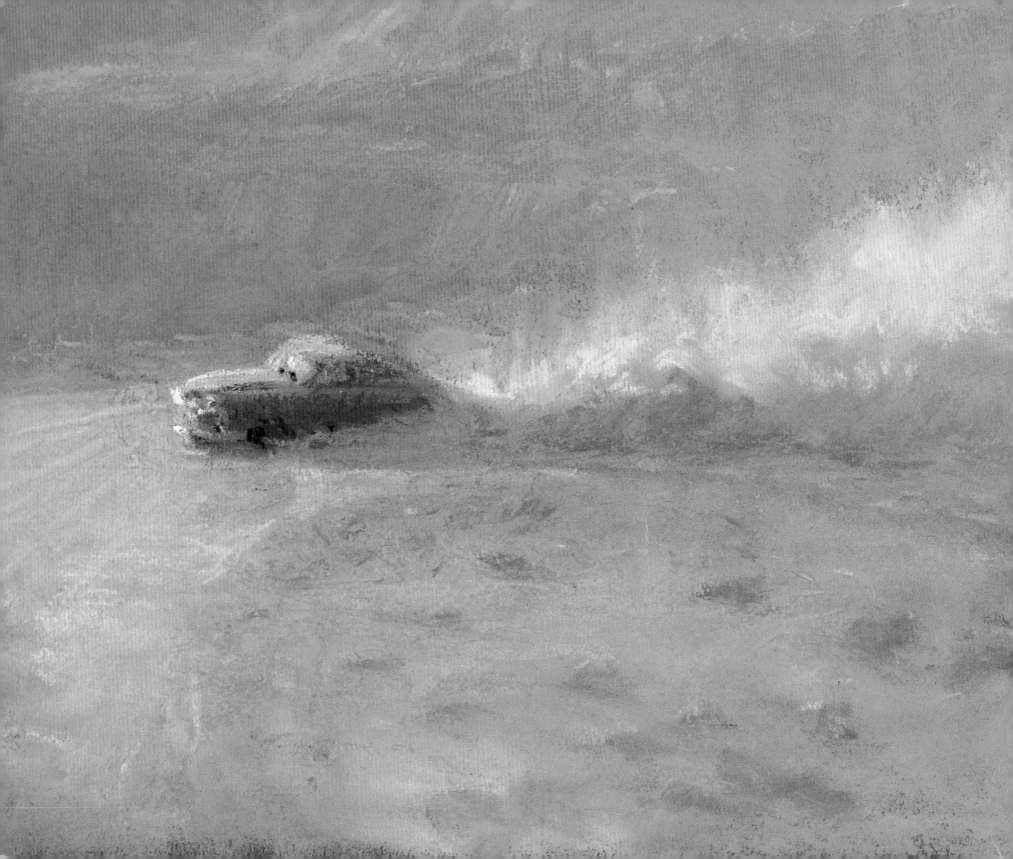

Motor City

In order to learn everything there was to know about automobiles, the Pixar team realized they would need to go to the place that had become synonymous with cars—Detroit. Although the city may no longer be the world's leading auto manufacturer, Detroit will always be the Motor City. A variety of Pixar animators and artists descended on the city, and with each trip they collected invaluable data as they scrutinized every facet of automobile history, development, design, and technology.

"Our Pixar team members absorb all types of information on research trips," says Joe Ranft, a longtime Pixarian and Head of Story for Cars. "But what happens is that different things strike different members and not everyone sees a subject in the same light. That, of course, is just what needs to occur, so that later when we come home and regroup, we talk about what we encountered, and different perspectives emerge."

During the North American International Auto Show, a phenomenal automotive gathering

situated inside Cobo Center in downtown Detroit, the Pixar team devoted considerable time to experiencing all vehicle exhibits and demonstrations, which covered more than seven hundred thousand square feet of floor space. Along with thousands of automotive fans from around the globe, the team inspected the best the world's automakers had to offer, including fire-breathing super cars, new lineups of production and concept vehicles, and exotic glamour cars. The team also took in everything else related to autos that Detroit had to offer. They went to manufacturing plants and watched automobiles being designed and assembled, knowing they would soon be making animated cars of their own back at the studio.

Pixar conferred with some of the nation's most prominent auto collectors, including Don Sommer, automotive specialties manufacturer and founder of the Meadow Brook Concours d'Elegance. This classic-car show features scores of the most lavish and expensive

automobiles competing for awards in various classes. Unexpected details are the hidden treasures of research, and Pixar found gold in the refinements of these classic autos. Sommer's large collection of ornate hood ornaments so impressed the creative team that they integrated many into the film's environments, such as Willys Butte and Ornament Valley.

Other noted Michigan car collectors Dick Kughn and his wife, Linda, proved a useful resource for the Pixar artists. The team spent hours roaming the Kughns' private Carail Museum and a warehouse stuffed with mint-condition classic cars and other exceptional collectible Americana, including model trains, rare toys, gas pumps, and vintage signage.

The Pixar team consumed Detroit. In studying every detail and nuance of the automobiles created there—past and present—they learned the fiber and fabric of this city that not only built cars but was also built by cars.

Doc Hudson: Bob Pauley, Pencil/Marker, 10.5 x 7.5, 2003.

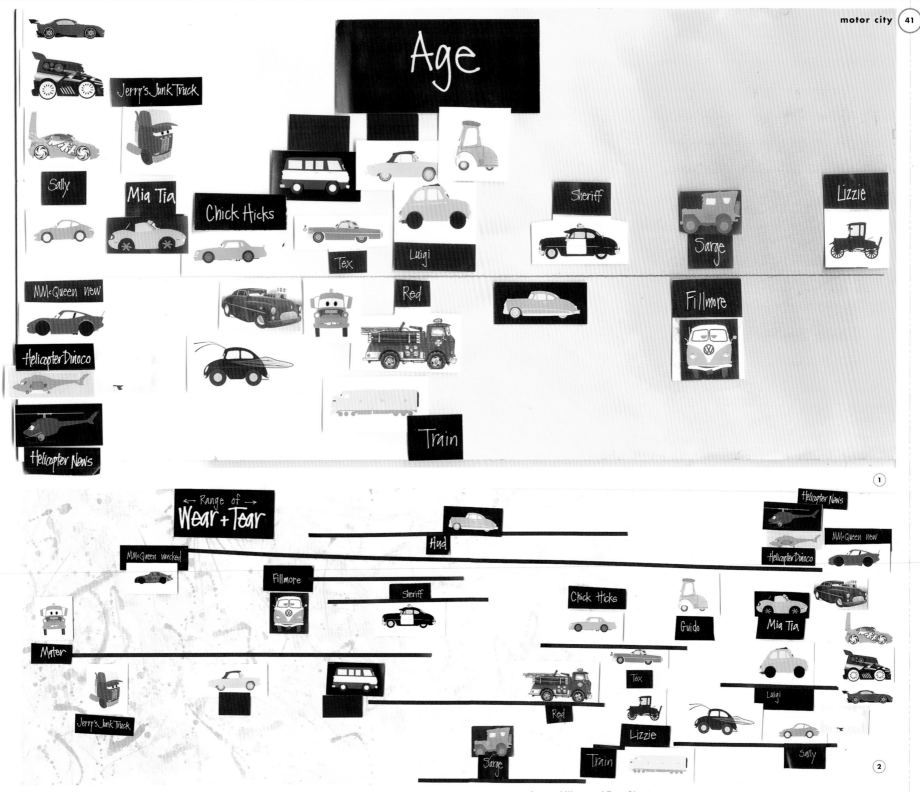

Age and Wear and Tear Charts: Tia Kratter, Mixed Media, (1) 20.5 x 10.75, (2) 30.25 x 10.25; 2004.

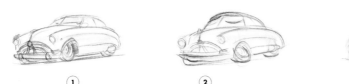
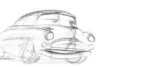
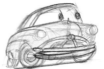
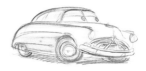

Doc Hudson

Bob Pauley, Pencil, (1) 9 x 8 [detail]; (2), 8.5 x 7.25 [detail]; 2003. (3) Steve Purcell, Acrylic, 11 x 8.5, 2002. (4) Steve Purcell [art] and Patrick Siemer [effects], Marker/Pencil/Digital Effects, 2004.

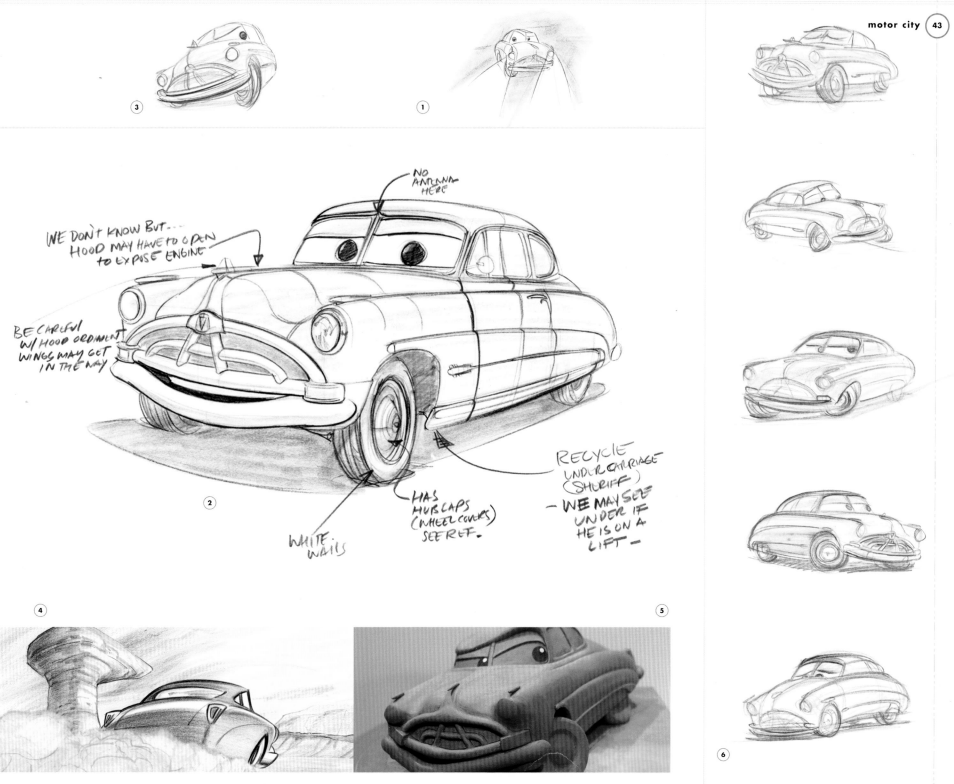

(3)

(1)

NO ANTENNA HERE

WE DON'T KNOW BUT...
HOOD MAY HAVE TO OPEN
TO EXPOSE ENGINE

BE CAREFUL
W/ HOOD ORNAMENT
WINGS MAY GET
IN THE WAY

(2)

RECYCLE
UNDER CARRIAGE
(SHERIFF)
- WE MAY SEE
UNDER IF
HE IS ON A
LIFT -

HAS
HUBCAPS
(WHEEL COVERS)
SEE REF.

WHITE
WALLS

(4)

(5)

(6)

Doc Hudson: Bob Pauley, Pencil, (1) 9 x 8 [detail], (2) 15 x 9.75, (3) 10.5 x 7 [detail], (6) 8.5 x 7.25 [detail]; 2003. (4) Steve Purcell [art] and Patrick Siemer [effects], Marker/Pencil/Digital Effects, 2004. (5) Jerome Ranft, Sculpt, 5.5 x 10 x 12, 2003.

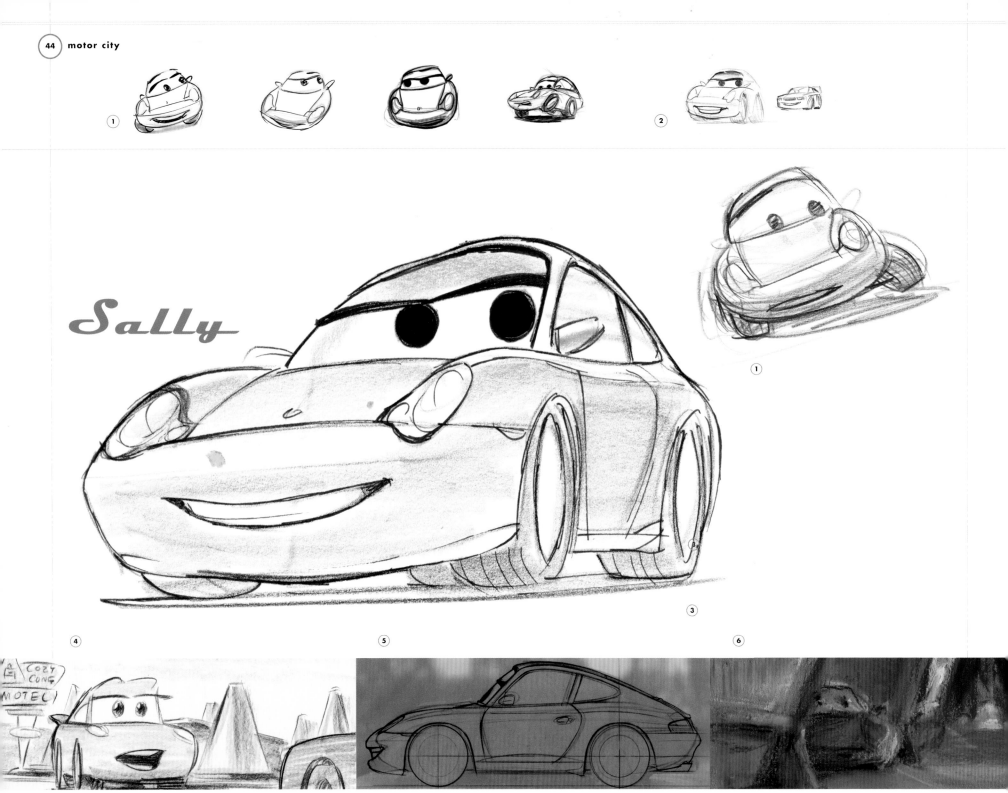

Sally

(1), (2) Bob Pauley, Pencil, 17 x 11 [detail], 2002. (3) Bob Pauley, Pencil, 8.75 x 6, 2003. (4) Dan Scanlon, (5) Garett Sheldrew; Pencil, 9 x 5, 2004. (6) Bill Cone, Pastel, 18 x 8 [detail], 2004.

Mater

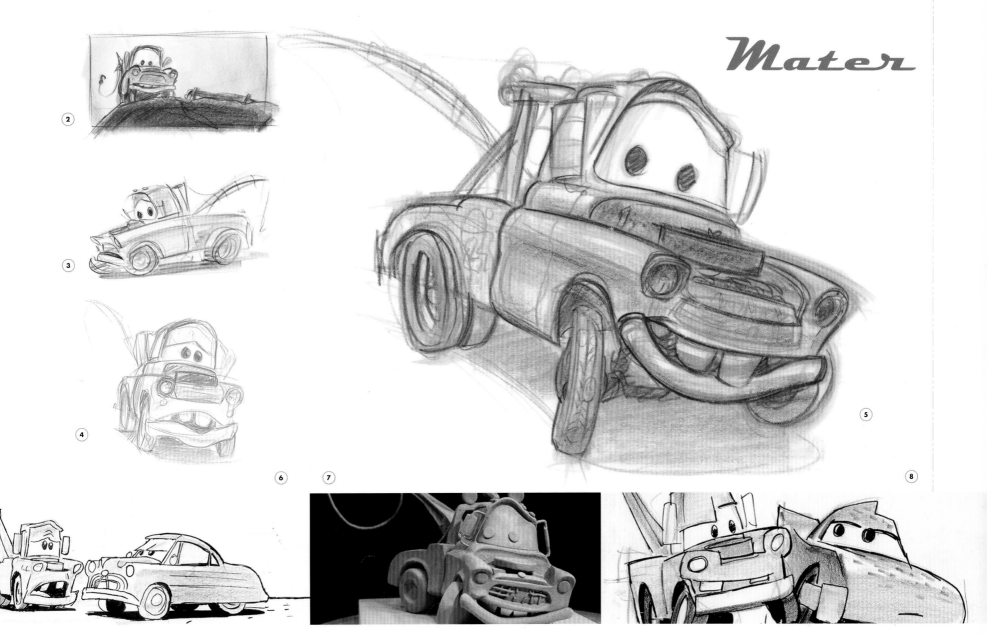

(1) Joe Ranft, Marker, 9 x 5 each, 2002. Bob Pauley, Pencil, (2) 10.5 x 7.25 [detail], 2003; (3) 15.5 x 9.25 [detail], 2003; (4) 6 x 6.5, 2004; (5) 11 x 17, 2003. (6) Ted Mathot and James S. Baker, (8) Steve Purcell; Marker/Pencil, 9 x 5, 2003. (7) Jerome Ranft, Sculpt, 6.5 x 8.25 x 13.25, 2004.

PIT STOP

Tin Lizzie

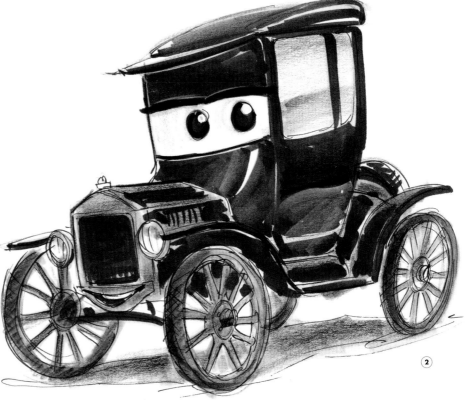

(2)

Henry Ford, the son of Irish immigrants, bears much of the responsibility for America's addiction to cars. After founding the Ford Motor Company in 1903, he set about creating a simple but sturdy car that the average American could afford. In 1908, Ford released the Model T touring car. Although the new model appealed to the public, the sticker price of $825 was still too steep for most people.

Ford did not give up on his dream of offering the first "people's car." In 1913, he launched mass production of Model Ts with interchangeable parts using the first moving assembly line, an innovation that completely streamlined production. This enabled Ford to plow profits back into manufacturing, and by increasing production he was able to lower sticker prices substantially.

The result was the Tin Lizzie, so nicknamed because the body was built of lightweight steel. The vehicle was a great commercial success. Before Ford retired the Model T in 1927 and unveiled the redesigned Model A, more than 15 million of the now-classic automobiles had been manufactured. As an homage to Ford's revolutionary car, a Model T character named Lizzie appears in *Cars*.

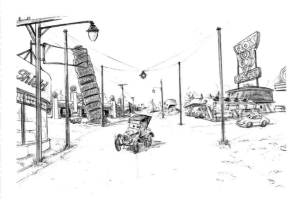

(1)

Early Radiator Springs: (1) Bud Luckey, Pencil, 17.25 x 11, 2001. (2) Bob Pauley, Pencil/Marker, 8.25 x 8.5, 2004.

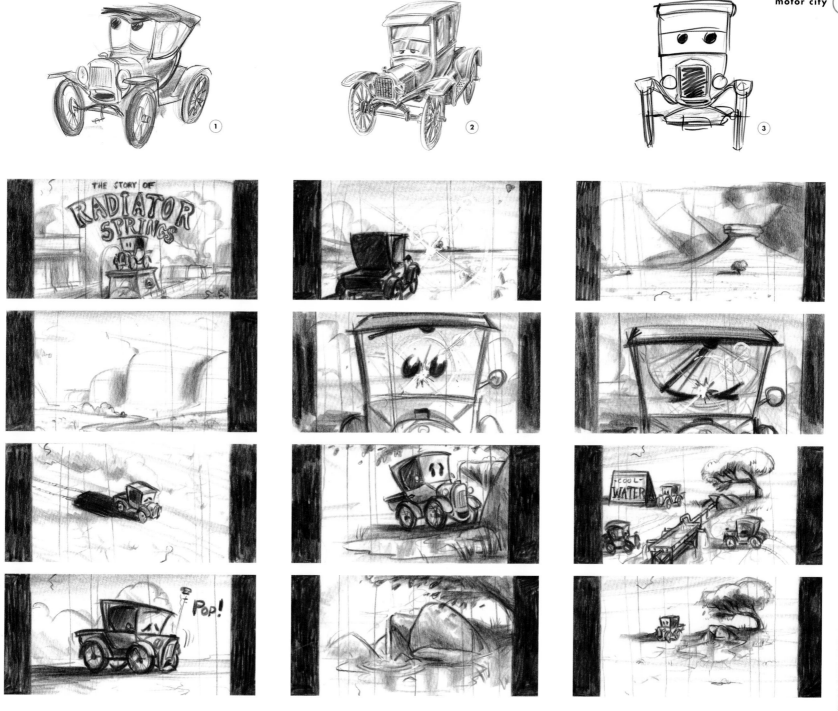

Lizzie: Bob Pauley, (1) Pencil, (3) Pencil/Marker; 17 x 11, 2003. (2) Bud Luckey, Pencil, 17 x 11, 2001. **Radiator Springs Town History:** (4) Nat McLaughlin, Pencil, 5.5 x 2.5 each, 2002.

Flo

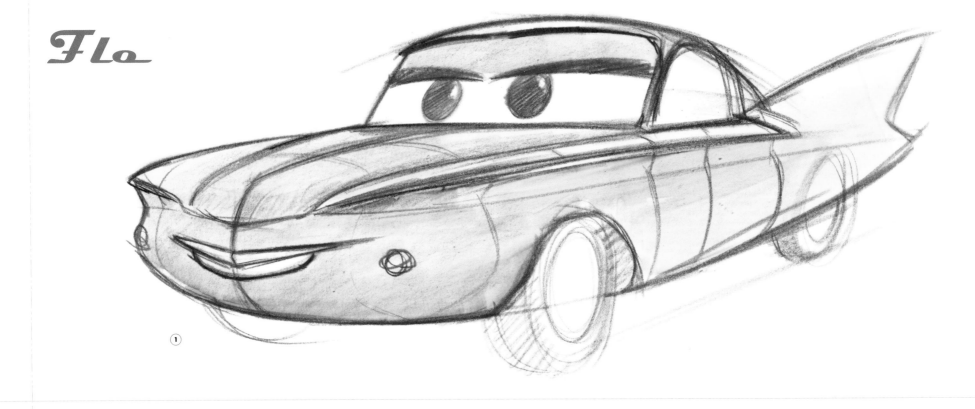

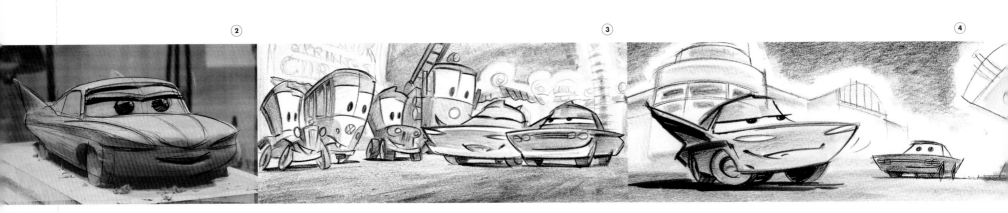

(1) Bob Pauley, Pencil/Marker, 17 x 11, 2004. (2) Jerome Ranft and Bob Pauley, Sculpt/Overlay, 17 x 11, 2003. Steve Purcell, (3) Pencil, 9 x 5, 2004; (4) Marker/Pencil, 9 x 5, 2004.

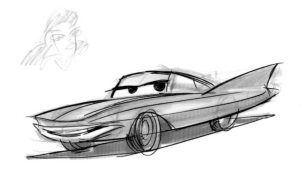
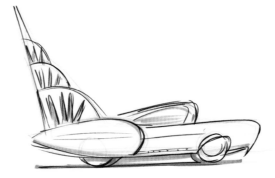
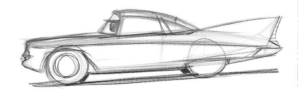
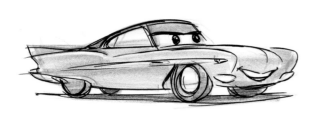
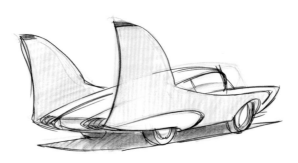
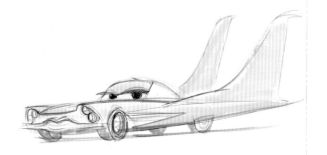
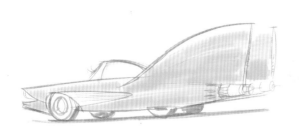
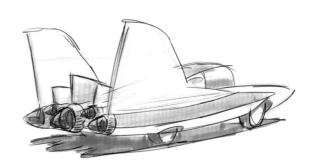
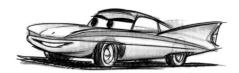
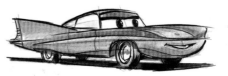

Flo: Bob Pauley, Pencil/Marker, 17 x 11 each, 2004.

Ramone

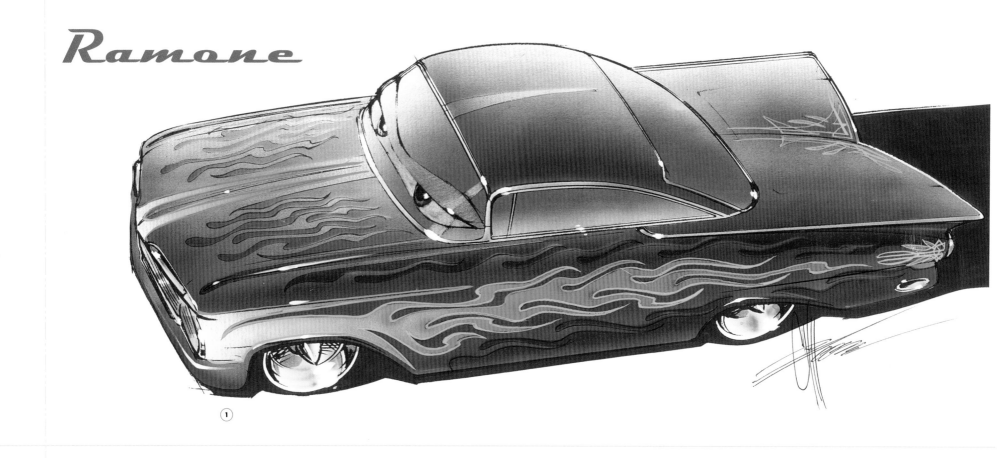

(1)

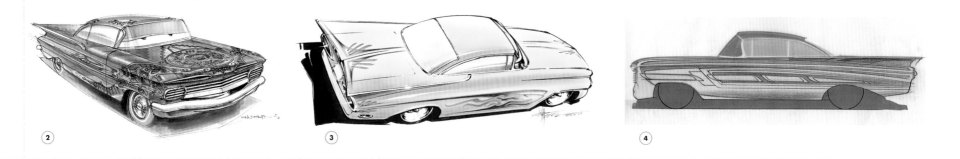

(2) (3) (4)

(1), (3) Chip Foose, Pen/Marker, 17 x 8, 2004. Jay Shuster, (2) Pen/Marker, 17 x11, 2003; (4) Pencil/Overlay/Digital, 17 x 11, 2004.

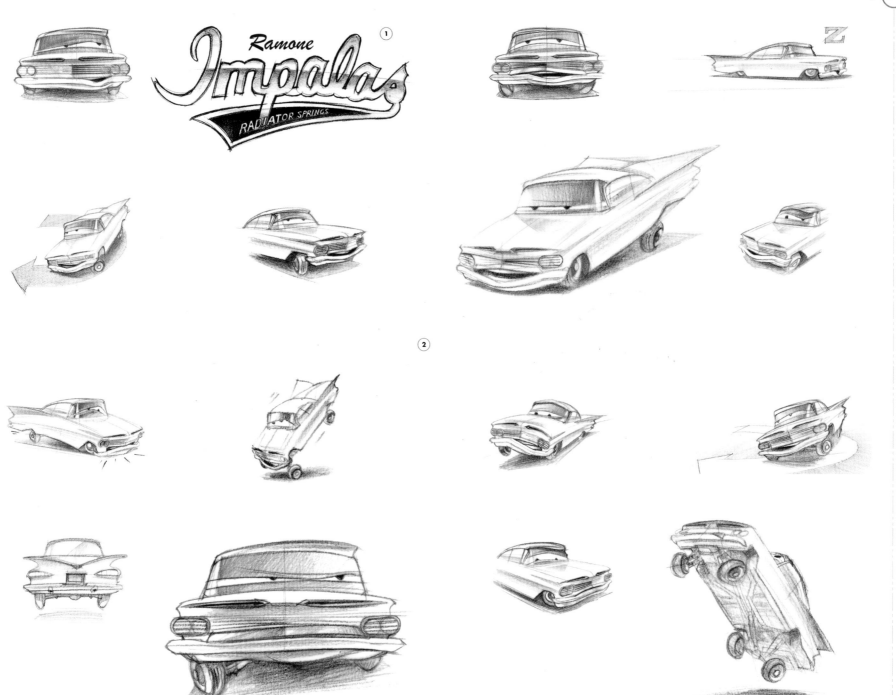

Ramone: Jay Shuster, Pencil, (1) 17 x 11 [detail], 2003; (2) 16.25 x 12.25 and 5.5 x 12.25 [details], 2003–04.

Sheriff

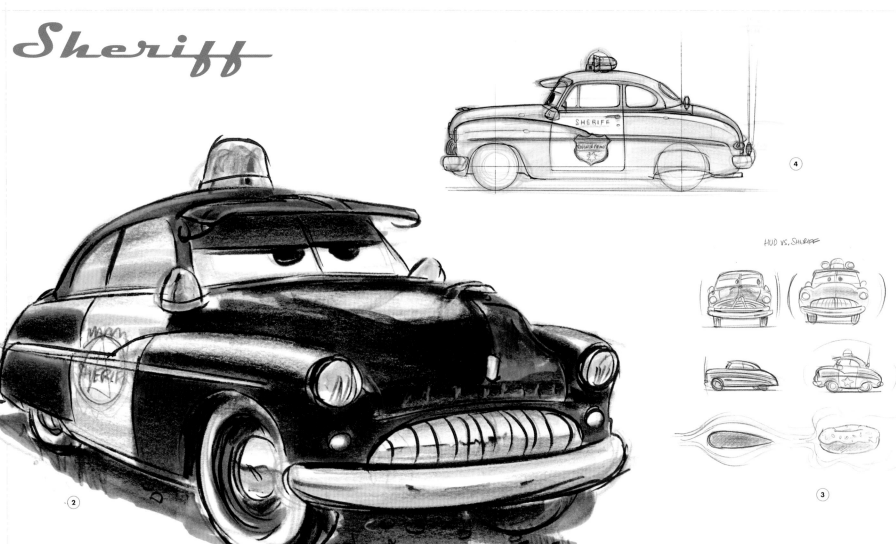

Bob Pauley, Pencil, (1) 17 x 11 [detail], 2002; (3) 15 x 9.75, 2003; (4) 17 x 11, 2002. (2) Bob Pauley, Pencil/Marker, 17 x 11, 2003.

① ② ③

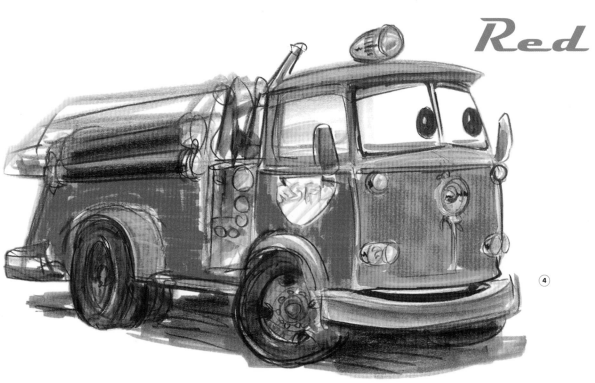

Red

② ④

⑤ ⑥ ⑦

(1), (2), (3) Bob Pauley, Pencil, 17 x 11 [detail], 2002. (4) Bob Pauley, Pencil/Marker, 10.5 x 7.25, 2003. (5), (6) Josh Cooley, Pencil/Marker, 9 x 5, 2004. (7) Max Brace, Pencil/Marker, 9 x 5, 2004.

PIT STOP
Ghosts

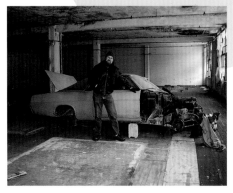

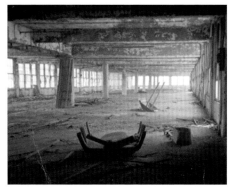

In the 1890s, when gasoline-powered horseless carriages puttered down Woodward Avenue, and for many years after, auto pioneers found all the industrial and human resources they needed in Detroit. Metal components were forged in the city's factories where car bodies were constructed. And plenty of ambitious financiers and industrialists, creative designers and engineers, and an endless labor force were at the ready. All that had changed by the 1970s, however. Detroit lost its coveted spot as the world's leading automobile-manufacturing center. The city's car manufacturing booms later in the century brought about mixed economic results.

Bankruptcy, urban blight, and suburban sprawl have all taken a toll on Detroit's industrial heritage. The Pixar creative team noted this erosion when they toured several of the city's derelict automotive landmarks that have fallen victim to crime, arson, and apathy.

"There was so much to learn, even from an old, abandoned auto plant," says Bill Cone. "We found that layers and levels of decay spoke volumes about the history of a place. Decay, dirt, and rust have a story to tell."

The Packard Motor Car Company plant proved to be a favorite site for the Pixar team, who paid homage at the sprawling remains on East Grand Boulevard. Built in the 1900s, the colossal 3.5-million-square-foot complex spread over forty acres was once a bustling site for one of the last independent American automakers. As the creative team carefully picked their way through heaps of trash, bird droppings, broken concrete, and shattered glass, they found a mile-long maze of empty ruins waiting for the demolition crews. The plant was a poignant reminder of the hundreds of automobile assembly plants and thousands of skilled craftsmen who once made Detroit the world's automobile capital.

Today, Detroit is just a ghost of its former self, but its memory lives on in the vehicles that were once assembled there—cars that are now considered classics for their distinctive style, shape, and color. Pixar drew from this canon of classic cars, modeling some of the film's characters after a 1951 Hudson Hornet, a 1949 Mercury Police Cruiser, and a 1959 Chevrolet Impala.

Detroit Reference Photographs: Jay Ward and Bill Cone, 2001.

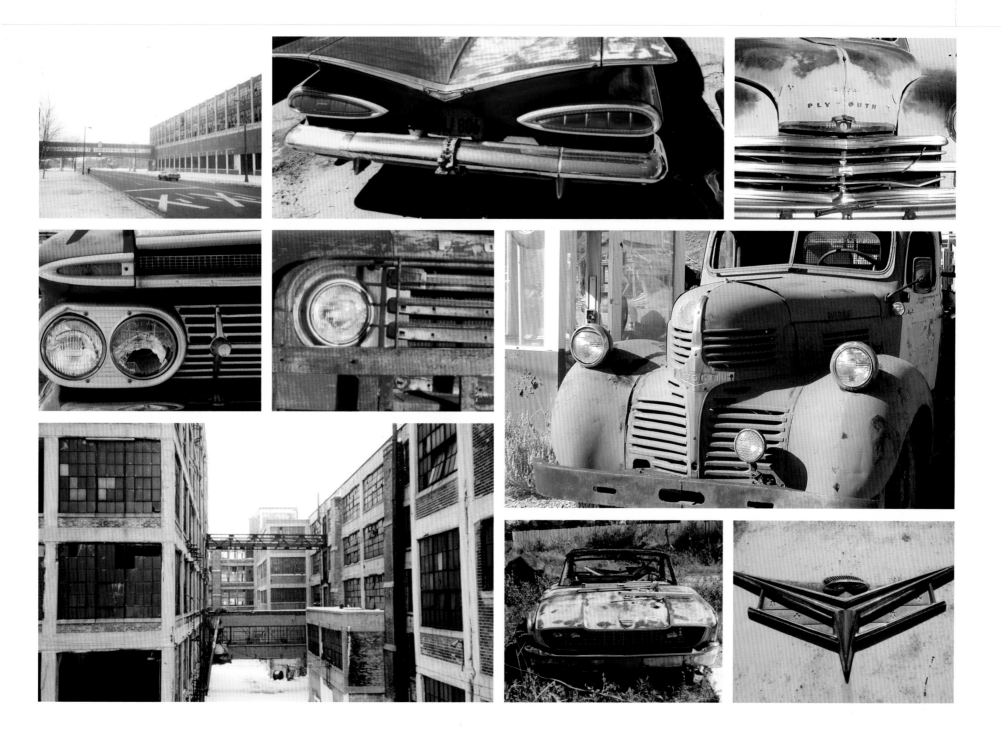

Car Reference Photographs: Bob Pauley, 2001.

ONLY UNDER GREAT LOAD (OR SADNESS) DOES HE DROP LOW

HE IS LIGHT

THAT WHY HIS WHEELS LOOK LIKE THIS

YES!

HIS THIN WHEELS ARE IN & UNDER

HE IS LIGHT ON HIS FEET

ON HIS FEET

NO

NOT WIDE & AT THE CORNERS — HE ONLY THING HE IS A RACE CAR

Luigi

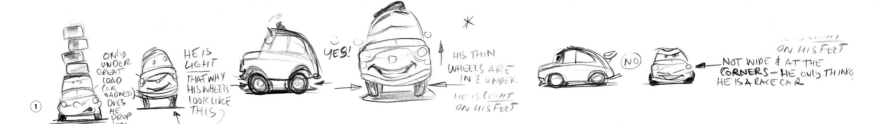

Bob Pauley, Pencil, (1) 16.75 x 11 [detail], 2003; (5) 16.5 x 10.75 [detail], 2002; (6) 10 x 3.25, 2002. (2) Bob Pauley, Pencil/Marker, 6.25 x 6.5, 2003. (3) Rob Gibbs, Marker/Pencil, 9 x 5, 2004. (4) Dan Scanlon, Pencil, 9 x 5, 2004.

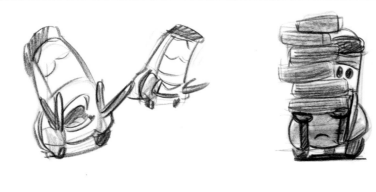

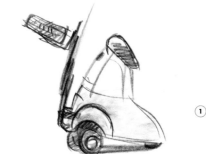

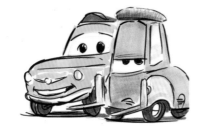

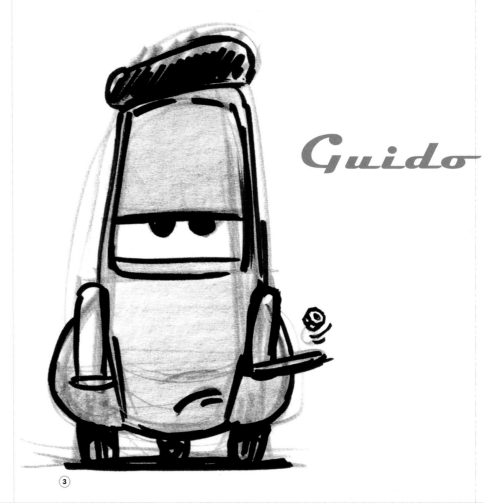

Guido

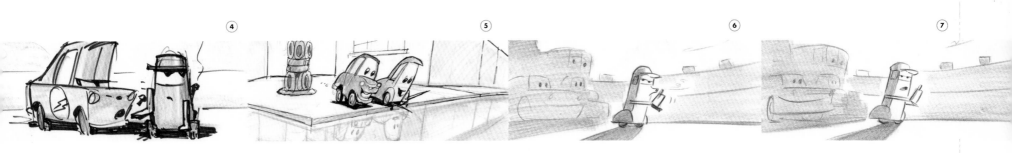

Bob Pauley, Pencil/Marker, (1) 17 x 11; (2) 12.75 x 9.25; (3) 8 x 8; 2003. (4) Garett Sheldrew, (5) James S. Baker; Marker/Pencil, 9 x 5, 2003. (6), (7) Dan Scanlon, Pencil, 9 x 5, 2003.

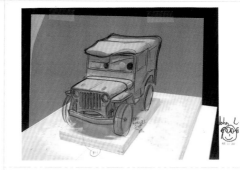

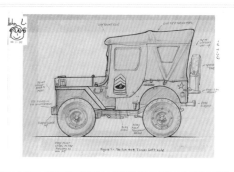

Sarge

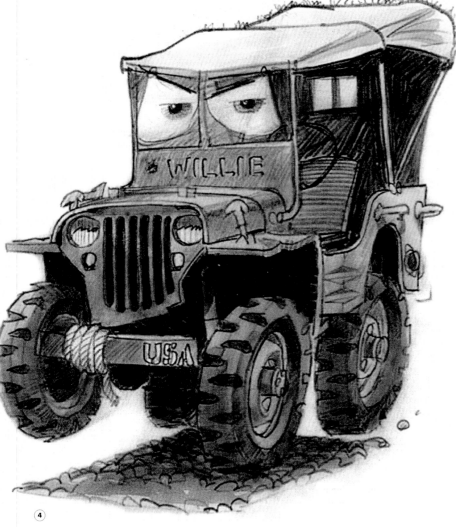

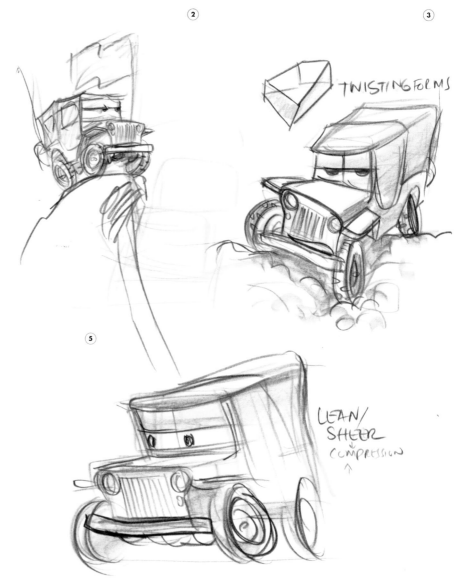

TWISTING FORMS

LEAN/
SHEER
↓
COMPRESSION

Bob Pauley, Pencil, (1) 12 x 9, (5) 17 x 11; 2002. (2) Jerome Ranft [sculpt] and Bob Pauley [overlay], Sculpt/Overlay, 17 x 11, 2002. (3) Gary Schultz, Pencil, 17 x 11, 2002. (4) Dave Deal, Pencil, 14 x 11, 2000.

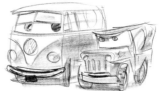

(1)

(2)

(3)

Fillmore

(2)

(5)

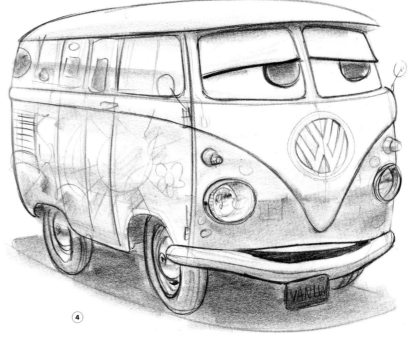

(4)

(6)

(1) James S. Baker, Marker/Pencil, 9 x 5, 2003. Bob Pauley, Pencil, (2) 16.25 x 10 [detail], (4) 11 x 8; 2004. (3) Yvonne Herbst [graphics] and Bob Pauley [layout], Digital, 2005. (5), (6) Bob Pauley, Digital, 2004.

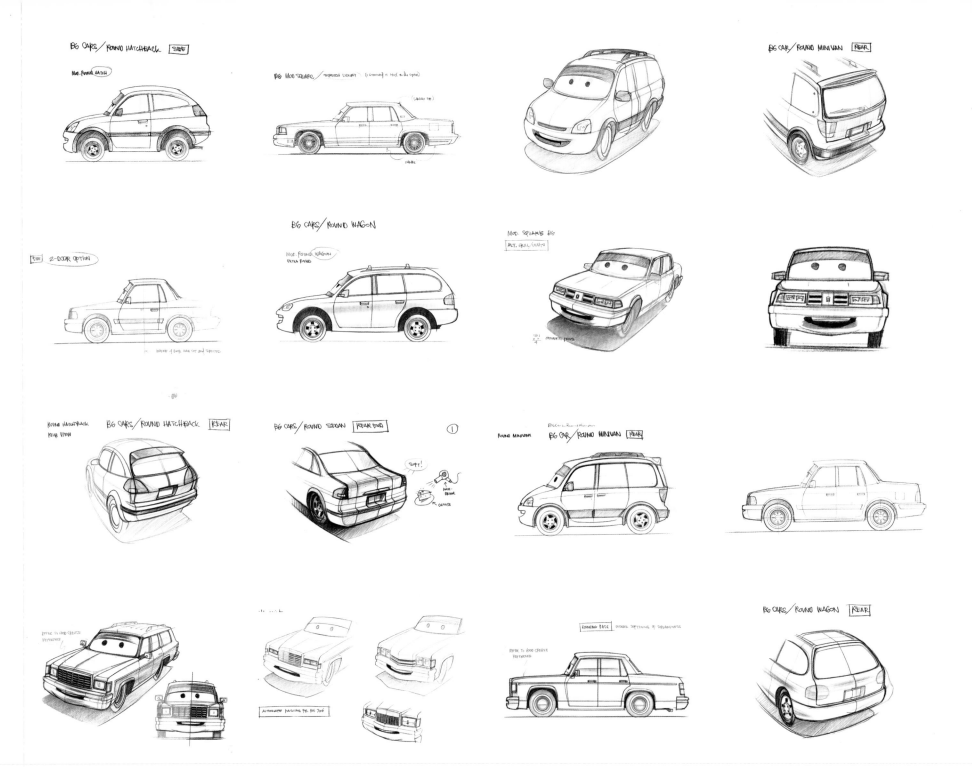

Background Cars: Jay Shuster, Pencil, 17 x 11 each, 2004.

GENERIC 60's/50's SEDAN

GENERIC 50's SEDAN

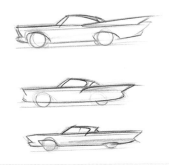

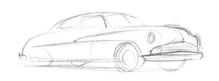

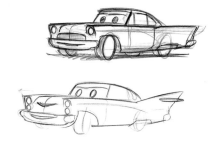

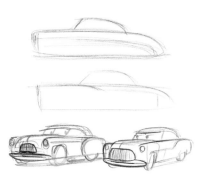

Background Cars: Bob Pauley, Pencil/Marker, 17 x 11 each, 2005.

> "When we get these thruways across the whole country, as we will and must, it will be possible to drive from New York to California without seeing a single thing."
>
> —John Steinbeck, *Travels with Charley: In Search of America*

3

Super Slab

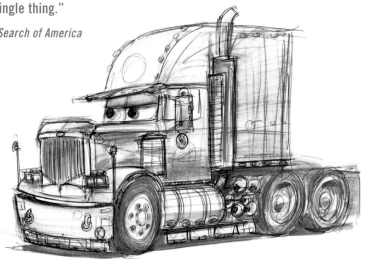

Pixar's creative team clearly understood that the film's automobile characters had to have locales. Cars need roads. Some of the action would take place at a motor speedway, but there had to be roads, too.

In the early stages of film development, the team poured over reference books, catalogs, and other publications to learn everything they could about automobiles and the roads that carried them. They spent hours viewing feature films and documentaries about every possible automotive subject, including the coming of the interstate highway system.

In the 1950s—in the midst of the Route 66 heyday—the biggest public works program in the history of the nation was launched. The Federal-Aid Highway Act of 1956 authorized the use of $25 billion to build a system of interstate highways, all forty-one thousand miles designed for high speed and smooth access.

The brainchild of President Dwight Eisenhower, who during World War II had been inspired by the efficiency of the high-speed German autobahns, this vast network of superhighways promised to create a slew of new jobs, stimulate the economy, and help ease the nation's overcrowded highway conditions. The emergence of these roads, however, would also have an enormous impact on the nation and our way of life.

Overdevelopment and creeping suburban sprawl was already endangering much of America's landscape. The super slabs brought even more damage as they gashed into cities and cut through farms. Highway bypasses changed traffic patterns and caused whole towns to dry up and disappear. The natural environment was ravaged, and the privately owned rail system was left in shambles. Entire city centers were destroyed, homes and family businesses were leveled, and established neighborhoods vanished.

During research trips, the Pixar team saw how many small towns and landscapes had been adversely affected by the coming of the superhighways, and they transferred this reality to the film. For example, when Lightning McQueen hops on the interstate for a cross-country trip to California, he travels on a long straight slab of monotony built for speed. Later, when he gets lost and finds himself on a winding road known as Route 66, he gets stuck in the small, dilapidated town of Radiator Springs. He doesn't understand why anyone would live there until a local beauty named Sally takes him on a drive to an abandoned cliff-top motel, a victim of the nearby interstate skirting the town. As Sally points to the valley below, McQueen sees a network of small roads snaking within a landscape of beautiful natural monuments. He also spots the interstate cutting right through it all.

"Look at that," McQueen says. "All those cars and trucks are driving right by. They don't even know what they are missing."

Background Semi: Bob Pauley, Pencil/Marker, 13 x 9.5, 2002.

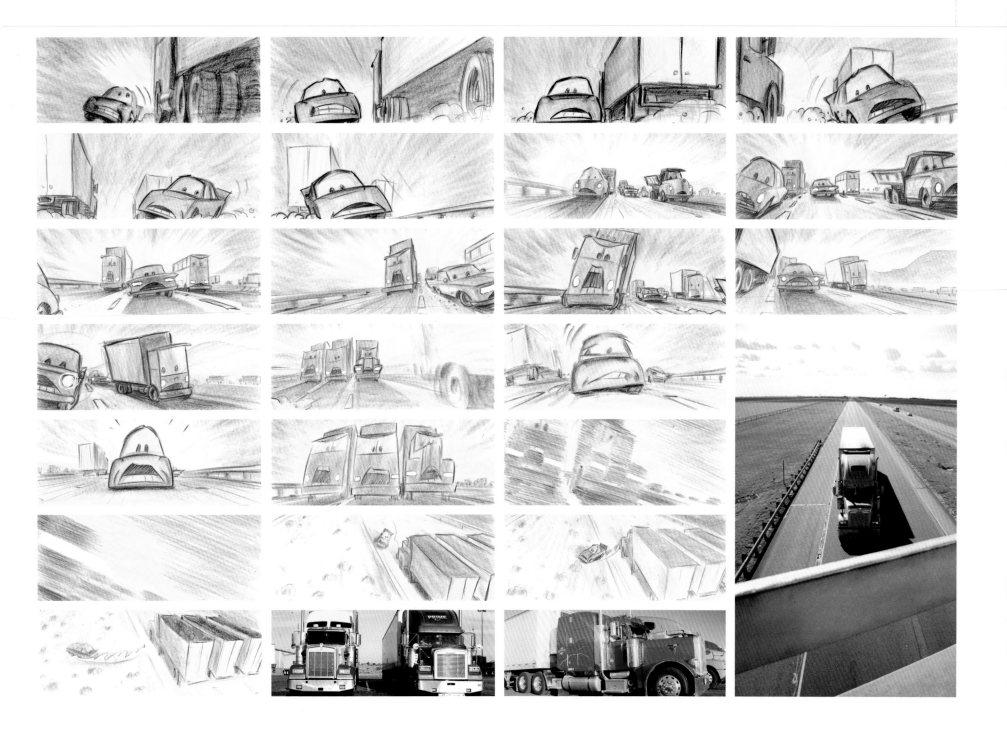

Interstate Storyboards: Garett Sheldrew, Pencil, 9 x 5 each, 2002. **Interstate Reference Photographs:** Bob Pauley, 2001.

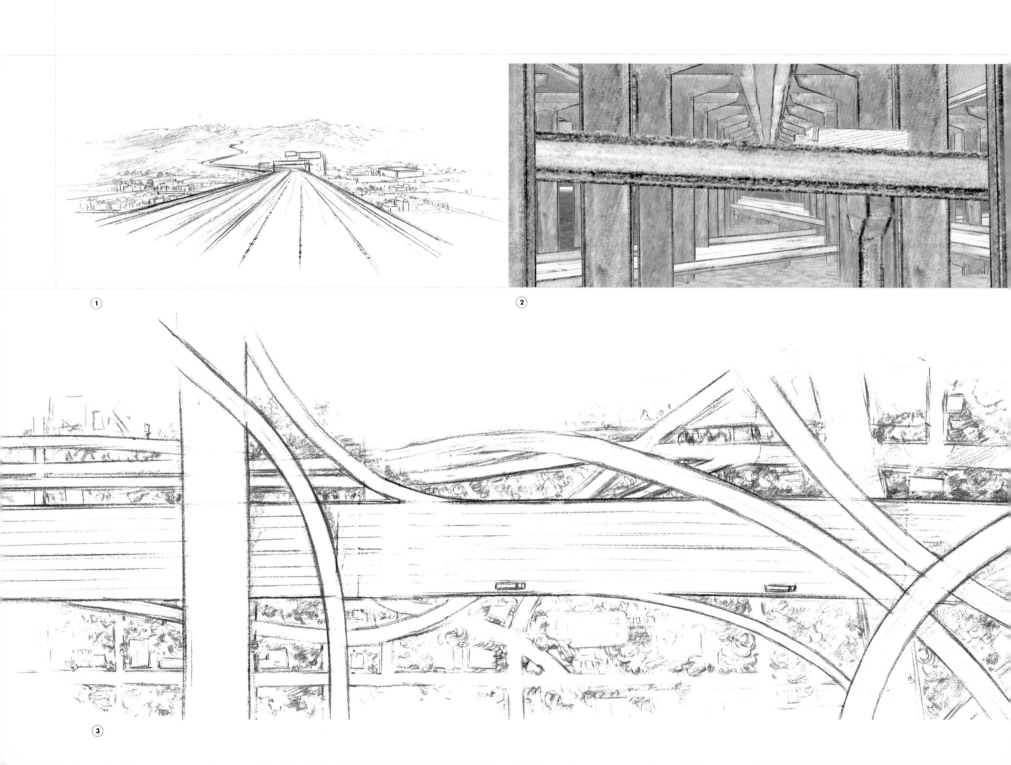

1

2

3

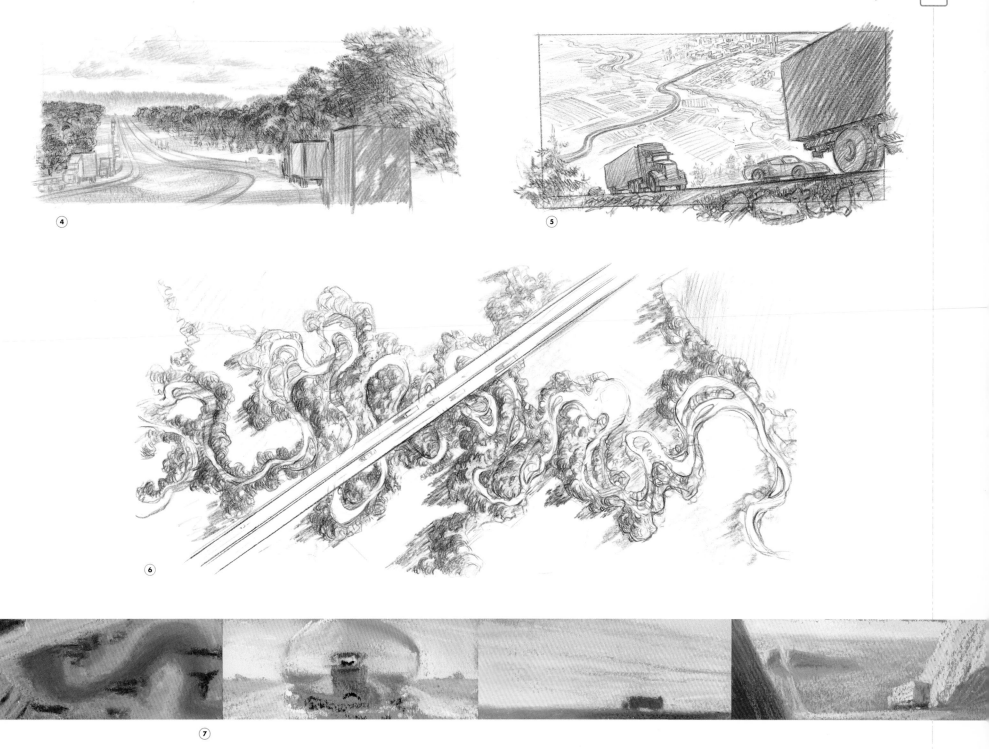

Interstate: Anthony Christov, Pencil, (1) 13.5 x 9.25; (3) 15 x 6; (4), (5) 13 x 10.5; (6) 17 x 12; 2004. (2) Anthony Christov [art] and Patrick Siemer [effects], Pencil/Digital Effects, 2004. (7) Bill Cone, Pastel, 18 x 8 [detail], 2004.

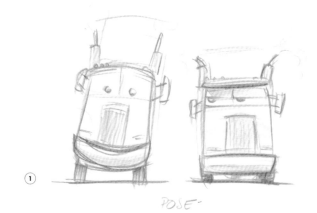

①

POSE-

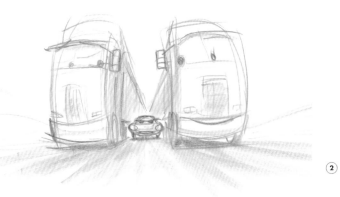

②

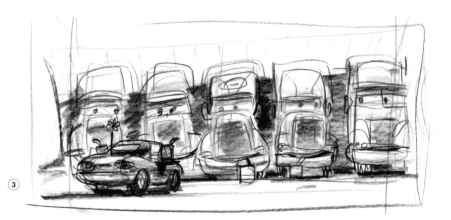

③

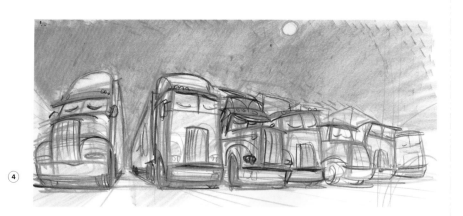

④

⑤

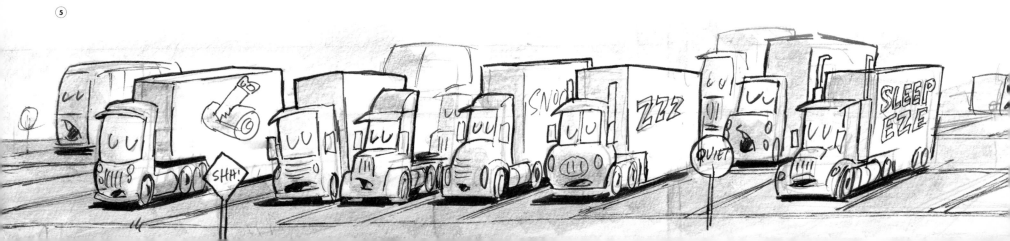

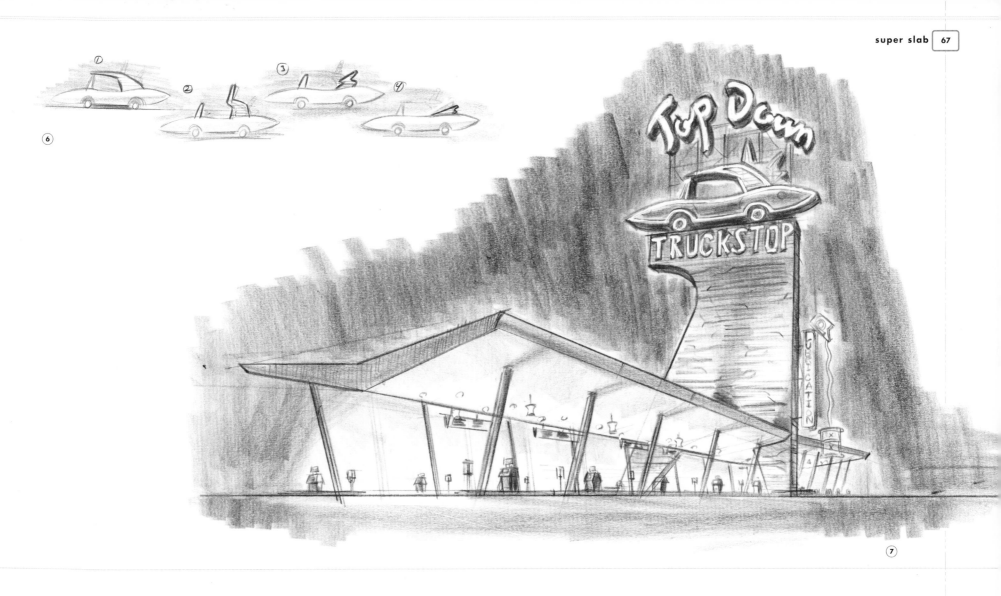

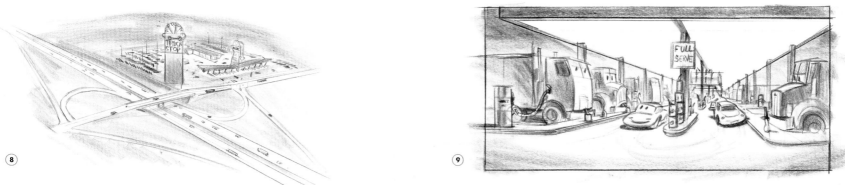

Background Semis: Bob Pauley, Pencil, (1) 15.5 x 10.25 [detail], (2) 10.25 x 6.5, (3) 17.25 x 11, (4) 10.5 x 4.75; 2002. (5) James S. Baker, Marker/Pencil, 27.5 x 11, 2004.
Truck Stop: Nat McLaughlin, Pencil, (6) 17 x 11 [detail], (7) 15 x 9.5, (8) 16.75 x 12.25 [detail], (9) 17 x 10.5; 2002.

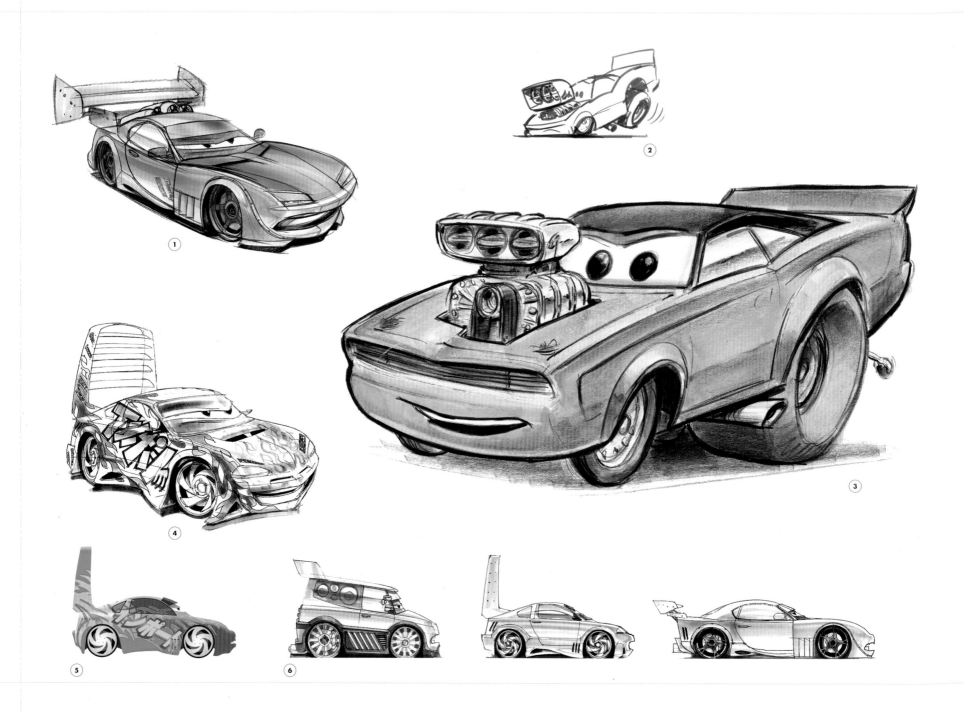

Import Racers: (1) "Boost," Jay Shuster, Pen/Marker, 11.5 x 7.5, 2004. (2) "Snot Rod," Bob Pauley, Marker, 17 x 11, 2004. (3) "Snot Rod," Bob Pauley, Pencil/Marker, 14 x 8.25, 2004. (4) "Wingo," Jay Shuster, Pen/Marker, 10 x 8, 2003. (5) "Wingo," Tia Kratter, Digital, 2003. (6) Jay Shuster, Pen/Marker, 27.5 x 6.75, 2003.

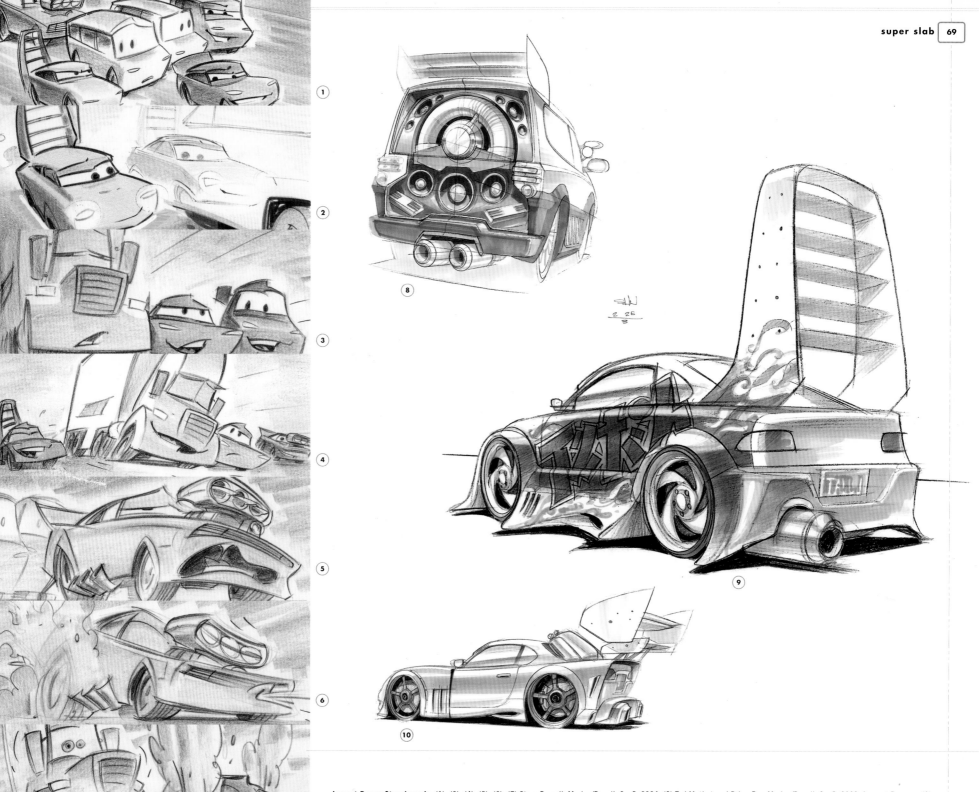

Import Racer Storyboards: (1), (3), (4), (5), (6), (7) Steve Purcell, Marker/Pencil, 9 x 5, 2004. (2) Ted Mathot and Brian Fee, Marker/Pencil, 9 x 5, 2003. **Import Racers:** (8) "DJ," Jay Shuster, Pen/Marker, 16 x 10.25, 2003. (9) "Wingo," Jay Shuster, Pen/Marker, 14.25 x 10.5, 2004. (10) "Boost," Jay Shuster, Pen/Marker, 15.5 x 10.5, 2004.

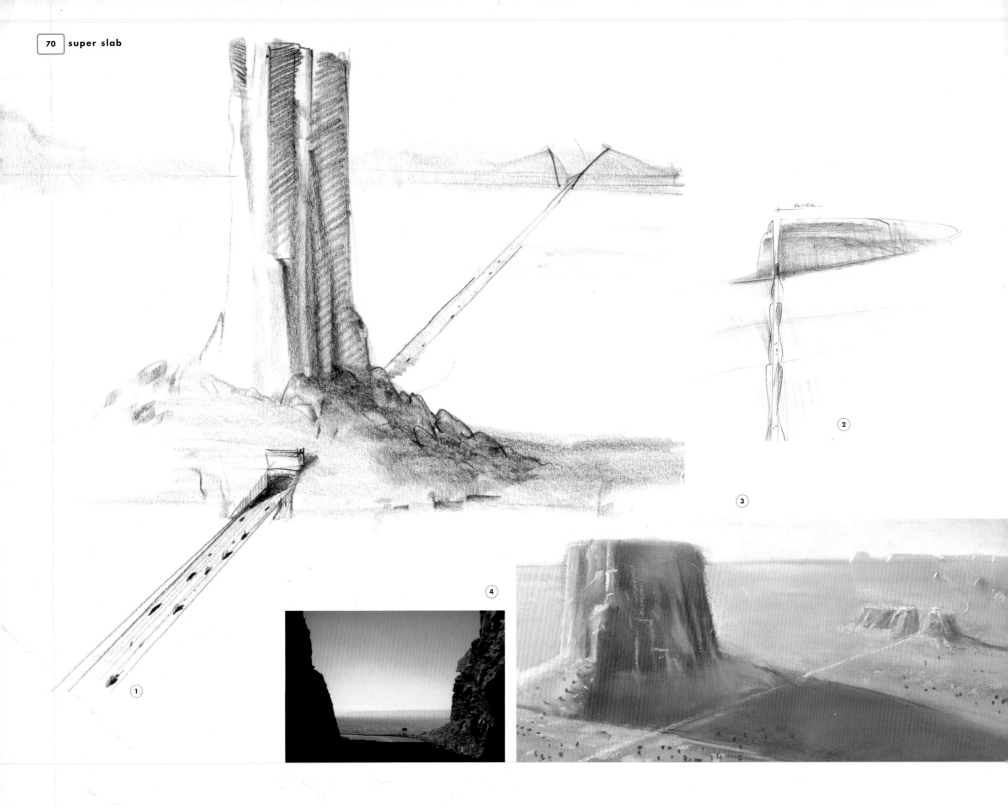

The circled numbers 1, 2, 3, and 4 label the individual studies within the image.

Interstate Studies: Bill Cone, (1) Pencil, 11.25 x 8.75, 2001; (2) Pencil, 11.25 x 9.25, 2001; (3) Pastel, 14.5 x 8, 2002. (Opposite) Tia Kratter, Acrylic, 13 x 9.5, 2004. **Interstate Reference Photograph:** (4) Bill Cone, 2001.

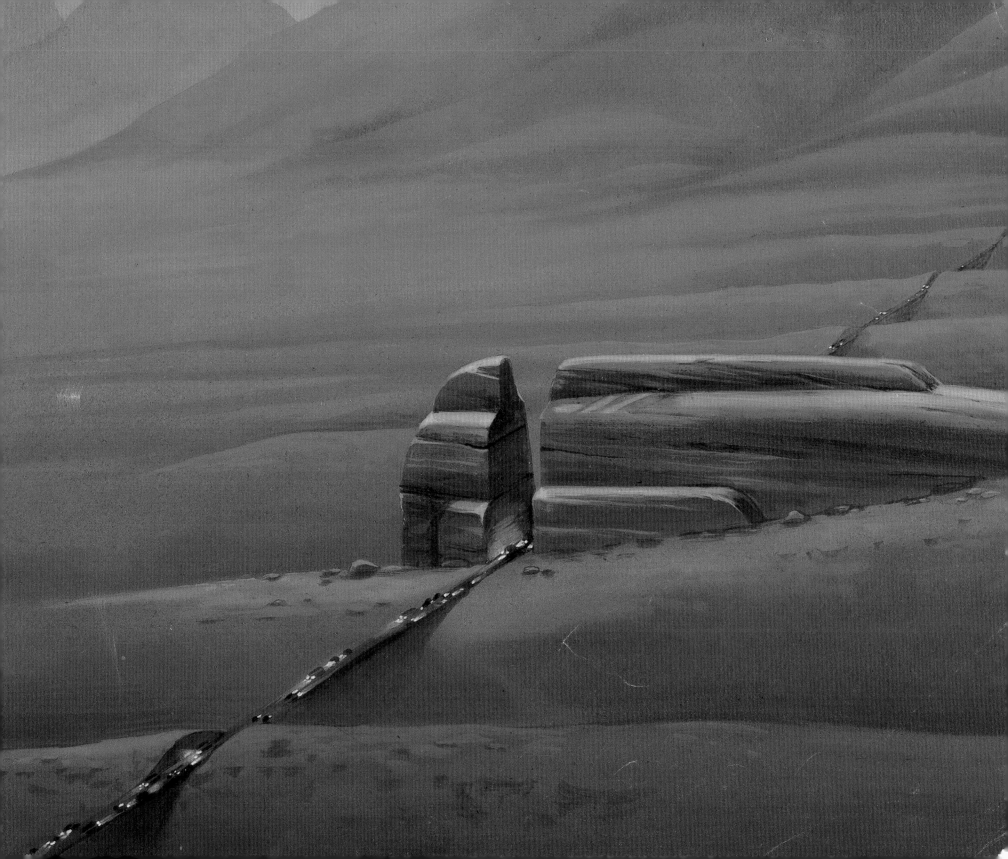

> "People say they're tired of driving the interstates. They want to get off the high-speed roads and see something else. Young people whose parents and grandparents drove Route 66 want to experience the highway. It's a piece of history. The old road has new life."
>
> —Angel Delgadillo, barber in Seligman, Arizona

4 *Slow Lane*

In addition to researching the nation's interstate system, the Pixar team devoted countless hours to studying Route 66, the famous highway that may have become obsolete but will not die. What they discovered grabbed their hearts.

"We were all quickly seduced by Route 66 and what it must have been like for the many small towns along the highway when the interstates came along and bypassed them," says John Lasseter. "The visual kitsch of Route 66 and the picturesque settings also had great appeal."

It wasn't long before Pixar contacted me, since I had written *Route 66: The Mother Road.* I met with John and the rest of the Pixar team and told them about the people and places waiting to be discovered on Route 66.

To give them a true feel for traveling the old road, I led members of the team on two tours along the original Route 66. Both journeys were unforgettable. The first trek, in June 2001, included John Lasseter and Darla Anderson,

the film's producer, along with enough artists, writers, and creative types to fill a trio of shiny, rented Cadillacs. Everyone came well armed with cameras, notebooks, sketchpads, and tape recorders. The same was true when I led the second tour a year later.

As we traversed the highway, we really did get our kicks, just like Bobby Troup promised in his classic song, which remains the anthem for Route 66. I knew I was in for a good time just as soon as we cruised off in our Caddies, headed west on a highway spawned by the demands of a rapidly changing America. After just a half day out on the road, I called my wife, Suzanne, and told her I was traveling with people just like myself—adventurous, curious, and lovers of the open road.

The Pixar bunch enjoyed stopping for little or no reason, and that is just what we did. We stopped to eat and drink. We stopped to meet people and to take pictures and notes and to make sketches.

We stopped to move box turtles off the pavement, to collect snake skins, to smell wildflowers, to examine roadkill, to look at the clouds, to wade through wheat and cotton fields, to pick sunflowers, and to prowl ghostly, abandoned buildings for precious road loot.

We saw natural and manmade attractions and magical human and nonhuman icons. We met road celebrities, road warriors, and travelers from around the world. Best of all, we met hundreds of everyday folks who continue to eke out a daily living on the edges of that varicose ribbon of concrete and asphalt.

"There was something about seeing the real thing that made those trips so worthwhile," says Joe Ranft, a veteran of both research trips. "We connected with the people and their towns, and we really got it. We found out that life out on that old highway is never predictable, and that's what makes the journey so much more memorable than just driving down some superhighway

Fillmore: Bob Pauley, Pencil, 16.25 x 10 [detail], 2004.

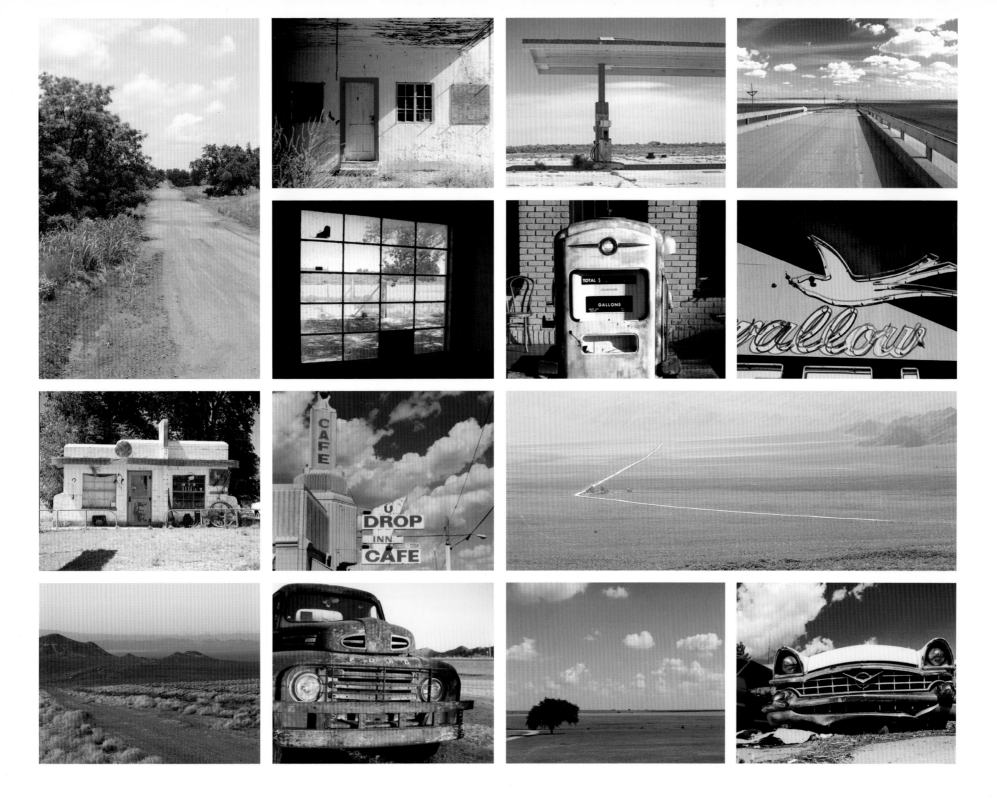

Road Trip Reference Photographs: Bill Cone, Bob Pauley, Eben Ostby, and Lee Unkrich, 2001.

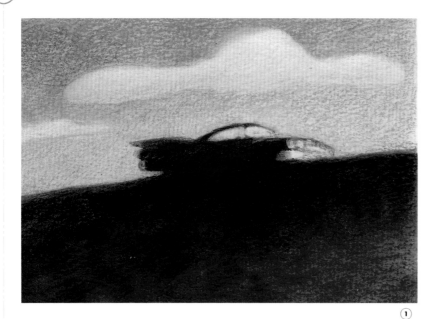

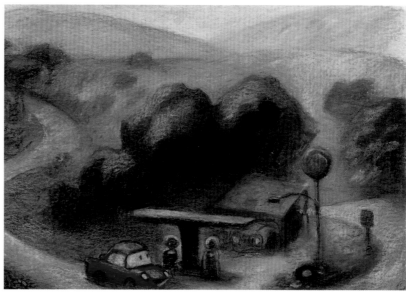

or freeway. We found the heartbeat of the Mother Road."

The Pixar team was traveling on a road that was once considered state of the art but outlived its usefulness because it could no longer handle the volume of traffic that gave it life in the first place. They came to see Route 66, a historic highway that is representative of all endangered two-lane roads that were left behind because of the super slabs. It is a reminder of America before our nation became generic and we lost our sense of place. Although we cannot get along without our superhighways, it is good to

know that Route 66 is still there as an alternative for those who want to slow down and take the pulse of the land.

"That Mother Road trip was the most memorable one I've ever taken," says Dan Fogelman, a writer who had been working at Pixar for just three days before he left for our second tour. "Even for someone who makes a living as a writer, it's difficult to find words to describe just how moving that time out on the old road was. Nothing about it was false. Everything we came upon was raw, honest, and so real. It felt the way America should feel."

This feeling prevailed for everyone on the Pixar team. It shows in the film, as characters emerge in settings as real as the people and places that inspired them. Much like the Pixar team, the film's main character, Lightning McQueen, also discovers the value of small-town life and the fact that, while speed is exciting, sometimes it is good to slow down.

Route 66: Buck Lewis, Pencil, (1) 10.25 x 7.25, (2) 10.5 x 7.75; 2001.

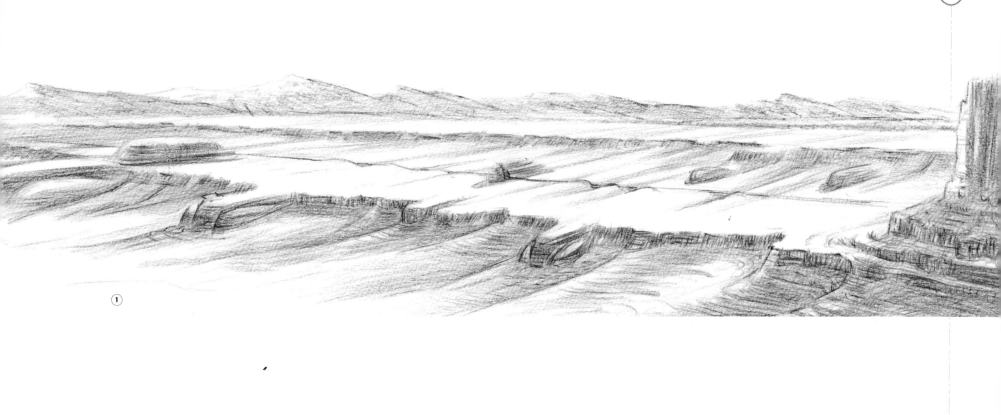

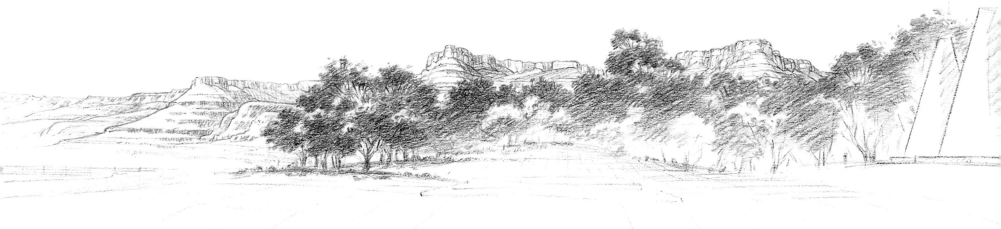

Ornament Valley Overview: Anthony Christov, Pencil, (1) 16.25 x 7, 2003; (2) 17 x 11 [detail], 2004.

(1)

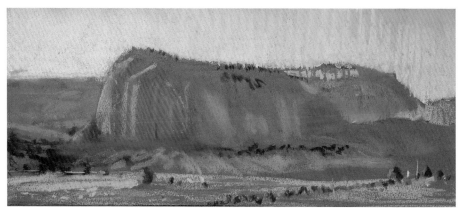

(2)

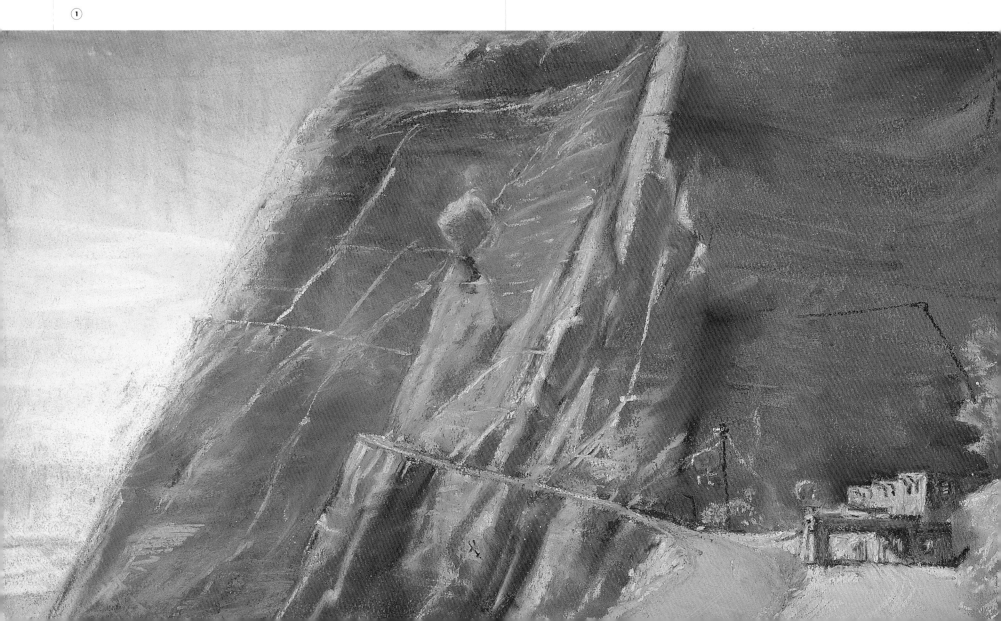

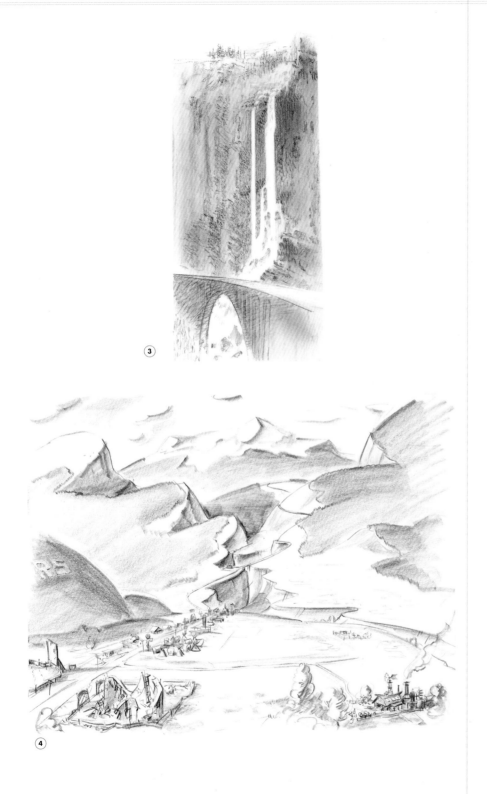

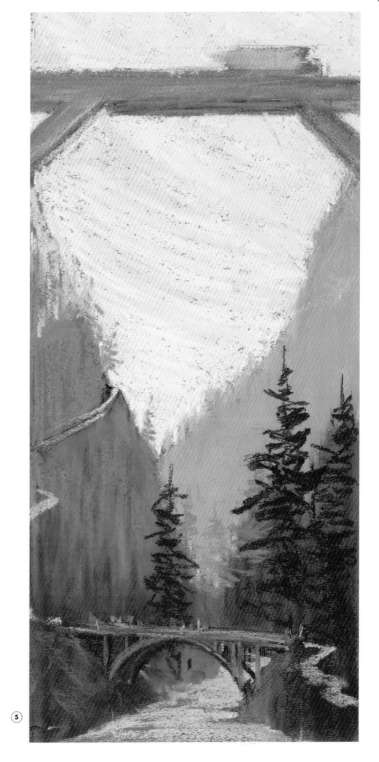

Landscape Studies: Bill Cone, Pastel, (1) 18 x 11, 2004; (5) 6 x 13.25, 2001. (3) Anthony Christov, Pencil, 8.25 x 12.5, 2004. (4) Bud Luckey, Pencil, 11.5 x 8.5, 2001. **East of Gallup, NM:** (2) Bill Cone, Pastel, 17 x 8.25, 2001.

Adrian, TX: (Previous Spread) Bill Cone, Pastel, 17 x 6, 2001. **Ornament Valley:** Anthony Christov [art], Gary Schultz and Suzanne Slatcher [model], Pencil, (1) 12.5 x 9, (2) 10.5 x 13, (3) 17 x 9.75; 2004. (5) Tia Kratter, Acrylic, 13.5 x 9.75, 2003. **Hood Ornament Reference Photographs:** (4) Bill Cone, 2001.

④

⑤

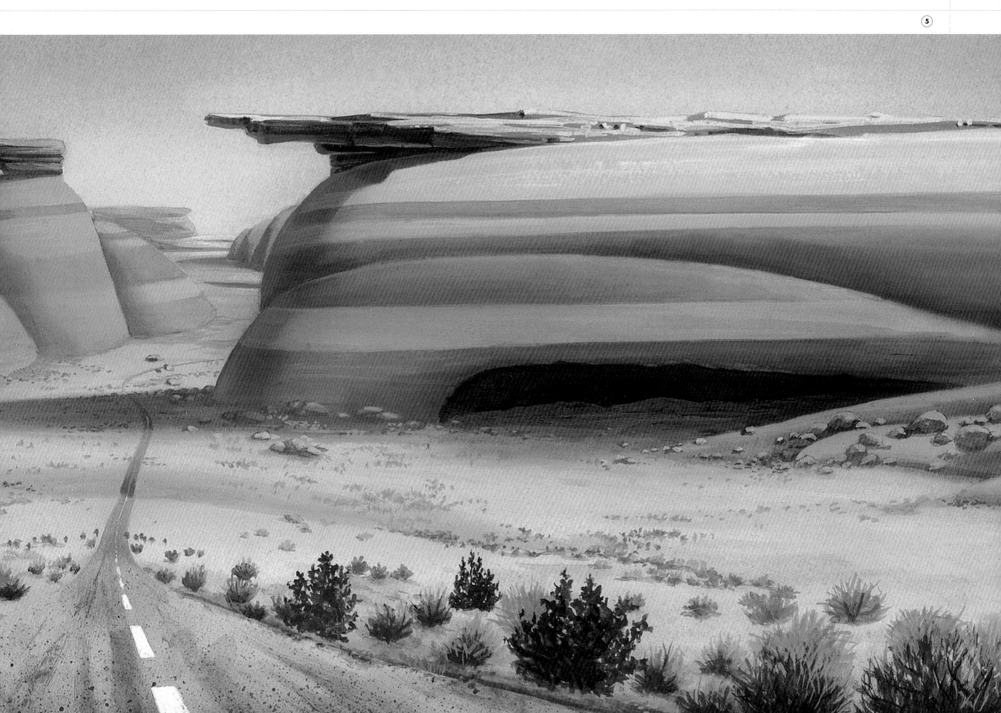

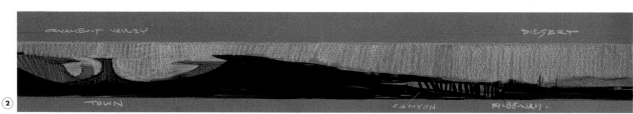

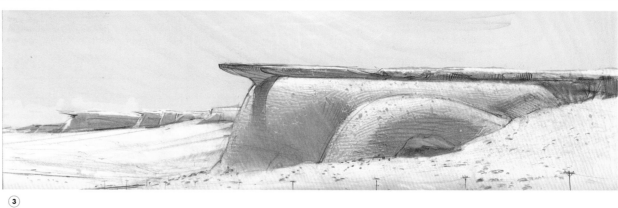

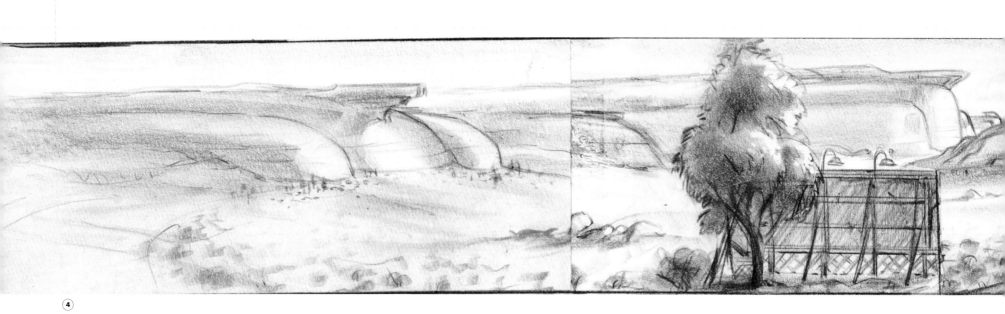

Ornament Valley: (1) Jerome Ranft, Sculpt, 5 x 29.5 x 47.75, 2002. (2) Bill Cone, Pencil/Marker, 17 x 3.25, 2004. (3) Jerome Ranft [sculpt] and Bill Cone [overlay], Sculpt/Overlay/Pencil, 17.25 x 10.25, 2004. (4) Nat McLaughlin, Pencil, 26 x 3.75, 2004. (5) Jerome Ranft [sculpt], Bill Cone [overlay], Gary Schultz and Suzanne Slatcher [model], Sculpt/Overlay/Pencil, 17 x 6.5, 2004.

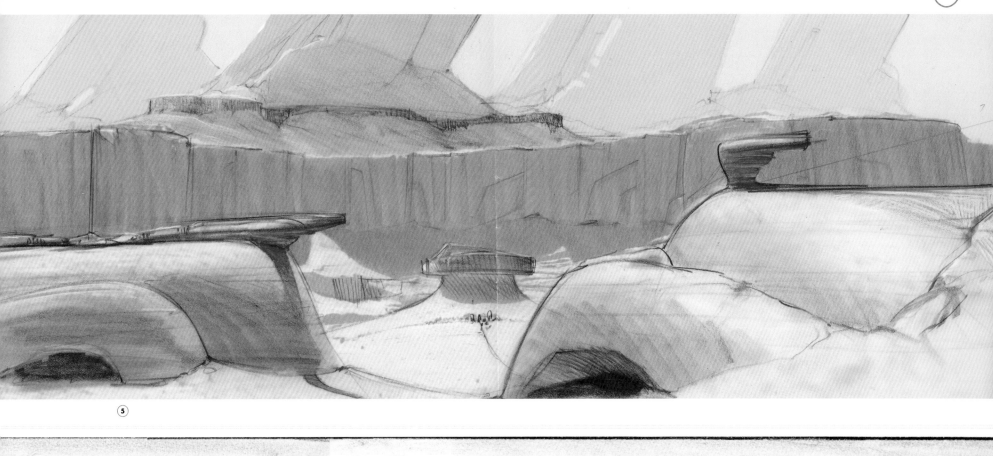

5

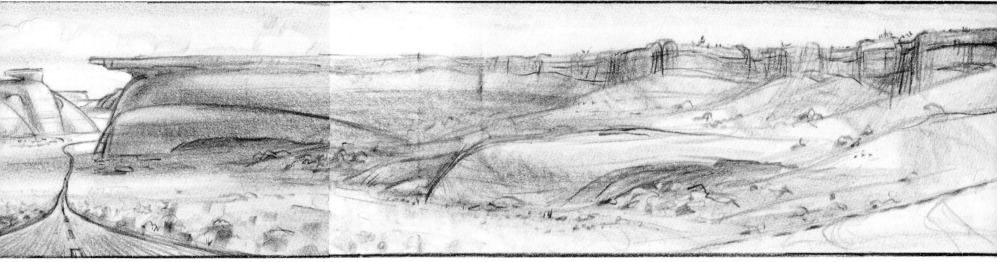

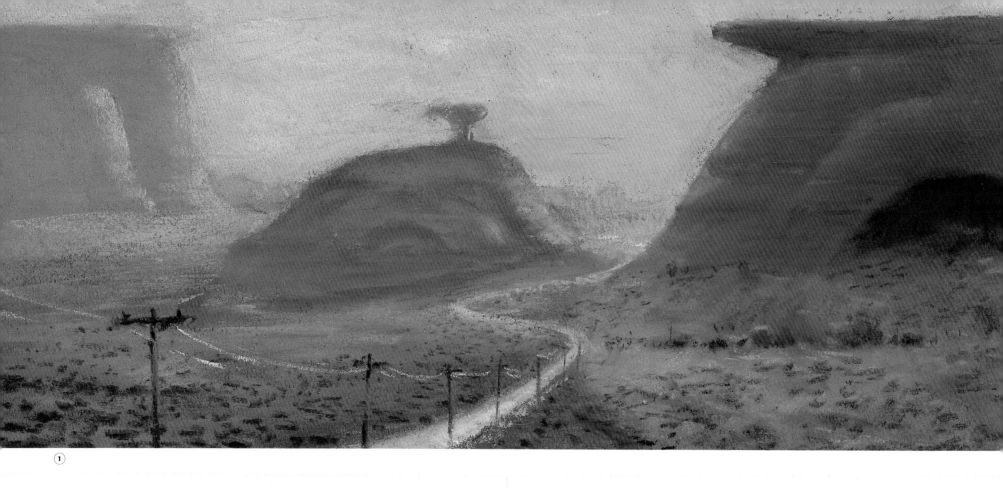

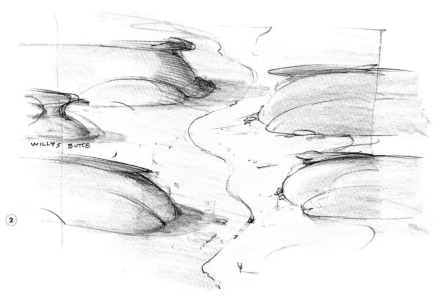

WILLYS BUTTE

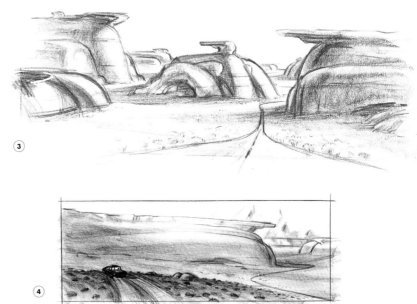

Ornament Valley: Bill Cone, (1) Pastel, 17 x 8, 2003; (2) Pencil, 11.5 x 9.25, 2004. Nat McLaughlin, Pencil, (3) 12 x 7, (4) 11 x 8; 2004.

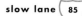

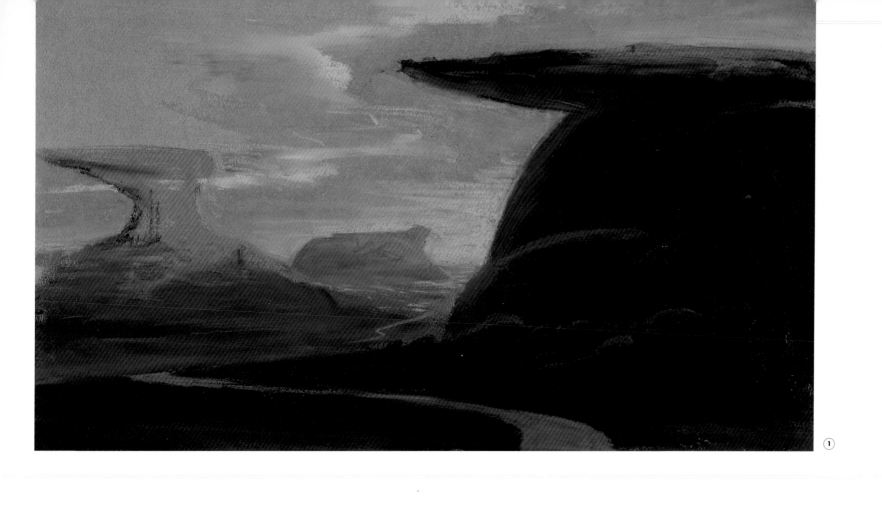

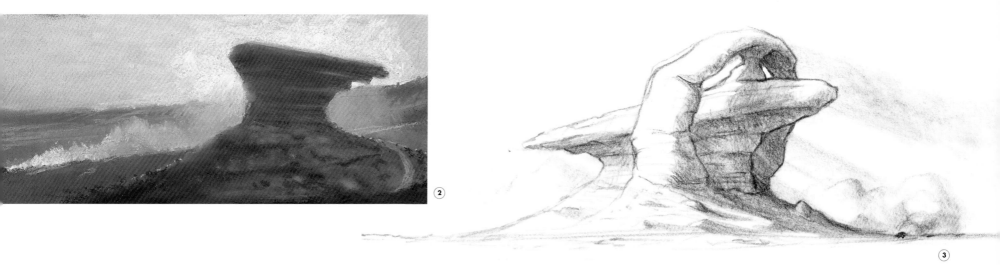

Ornament Valley: (1) Bill Cone, Pastel, 20 x 12.5, 2001. **Willys Butte:** (2) Bill Cone, Pastel, 13.25 x 5.5, 2003. (3) Nat McLaughlin, Pencil, 13 x 10.5, 2004.

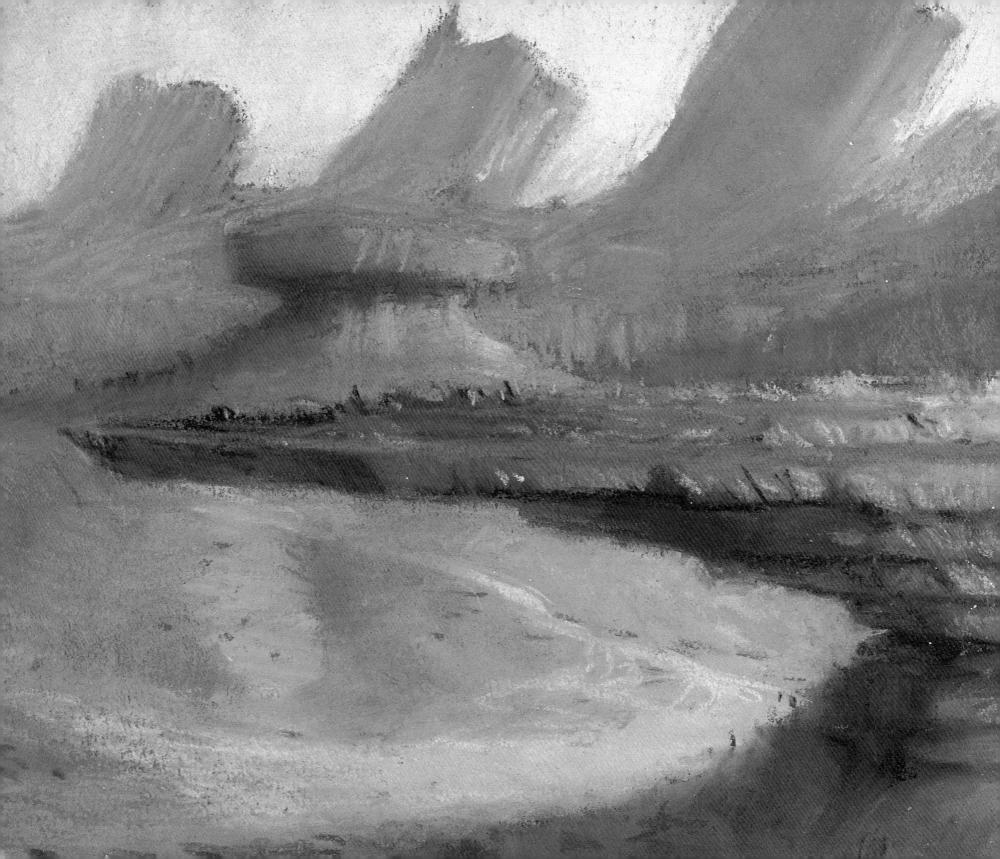

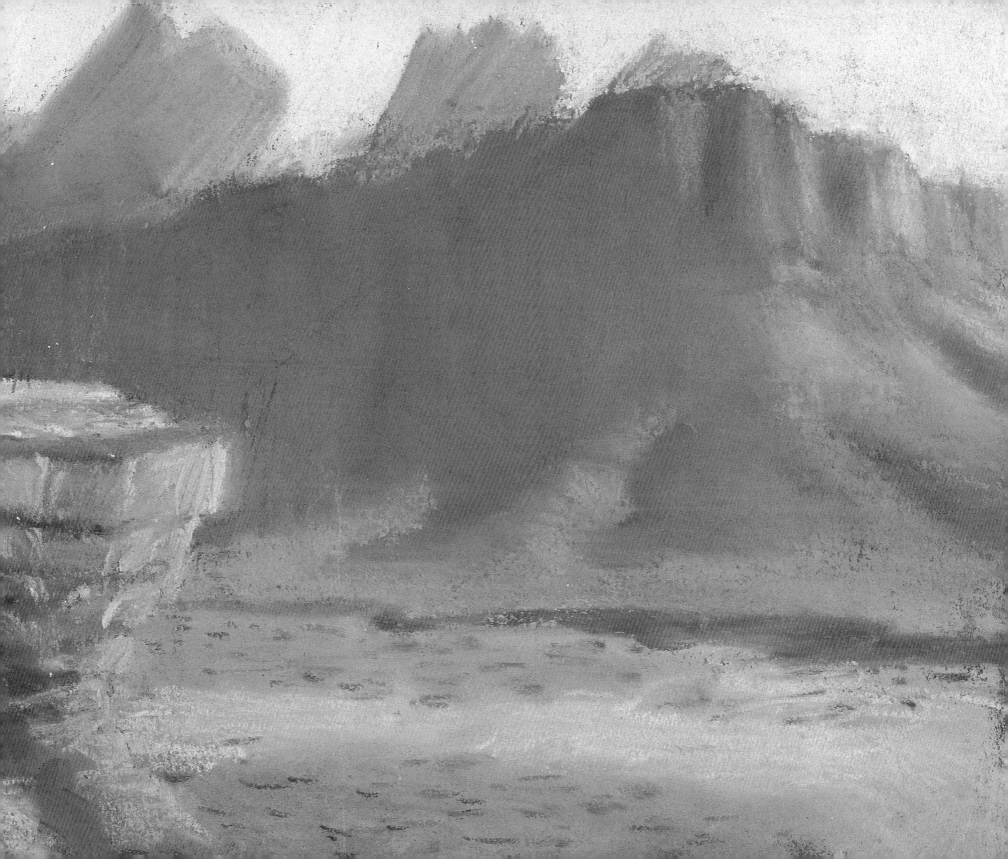

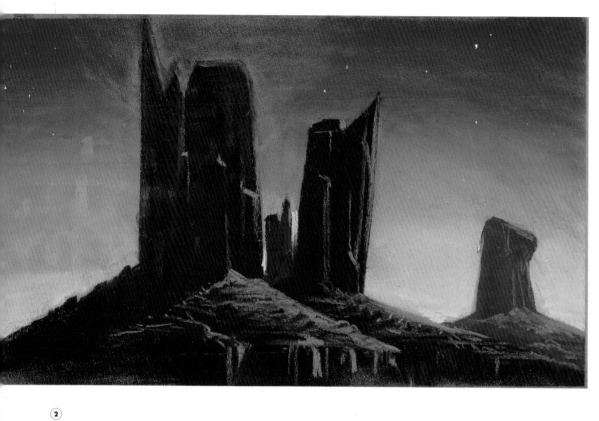

(2)

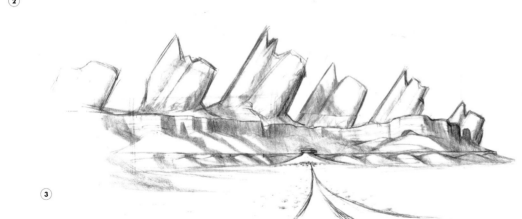

(3)

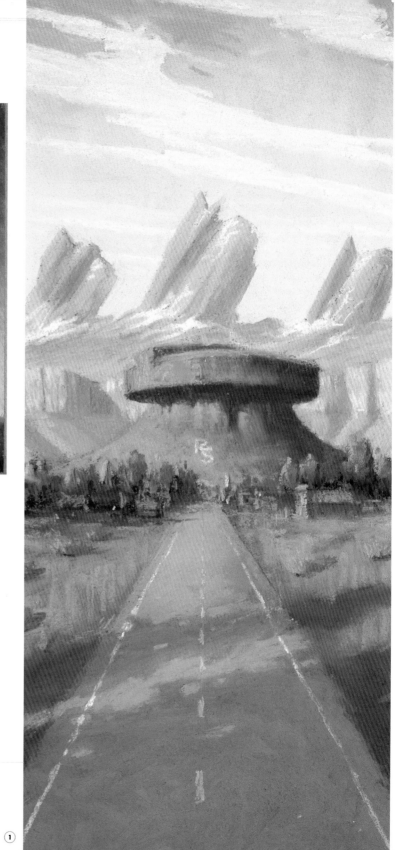

Willys Butte: (Previous Spread) Bill Cone, Pastel, 17.25 x 7.75, 2004. **Cadillac Range:** Bill Cone, Pastel, (1) 10 x 17.5, (2) 17 x 10; 2001.
(3) Nat McLaughlin, Pencil, 15.25 x 7.25, 2004.

(1)

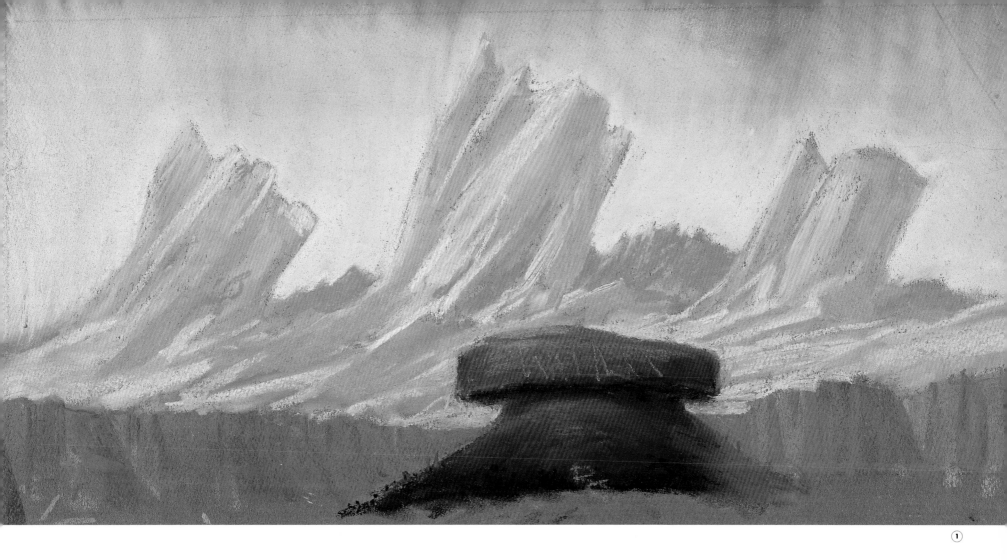

①

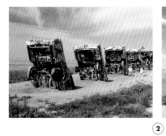

②

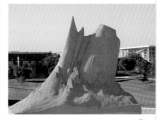

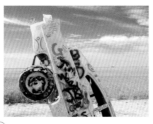

③

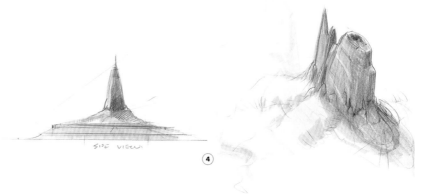

SIDE VIEW

④

Cadillac Range: Bill Cone, (1) Pastel, 17 x 8.5, 2003; (4) Pencil, 9.25 x 11.25, 2004. (3) Jerome Ranft, Sculpt, 20 x 24.25 x 16.5, 2002. **Cadillac Ranch Reference Photographs:** (2) Bob Pauley, 2001.

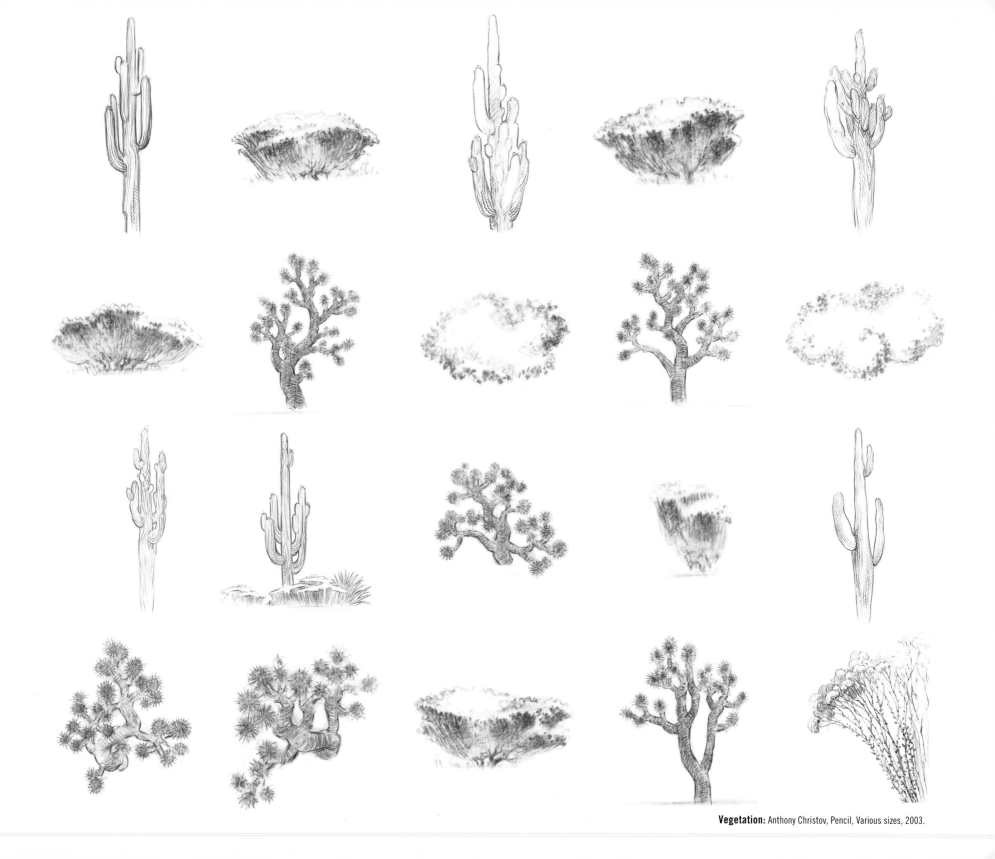

Vegetation: Anthony Christov, Pencil, Various sizes, 2003.

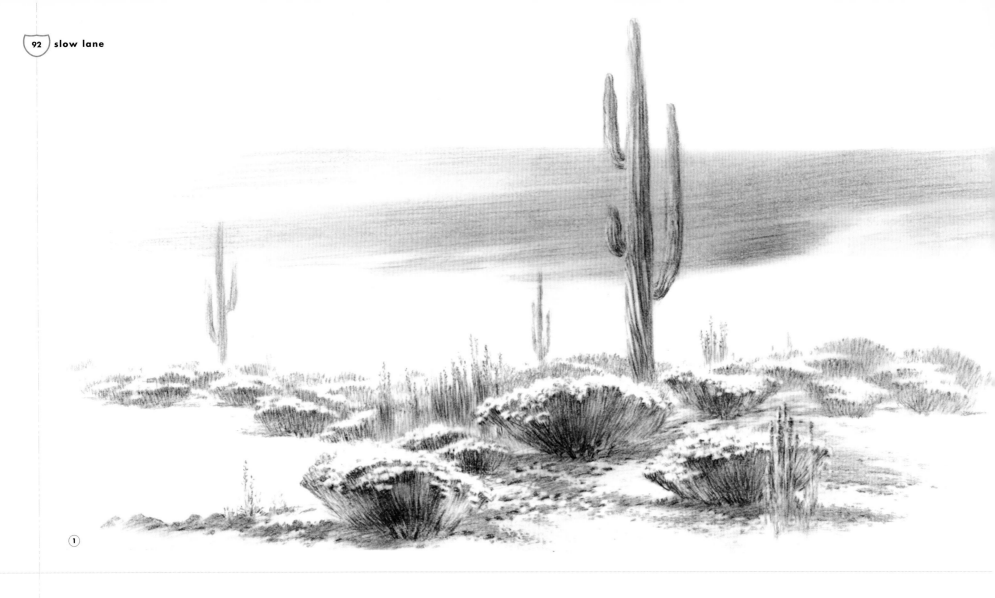

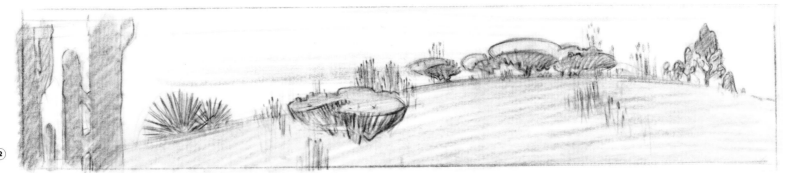

Hillscape Vegetation: Anthony Christov, Pencil, (1) 11.75 x 7.5, 2003; (2) 12 x 6, 2004.

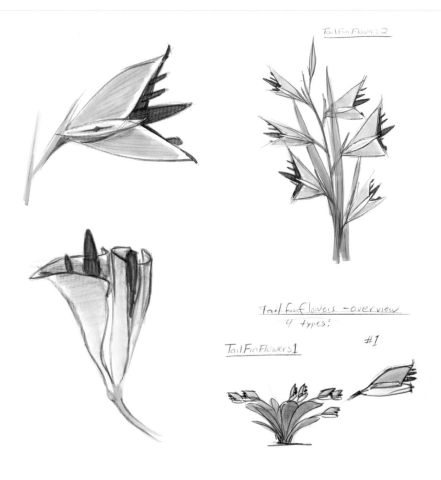

Tail Fin Flowers #2

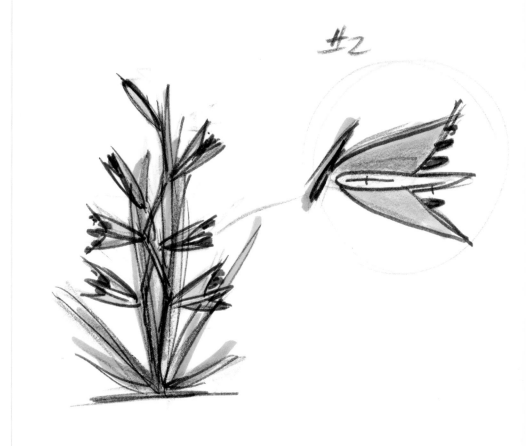

#2

Tail fin flowers — overview
4 types:

TailFinFlowers1 #1

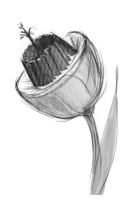

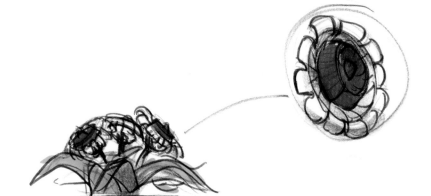

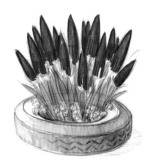

Tail Fin Flowers: Nat McLaughlin, Pencil/Marker, 17 x 11 each [detail], 2004.

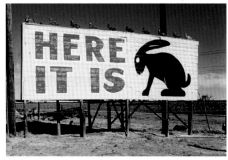

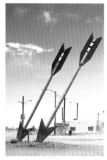

PIT STOP

Ya Gotta Have a Gimmick

Trips down Route 66 spawned many of the kitschy locales and character personalities in *Cars*. Bits and pieces of highway towns and slices of life straight from the old road would lend their spirit to the film. Various personalities encountered on the two research trips would give birth to plenty of composite characters. The film's central settings began to take shape, including the mythical town named Radiator Springs, which was inspired by real places and prominent natural features along the old road.

The Pixar team found that the old road still has allure as it winds through a necklace of towns, cities, and enticements along the way. Since the highway was created in the 1920s, a curious blend of good, bad, and ugly has littered the shoulders of Route 66. New attractions constantly appear, but some date back to the road's beginnings, and a few emerged long before the highway officially existed.

A sampling of what they encountered includes a man who can rotate his feet 180 degrees,

Mickey Mantle's first ballpark, the world's largest totem pole, a smiling blue concrete whale, a tree filled with pairs of shoes, a round barn, riding-lawn-mower races, Elvis Presley's favorite Route 66 motel suite, a meteor crater, a museum filled with barbed wire in an old brassiere factory, ten vintage Cadillacs buried nose down in the earth, graves of German soldiers, ancient beds of lava, the oldest house and oldest church in the United States, the largest cross in the Western Hemisphere, a steak weighing four and a half pounds, and much more.

The food alone was incredible. The team feasted on chicken-fried steak, berry pies, sopapillas to kill for, and fried onion burgers so juicy it took a dozen napkins to sop up the grease. We savored the handcrafted sandwiches at Eisler Brothers Store, the bread pudding at the Rock Cafe, the French Silk pie at the Country Dove, and the scrumptious Ugly Crust pie at the Mid-Point Cafe. We devoured fiery enchiladas at Joe & Aggies, sipped sweet cherry cider at the Jackrabbit Trading Post, and chewed Oklahoma beef ribs as big as a boy's arm at any number of places. Every joint we walked into offered nothing that was instant but the service.

We spent quality time at pie palaces, greasy spoons, motor courts festooned with neon, garages, melon patches, human and auto graveyards, tourist traps, curio shops, trading posts, deserted reptile ranches, museums, and bona fide ghost towns. Wherever we went, we met the people of the old road—fry cooks, waitresses, grease monkeys, wrecker drivers, con artists, hustlers, motel clerks, bikers, musicians, storytellers, entrepreneurs,

Roadside Gimmicks Reference Photographs: (1) Bob Pauley, 2001. **Gimmick Concept:** (2) Bud Luckey, Pencil, 14.5 x 11.5, 2001.

dreamers, cops, preservationists, farmers, ranchers, and many others. The team got to know Scott Nelson, Dean Walker and the Spooklight, Butch and his mom, Jim Ross, Eddie No Money, the Road Dancer, "Doc" Mason, Dawn Welch, Harley and Annabelle—the "Mediocre Music Makers," Alice and Stanley Gallegos, Diane Patterson and the Desert Ladies of Winslow, Delbert and Ruth Trew, Mike and Betty Callens, Hilda and Dale at the Blue Swallow, and Angel Delgadillo. All these places and the people we met there made for sweet memories and also became our best teachers.

The team learned that, besides the fact that nothing is predictable on Route 66, every town and place of business has always needed to have something special to lure customers and get them to stop. Simply put, "Ya gotta have a gimmick." This credo became a popular expression for everyone on the road trips. It and other catchphrases, including "Life begins on the off-ramp," became part of the Pixar team's mind-set when creating Radiator Springs.

Gimmick Concepts: (1) Nat McLaughlin, Pencil, 7 x 6.75, 2002. Bud Luckey, Pencil, (2) 12 x 7, (3) 14.5 x 11.5, (4) 12 x 8 [detail], (5) 8 x 7, (6) 6.75 x 5.5, (7) 13 x 11.25; 2001.

Building a World

Motor sports and Route 66—the two worlds in which *Cars* takes place—did not evolve overnight. Neither did the movie. As John is fond of saying, "Pixar films are never completed; they're just released." From the beginning, John wanted *Cars* to be authentic, to be as real as the cars, places, and people they were researching. As the harvest of field research started coming back to the studio, it was evaluated, sorted, and carefully culled. This research material included thousands of still photographs and sketches and an abundance of video footage. In the same way they might assemble a complex jigsaw puzzle, the team, using cutting-edge technology, arranged and rearranged all the fragments and pieces until patterns and ultimately some sort of definable picture began to emerge.

It was decided that Radiator Springs would have a high-desert look and feel, similar to the Mother Road country between Gallup, New Mexico, and Kingman, Arizona. Once the setting was selected, various artists continued the research and made countless trips to Nevada and other desert locales. They wanted to learn even more so that Radiator Springs and the surrounding landscape would be as believable as the characters living there.

"We had to turn pencil sketches from previous trips into three-dimensional objects," explains Eben Ostby, supervising technical director. "That's why we drove out into the desert to see how the hills and cliffs look and then figure out just how we could capture their essence and make it all work in the film. We also drove down old highways just like Route 66 and through towns like Radiator Springs—towns with broken neon and peeling paint that time forgot."

"One of the main objectives of lighting is to understand the quality and brightness of light, so we went on desert trips to study that light at different times of the day," says Director of Photography Jean-Claude Kalache. "Since most cars have reflective paint, we paid infinite attention to the way light worked on these surfaces. Every detail needed to be weighed and considered."

Director of Photography Jeremy Lasky and Shading Lead Chris Bernardi teamed up with other production team members and went to yet more auto races to pick up important details of the track, the cars, and the people. They also traveled a long stretch of Route 66.

"John wanted the characters to have definite personalities, but still be cars," explains Lasky. "That's why the research trips provided us with a huge advantage. It was so good to actually know what it is like at a car race and get a feeling of being out on the old highway."

Other details studied by the teams include signage, neon, roadside architecture, commercial archaeology, and the vernacular landscape. Samples of desert sand, dust, soil, and road-surfacing material were tested and studied. When work crews resurfaced the city streets in front of Pixar's sixteen-acre campus, team members took copious notes and photographs. Everything to do with cars had to be learned, and learned well.

Mater: Bob Pauley, Pencil, 15.5 x 9, 2004.

(1)

(2)

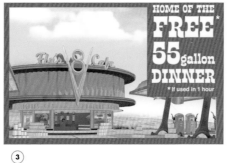

(3)

(4)

(5)

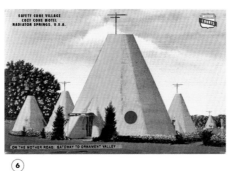

(6)

(7)

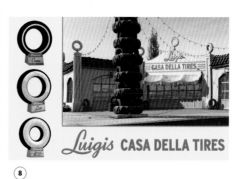

(8)

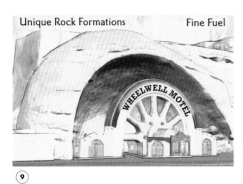

(9)

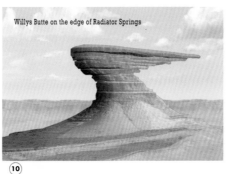

(10)

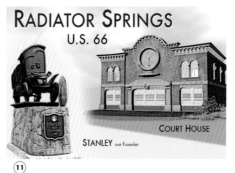

(11)

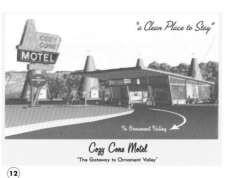

(12)

Curio Shop Souvenir Postcards: (1), (5) Chris Bernardi, Craig Foster, Tom Miller, David Munier, and Suzanne Slatcher; (2), (8) Craig Foster, Mike Krummhoefener, and Keith Stichweh; (3) Craig Foster, Sangwoo Hong, Ana Lacaze, Gary Schultz, and Athena Xenakis; (4) *Cars* Technical Crew and Craig Foster; (6) Craig Foster; (7) Mark Adams, Marc Cooper, Craig Foster, and Tom Miller; (9) Craig Foster, Sangwoo Hong, Ana Lacaze, Dale Ruffolo, Suzanne Slatcher, and Athena Xenakis; (10) Craig Foster, David Munier, and Suzanne Slatcher; (11) Marc Cooper, Craig Foster, Mike Krummhoefener, Brandon Onstott, and Evan Pontoriero; (12) David Batte, Craig Foster, Christina Garcia, and Gary Schultz; Digital, 2005.

Radiator Springs Billboard: John Lee [paint] and Bob Pauley and Nat McLaughlin [layout], Gouache, 32 x 11, 2004.

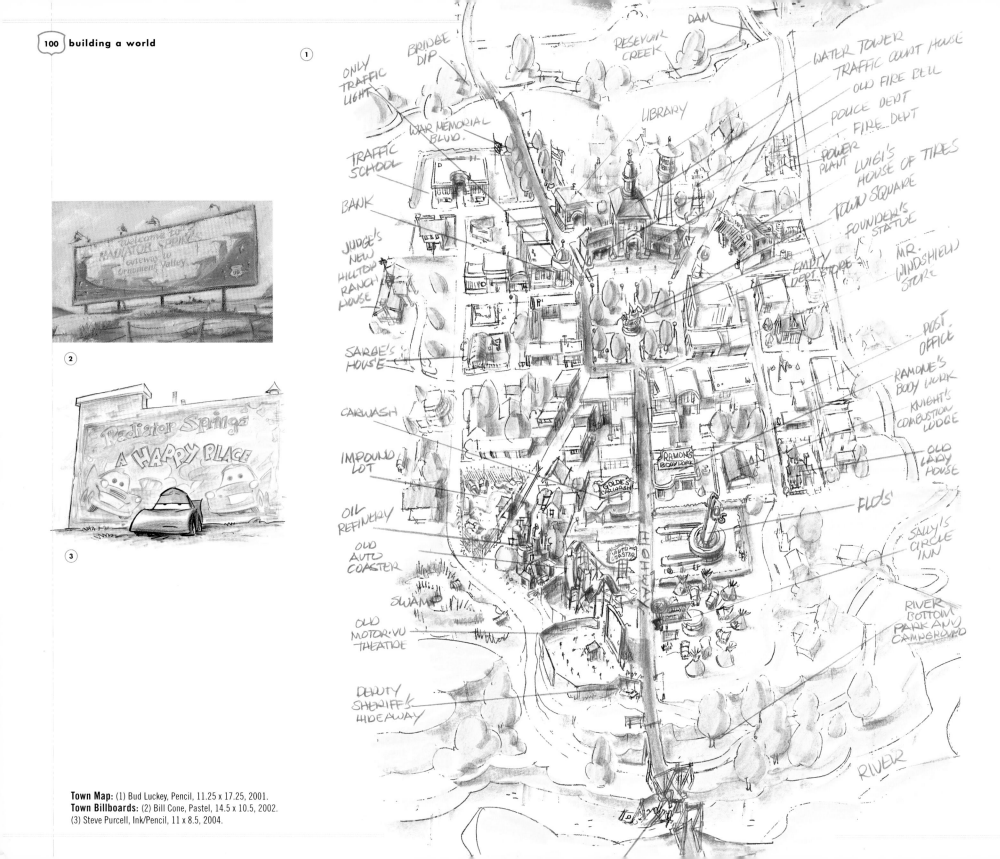

Town Map: (1) Bud Luckey, Pencil, 11.25 x 17.25, 2001.
Town Billboards: (2) Bill Cone, Pastel, 14.5 x 10.5, 2002.
(3) Steve Purcell, Ink/Pencil, 11 x 8.5, 2004.

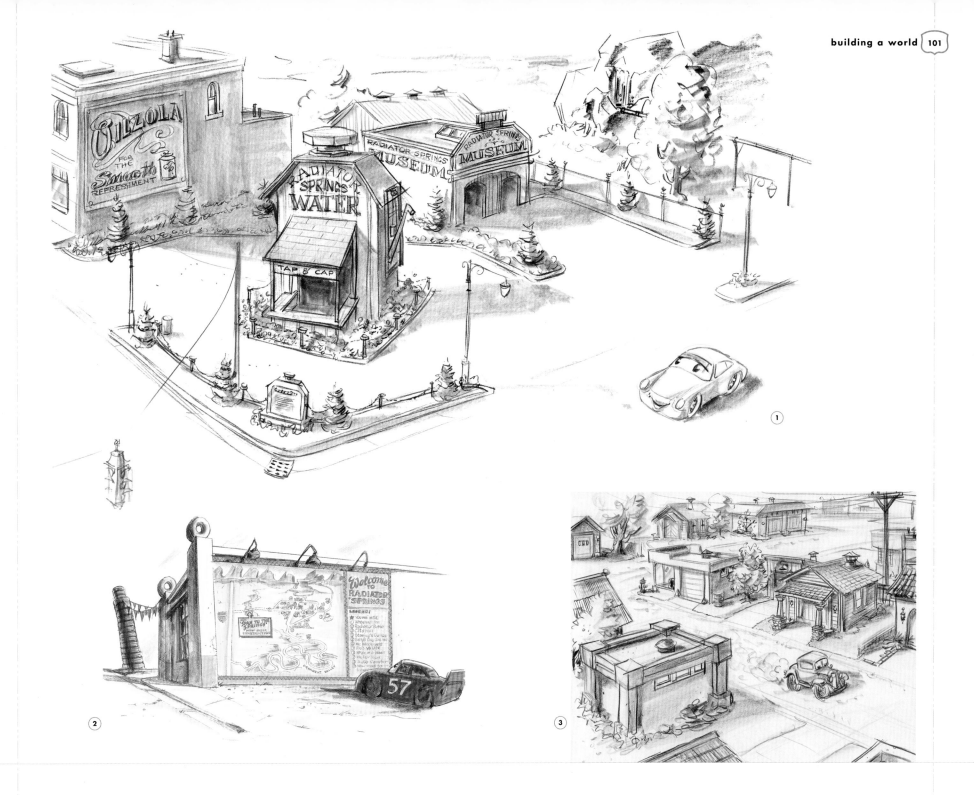

Radiator Springs Concepts: Bud Luckey, Pencil, (1) 17 x 10.5, (2) 10.5 x 6.5, (3) 11 x 8.5; 2001.

①

②

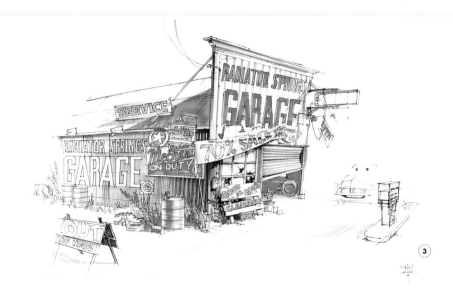

③

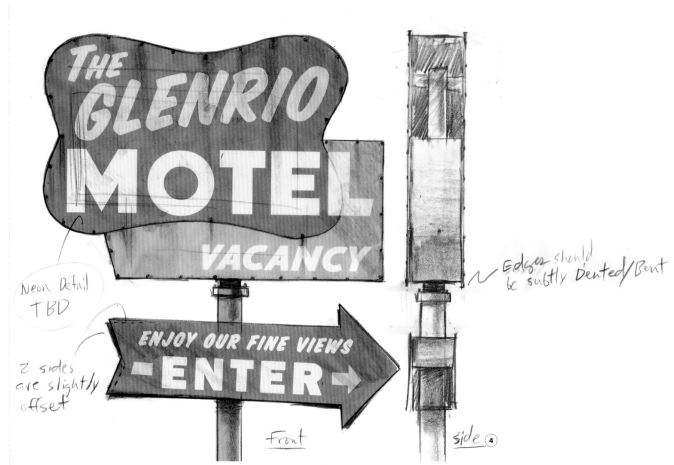

THE GLENRIO MOTEL

VACANCY

ENJOY OUR FINE VIEWS — ENTER →

Neon Detail TBD

2 sides are slightly offset

Edges should be subtly Dented/Bent

Front

side ④

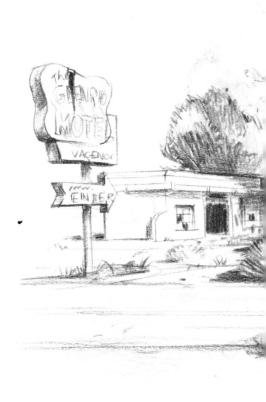

Town Reference Photographs: (1), (2) Bill Cone, 2001. **Storefronts and Signage:** (3) Jay Shuster, Pen/Marker, 17 x 11, 2004. (4) Nat McLaughlin, Overlay/Pencil/Digital, 15.75 x 11.25 [detail], 2004.

①

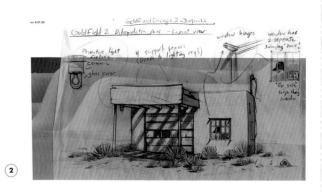

②

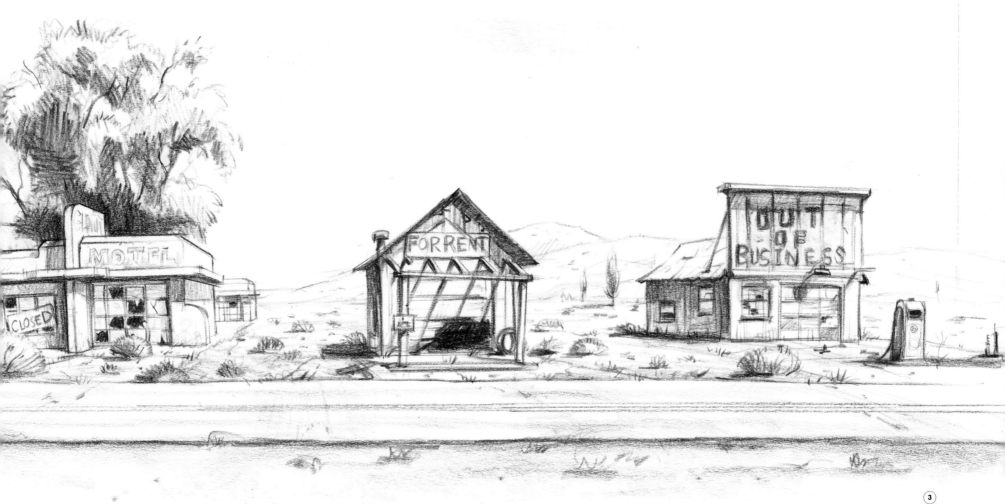

③

Storefronts and Signage: Nat McLaughlin, (1) Pencil, 12 x 7.75, 2003; (3) Pencil, 17 x 10.75, 2004. (2) Nat McLaughlin [overlay] and Jonathan Paine [model], Overlay/Pencil/Digital, 15.75 x 9.75, 2004.

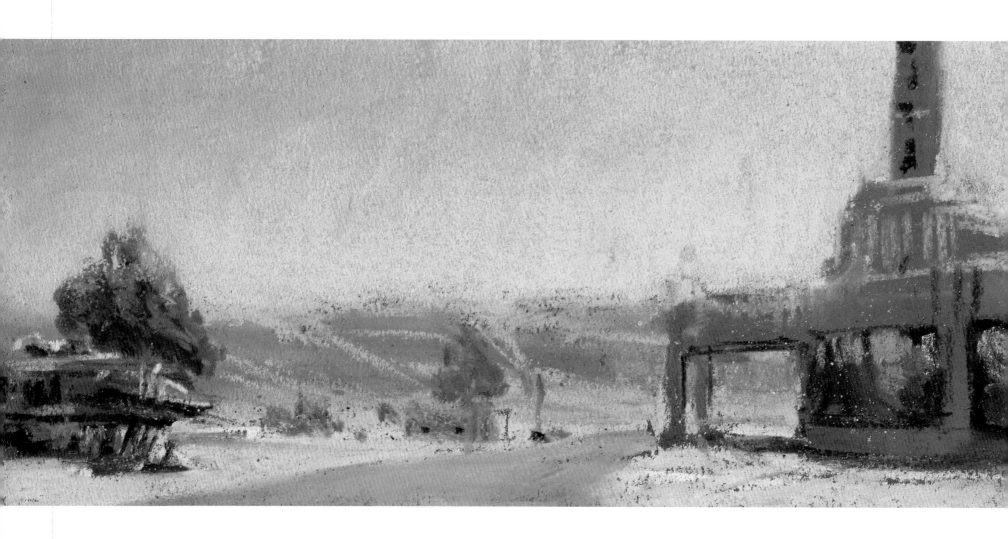

Radiator Springs: Bill Cone, Pastel, 9.5 x 5.25, 2002.

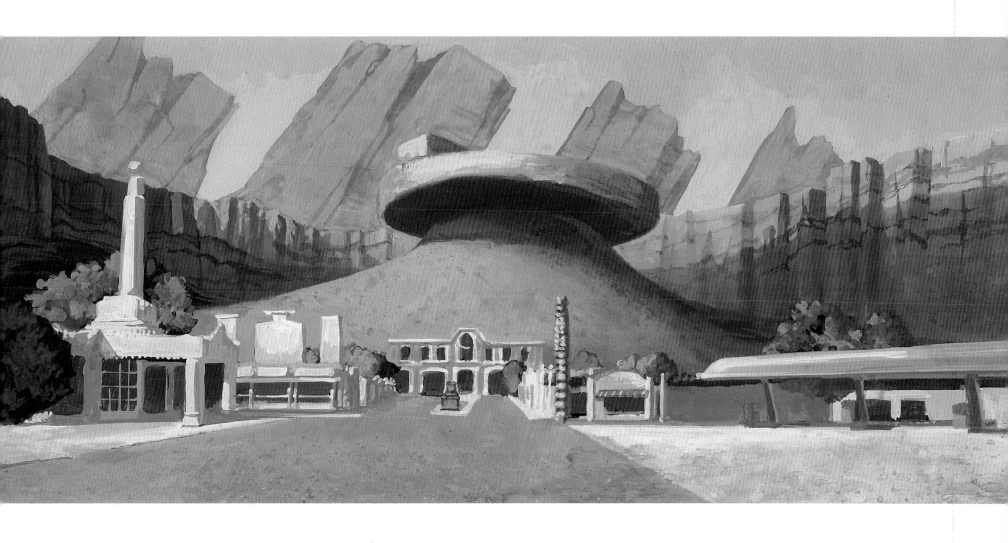

Radiator Springs: Tia Kratter, Acrylic, 10.5 x 5.25, 2003.

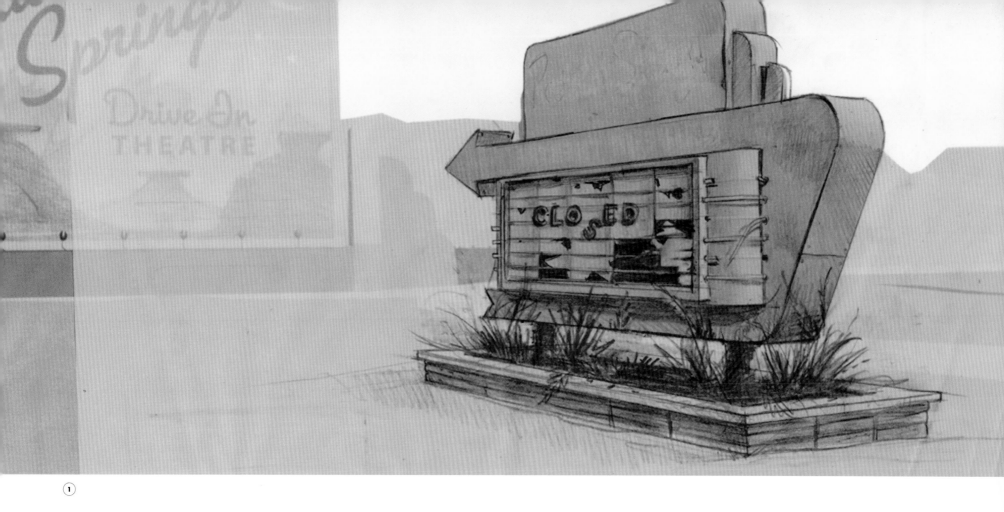

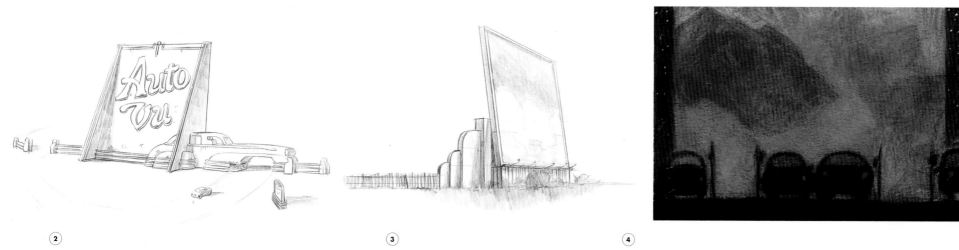

(1)

(2) (3) (4)

Drive-In Theatre Sign: (Opposite) Ellen Moon Lee [graphics], John Lee [paint], and Bill Cone [layout], Digital, 2004. **Drive-In Theatre Concepts:** (1) Nat McLaughlin [overlay], Gary Schultz and Mark Adams [model], Overlay/Pencil/Digital, 15.25 x 10.5, 2004. (2) Bud Luckey, Pencil, 17 x 11, 2001. (3) Nat McLaughlin, Pencil, 14.75 x 8.75, 2003. (4) Buck Lewis, Watercolor/Pencil, 7.25 x 5.5, 2001.

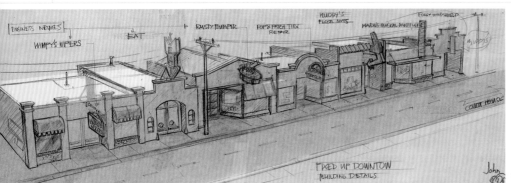

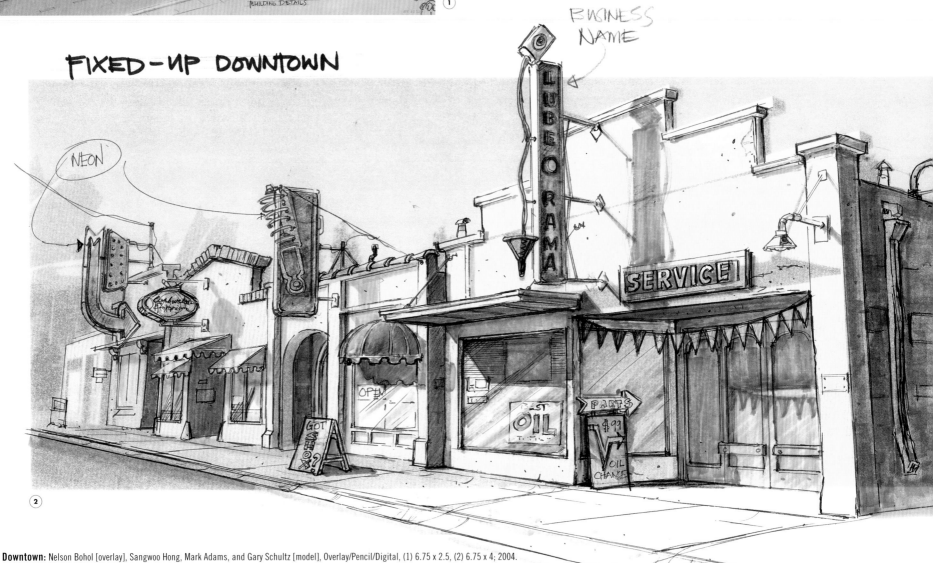

FIXED-UP DOWNTOWN

Downtown: Nelson Bohol [overlay], Sangwoo Hong, Mark Adams, and Gary Schultz [model], Overlay/Pencil/Digital, (1) 6.75 x 2.5, (2) 6.75 x 4; 2004.

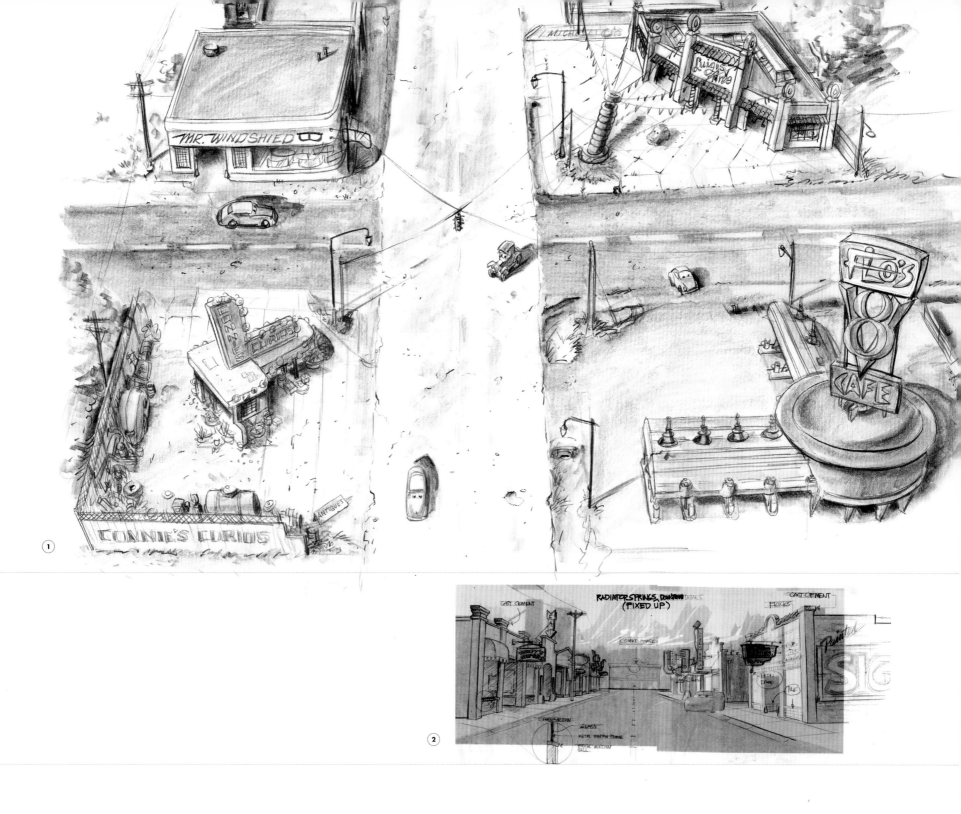

Downtown: (1) Bud Luckey, Pencil, 17.25 x 11, 2001. (2) Nelson Bohol [overlay], Mark Adams, Sangwoo Hong, Chris Sanchez, and Gary Schultz [model], Overlay/Pencil/Digital, 26.5 x 10.5, 2004.

(1)

(2)

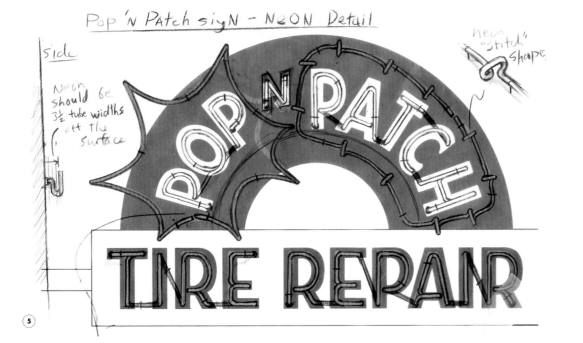

(3)

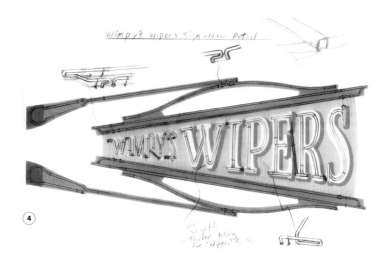

Wimpy's Wipers Sign - Neon Detail

(4)

(6)

Pop 'N Patch sign - Neon Detail

(5)

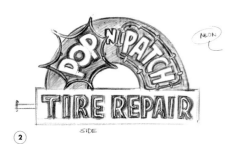

Rusty Bumper Sign - Construction & Neon Detail

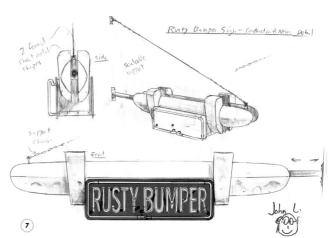

(7)

Store Signs: (1) Jay Shuster, Pen/Marker, 6 x 7, 2004. (2) Nat McLaughlin, Pencil, 9.25 x 5.75, 2004. (3) Nelson Bohol, Pencil, 4.25 x 6, 2004. (4) Nat McLaughlin and Ellen Moon Lee [graphics], Overlay/Pencil/Digital, 15.25 x 10.75, 2004. Nat McLaughlin and Ellen Moon Lee [graphics] and Nelson Bohol [layout], (5) Overlay/Pencil/Digital, 11.5 x 9, 2004; (7) Pencil, 17 x 11, 2004. (6) Bill Cone, Pencil, 8.5 x 8.5, 2004.

LUBEORAMA Sign
Neon Detail

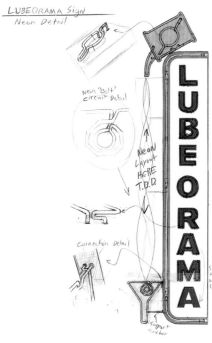

(1)

(2)

Miss Piston Sign Construction

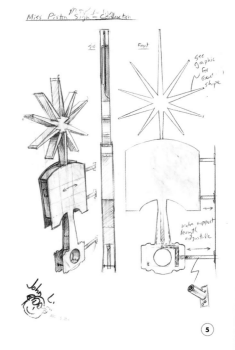

John L.

(5)

Mrs.
MUFFLER

Slight
Neon
Bow

(3)

Sparky's Spark Plugs Sign
Neon Detail

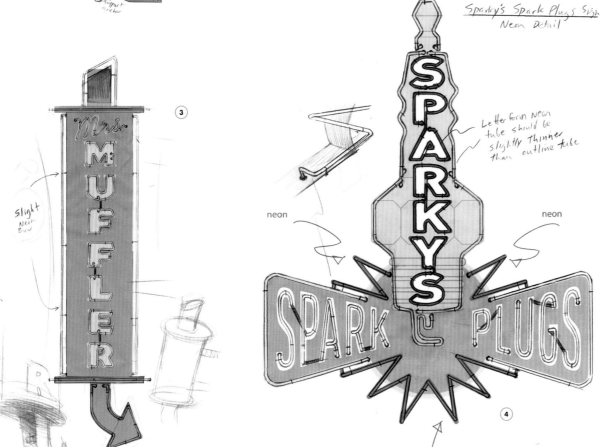

Letter form Neon
tube should be
slightly thinner
than outline tube

neon

neon

(4)

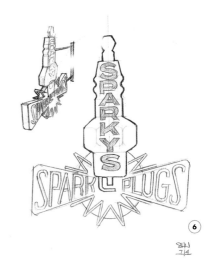

(6)

SHU
7/4

Store Signs: Nat McLaughlin and Ellen Moon Lee, Overlay/Pencil/Digital, (1) 11.5 x 16.5 [detail], (3) 11.75 x 17.25, (4) 11 x 16.5; 2004. Jay Shuster, Pencil, (2) 9.5 x 5, (6) 11 x 16.5; 2004. (5) Nat McLaughlin, Pencil, 11 x 15.5, 2004.

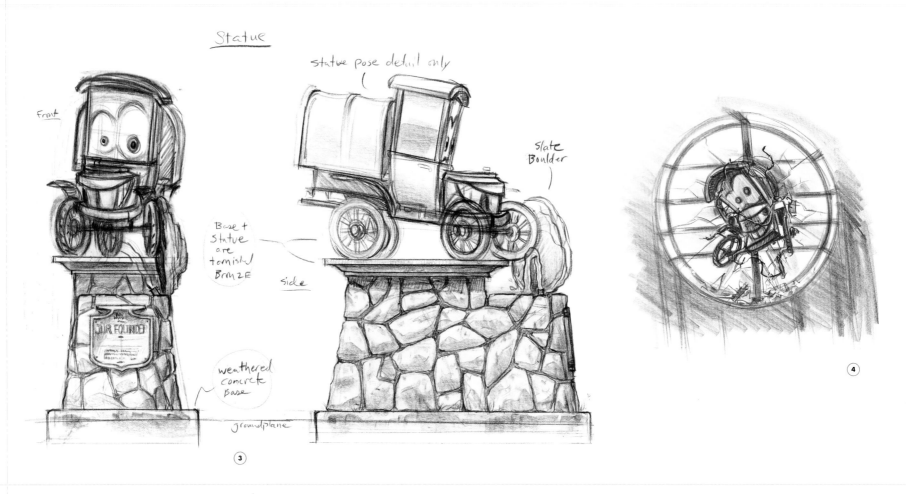

Statue

Front

statue pose detail only

Slate Boulder

Base + Statue are tarnished Bronze

side

weathered concrete Base

groundplane

OUR FOUNDER

Stanley Statue: Nat McLaughlin, Pencil, (1) 16.5 x 11, (2) 10 x 8.75, (3) 14.25 x 10.5, (4) 12 x 10.5; 2004.

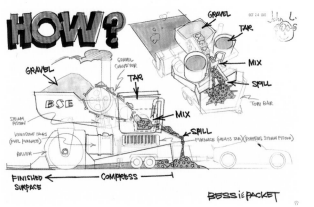

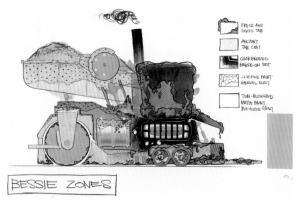

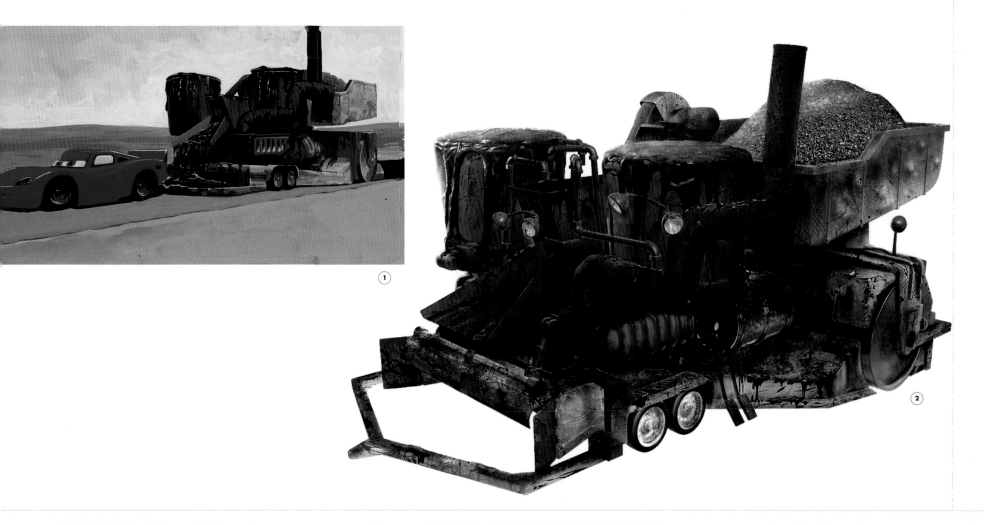

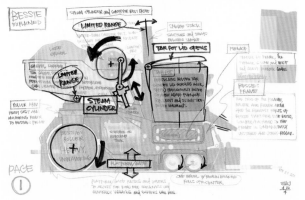

Bessie: (1) Tia Kratter, Acrylic, 11.25 x 7, 2003. (2) Glenn Kim [paint] and Mark Adams [model], Digital, 2004. **Bessie Manual:** (3) Jay Shuster, Marker/Pencil/Digital, 17 x 11 each, 2004.

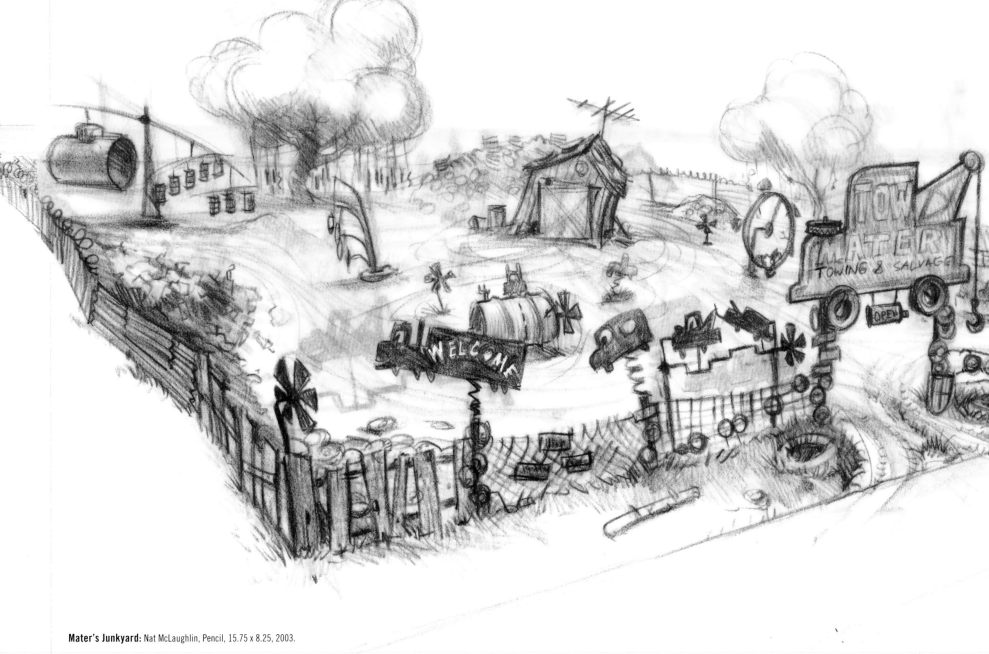

Mater's Junkyard: Nat McLaughlin, Pencil, 15.75 x 8.25, 2003.

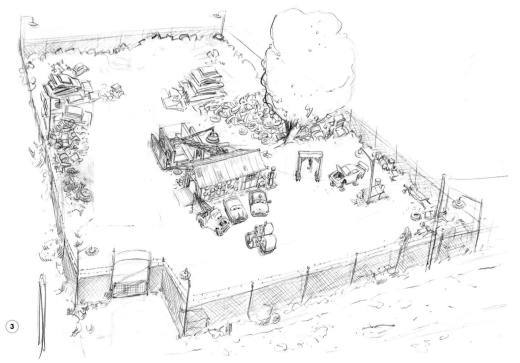

Mater's Junkyard: Bud Luckey, Pencil, (1) 6.5 x 10, (3) 12.25 x 17.25; 2001. (2) Nat McLaughlin, Pencil, 7.25 x 10.25, 2004.

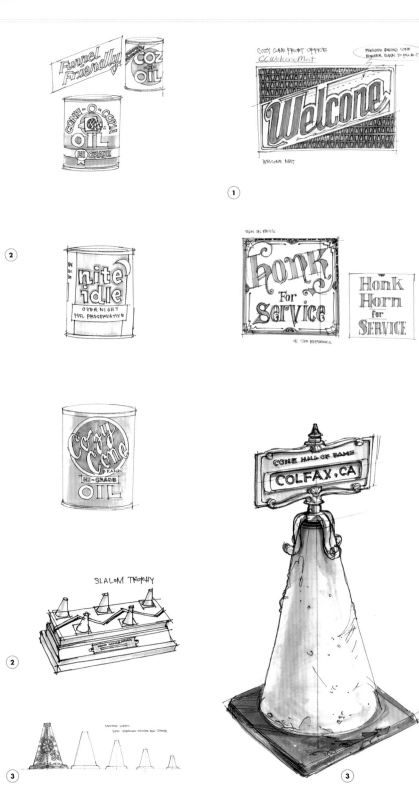

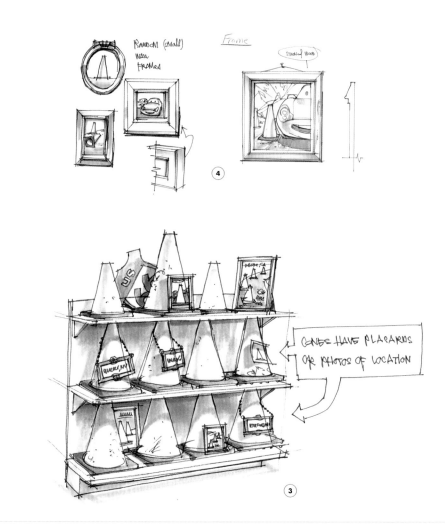

Cozy Cone Miscellany: (1), (2), (3), (4) Jay Shuster, Pen/Marker, 17 x 11 [detail], 2004.

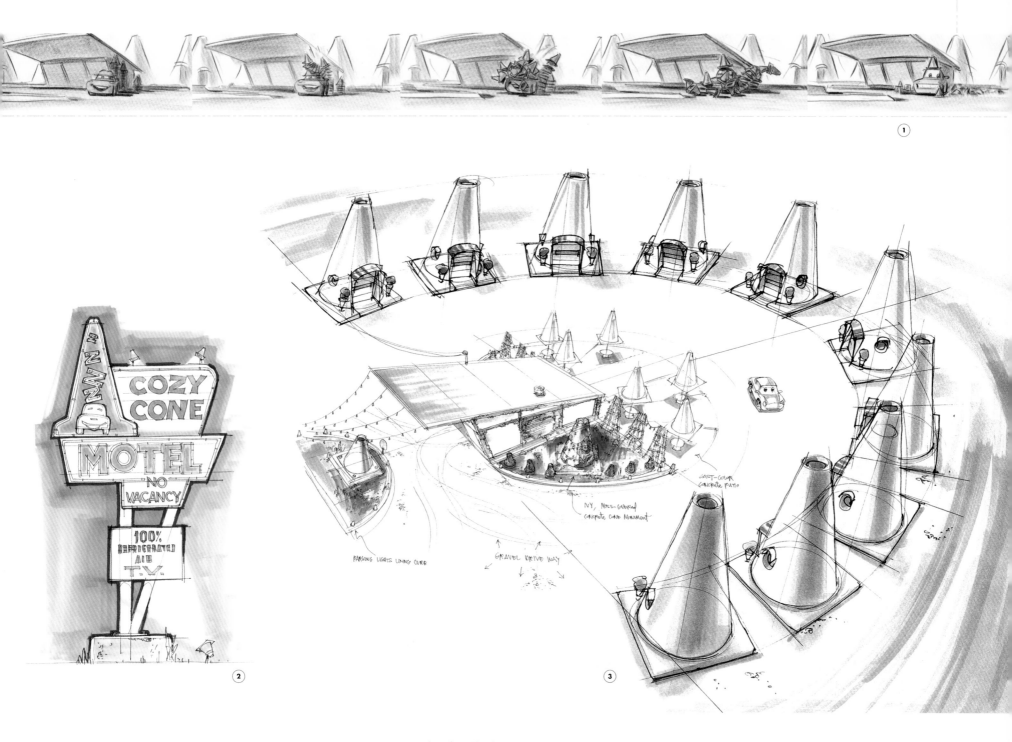

Cozy Cone Motel: (1) Garett Sheldrew, Pencil, 9 x 5 each, 2004. Jay Shuster, (2) Pen/Marker, 6.25 x 9.75, (3) Marker/Pencil/Digital, 11 x 17; 2002.

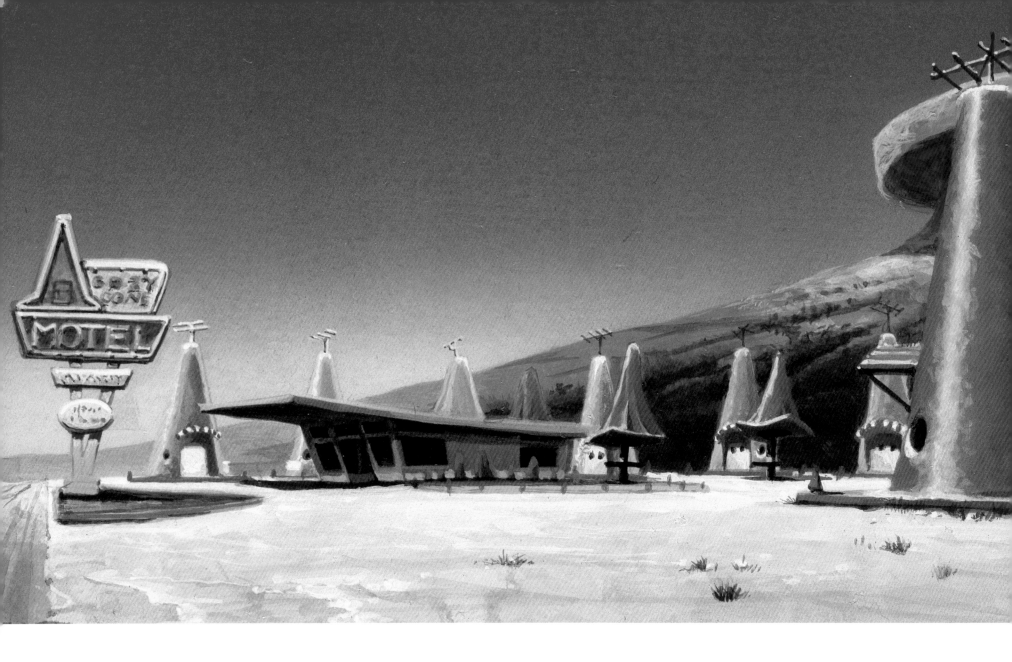

Cozy Cone Motel: Tia Kratter, Acrylic, 5.75 x 8.25 each, 2003.

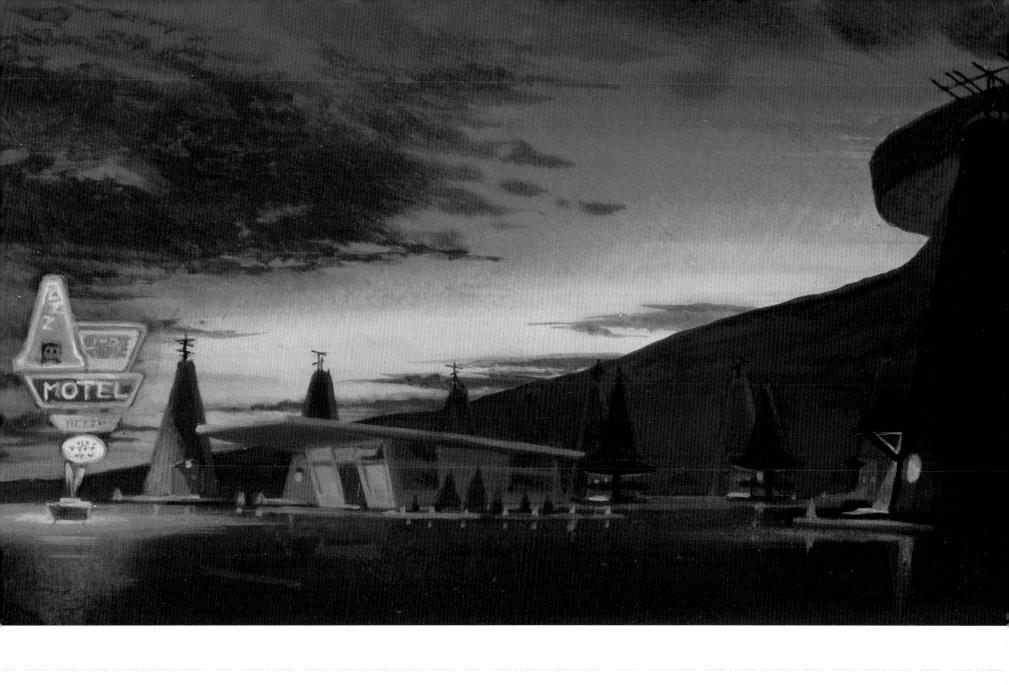

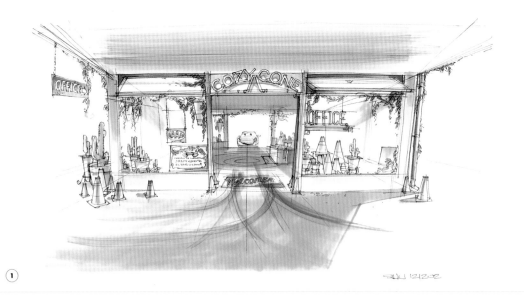

COZY CONE FRONT OFFICE

BEHIND FRONT DESK

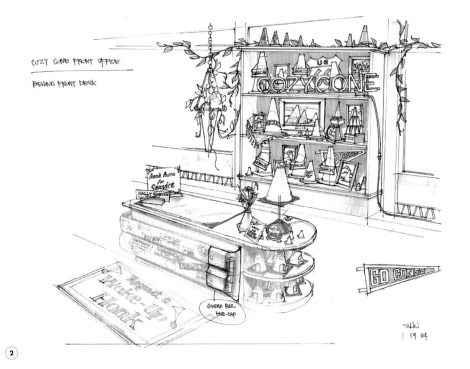

Cozy Cone Office: Jay Shuster, Pen/Marker, 17 x 11, (1), (3) 2002; (2) 2004.

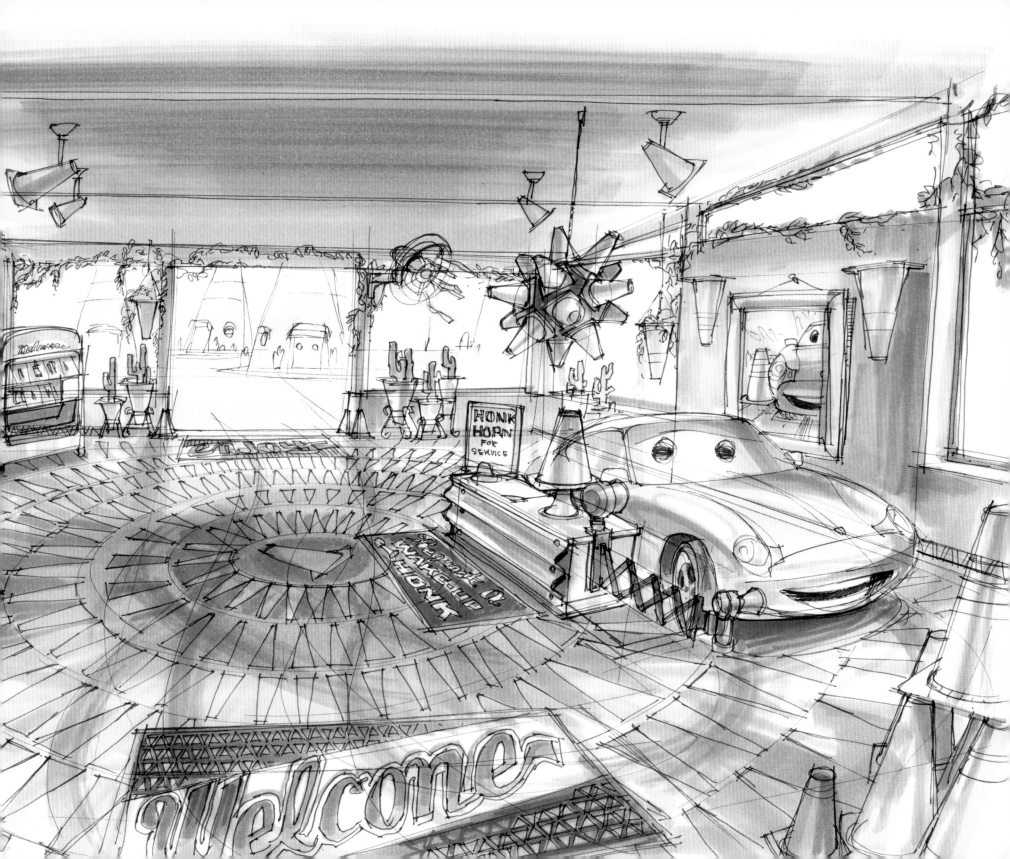

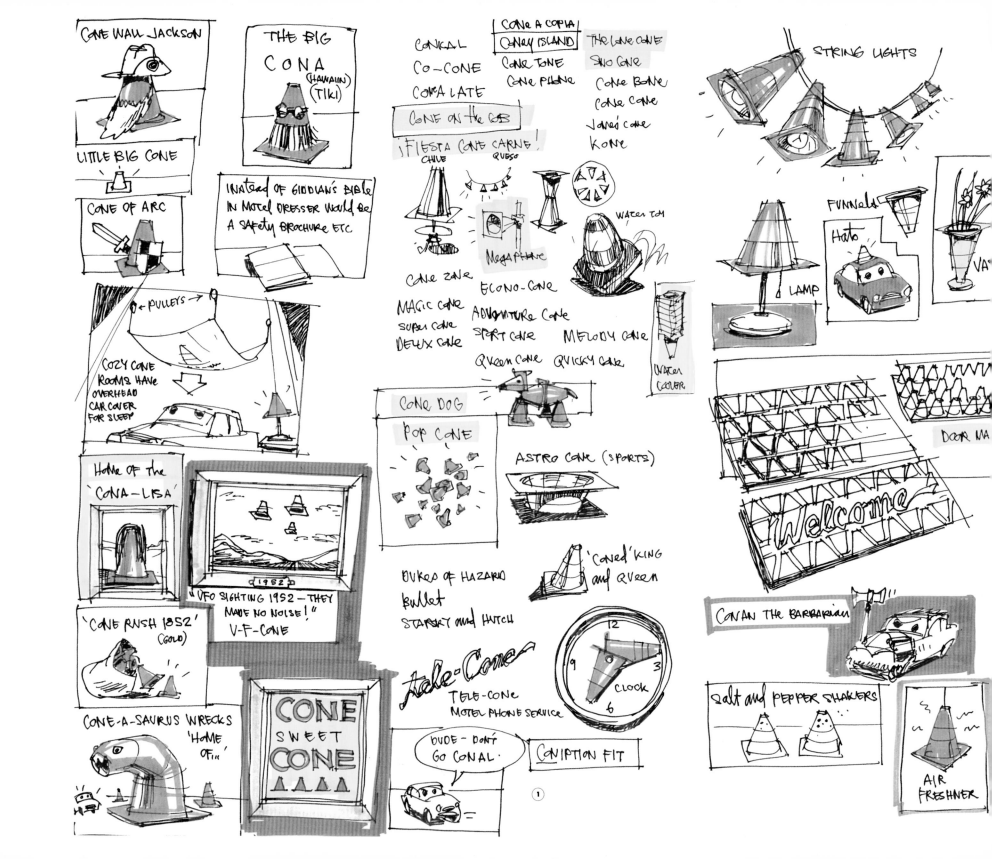

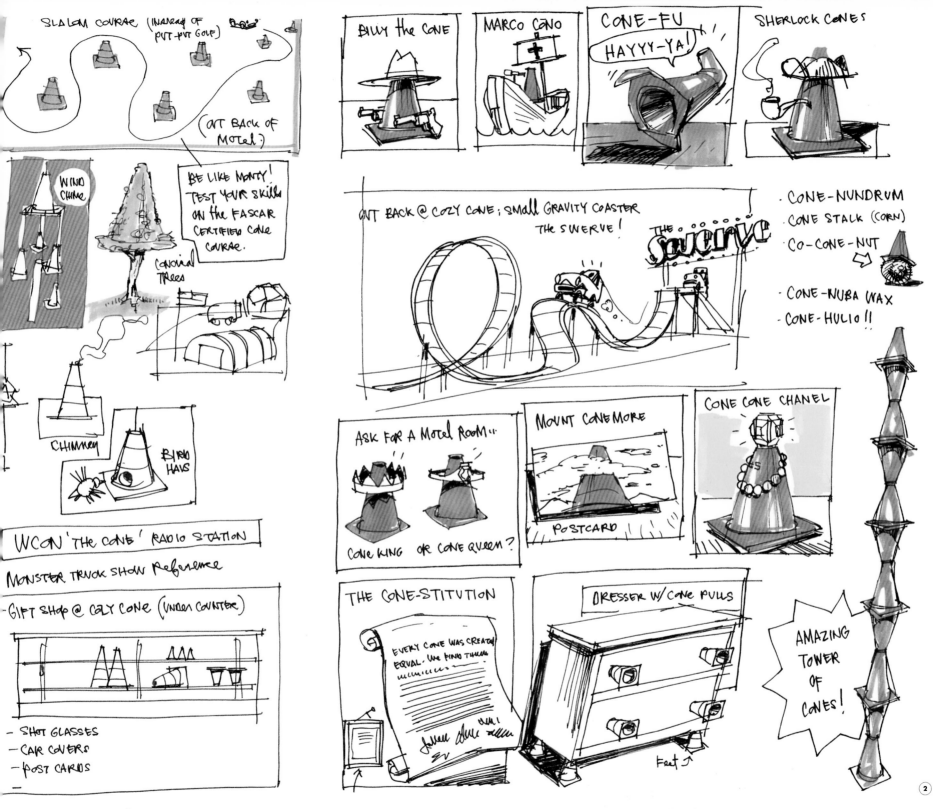

Caution Cone Gags: Jay Shuster, Pen/Marker, (1) 17.25 x 11.25, (2) 8.75 x 11; 2004.

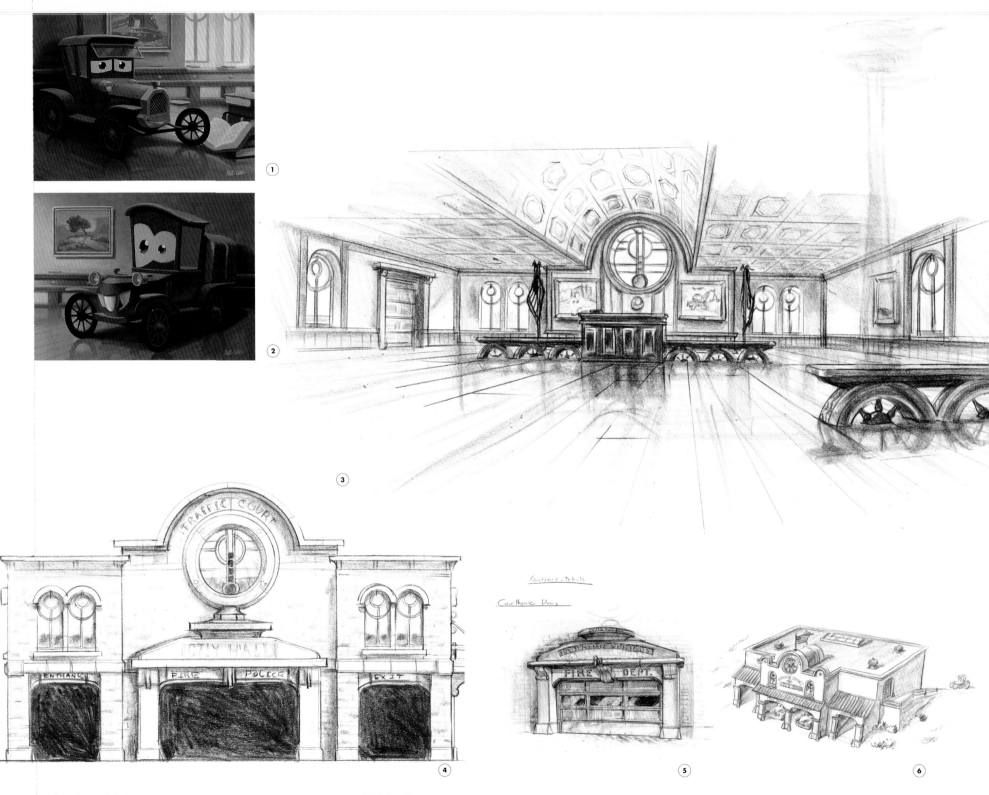

Courthouse Paintings: (1), (2) John Lee [paint] and Nat McLaughlin [layout], Digital, 2005. **Courthouse:** Nat McLaughlin, Pencil, (3) 17 x 11, 2002; (4) 10.75 x 5.75, 2003; (5) 8.5 x 11, 2002. (6) Bud Luckey, Pencil, 15.25 x 10.25, 2001.

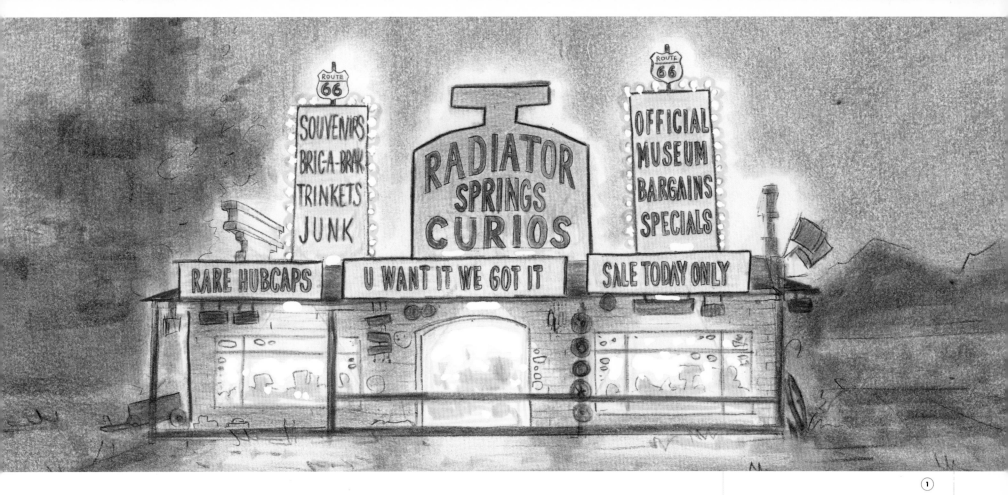

SNOWGLOBE

"snow" Drifts on roof Behind signs

Curio shop may need to be scaled slightly Bigger per Layout needs.

use heavy Dust to simulate fake snow

RADIATOR SPRINGS CURIOS

RADIATOR SPRINGS

Plastic Base

Painted Letters

modify ground Plane to Look like molded Plastic Base

John L.

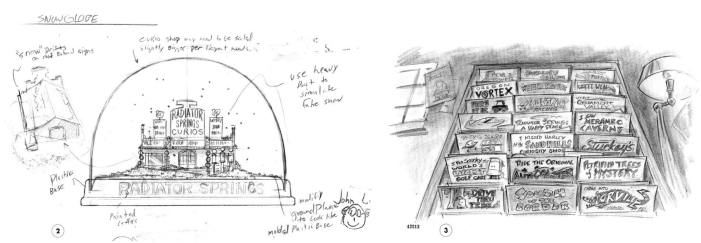

NO BACKFIRING OR IDLING WHEN DINING AT PUMP

VMC 32.45

Curio Shop: (1) Brian Fee, Pencil, 9 x 5, 2004. (2) Nat McLaughlin, Pencil, 17 x 11, 2005. (3) Steve Purcell, Pencil, 17 x 11, 2005. (4) Ellen Moon Lee, Digital, 2004.

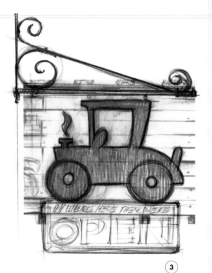

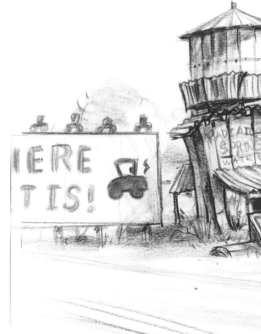

Curio Shop and Signage: (1) Bob Pauley, Digital, 2001. (2) Ellen Moon Lee, Digital, 2004. Nat McLaughlin, Pencil, (3) 7.5 x 10.25, (4) 17 x 11; 2003. (5) Ellen Moon Lee and Andy Dreyfus, Digital, 2004.

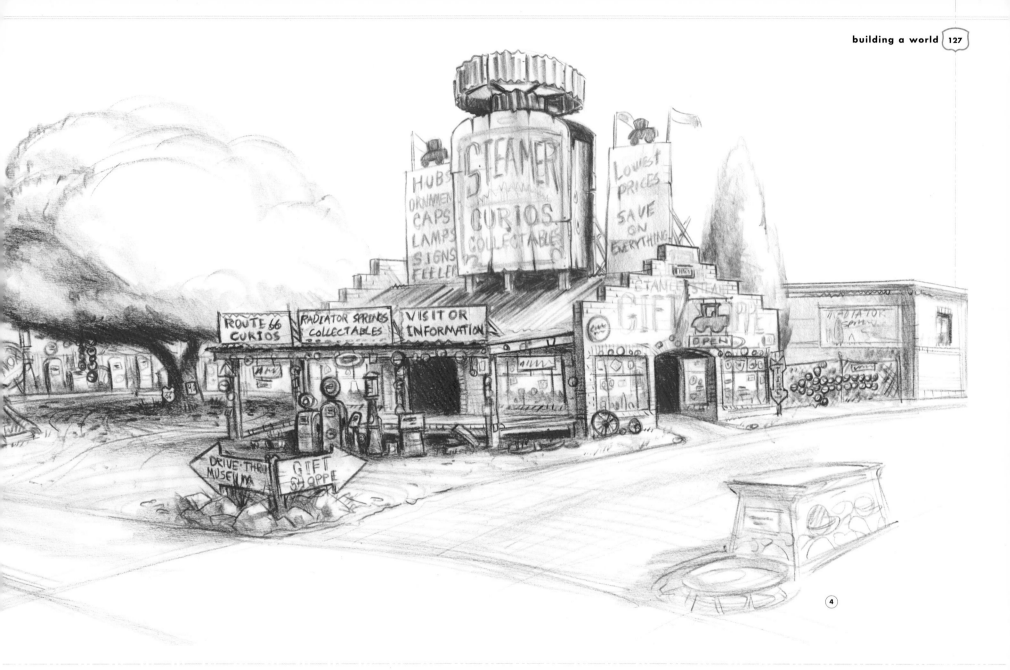

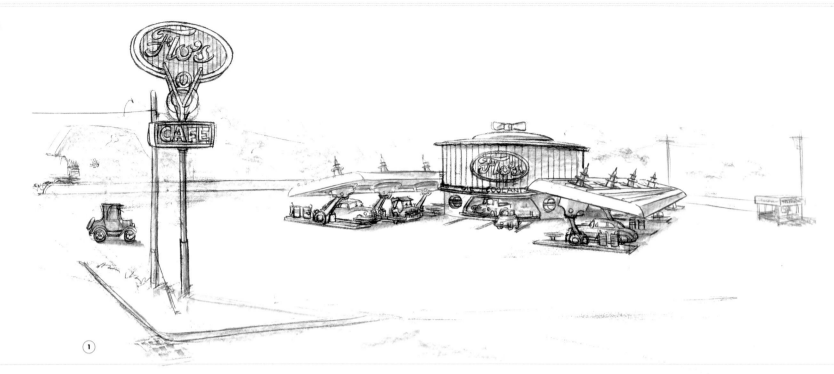

JUMBO
BIG
LUGNUTS

FROSTY-ANTI **FREEZE**

GREASY GREASE
HOT BRAKE PADS
LUBE-O-LICIOUS

DIP
STICKS

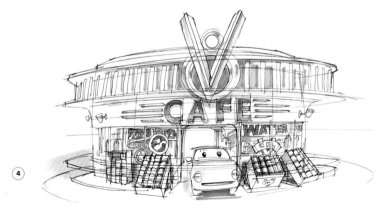

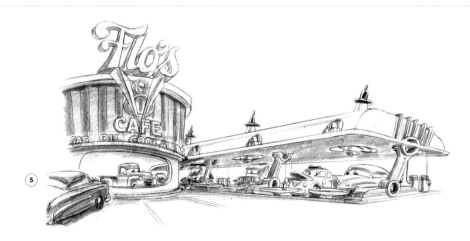

Flo's Café: Bud Luckey, Pencil, (1) 10.5 x 5.25, 2002; (5) 10.5 x 6.25, 2001. (4) Jay Shuster, Pen/Marker, 17 x 11 [detail], 2002. **Café Reference Photograph:** (2) Bill Cone, 2001. **Café Signage:** (3) Ellen Moon Lee, Digital, 2004.

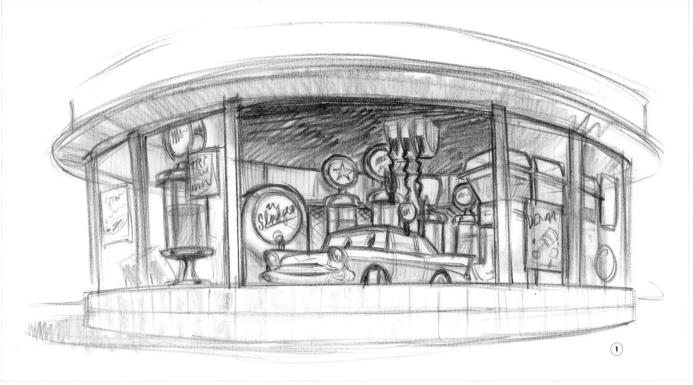

CAR-HOP SERVICE

ICE COLD COOLANT!

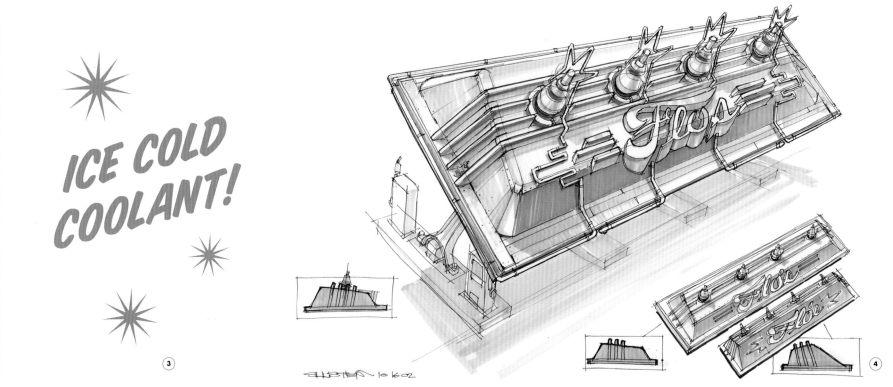

Flo's Café: (1) Nat McLaughlin, Pencil, 11 x 8.5, 2002. (4) Jay Shuster, Pen/Marker, 17 x 11, 2002. **Café Signage:** (2), (3) Ellen Moon Lee, Digital, 2004.

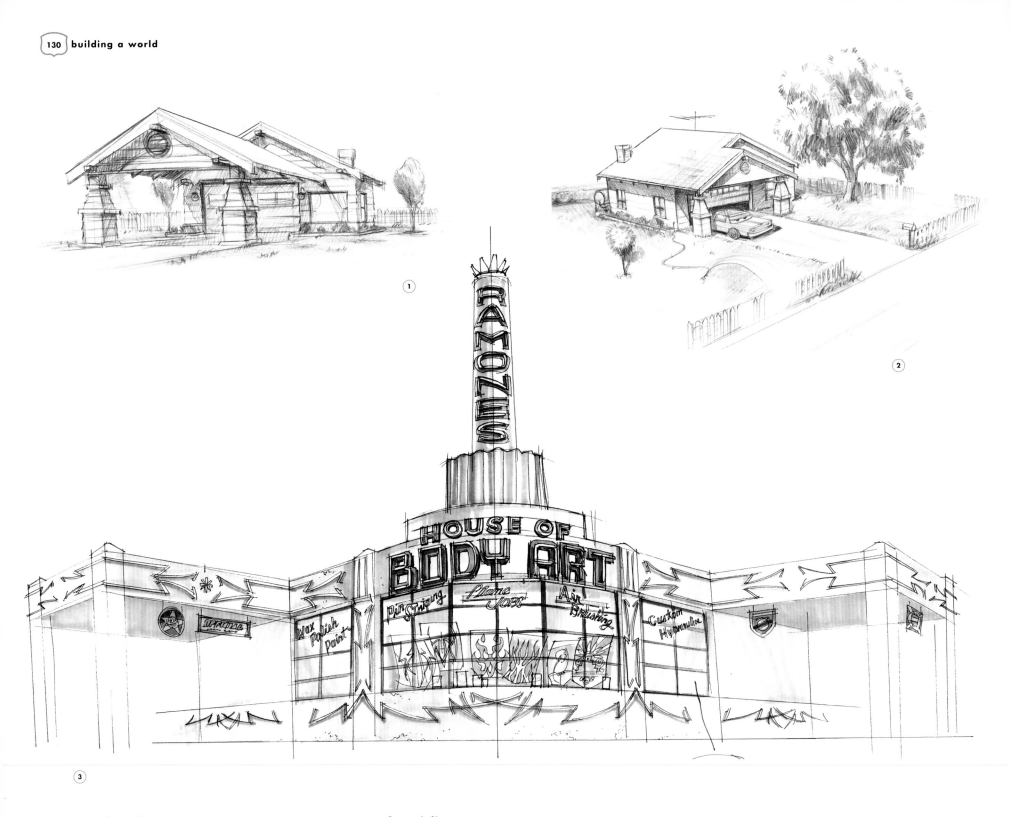

Flo and Ramone's House: Nat McLaughlin, Pencil, (1) 11 x 5, 2004; (2) 17 x 11, 2003. **Ramone's Shop:** (3) Jay Shuster, Pen/Marker, 17 x 11, 2004.

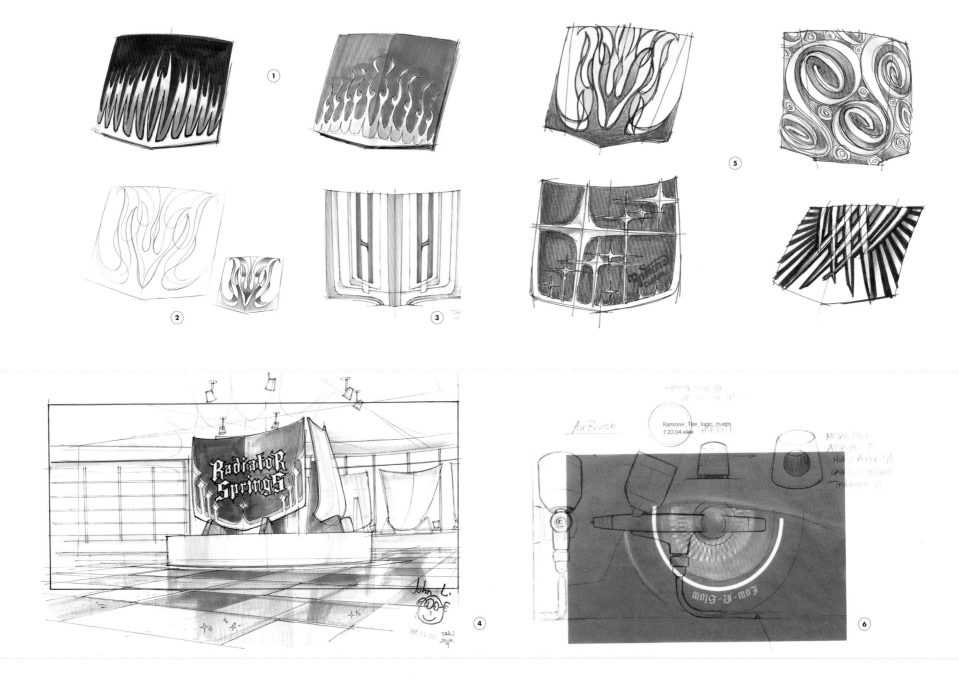

Ramone Paint Designs: Jay Shuster, Pen/Marker, (1) 17 x 11 each, (3) 17 x 11 [detail], (4) 17 x 11; 2004. (2), (5) Jay Shuster, Pencil/Marker, 17 x 11, 2004.
Ramone's Airbrush: (6) Albert Lozano [overlay] and Jason Bickerstaff [model], Overlay/Pencil/Digital, 9.75 x 10.5, 2004.

PIT STOP

Dave Deal

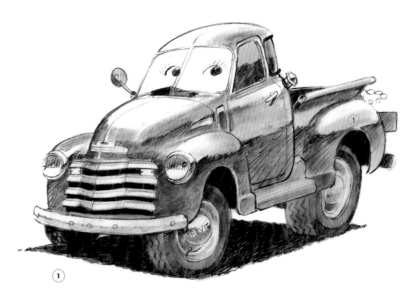
(1)

(2)

In 2000 Pixar reached out to Dave Deal, one of the foremost car artists whose work has spawned a generation of fellow automotive cartoonists and illustrators. "Big Deal," a nickname Dave picked up in the Marine Corps, was delighted when he was asked to visit the studio.

"I heard all about their plans from John Lasseter and a bunch of others and then I showed them my portfolio," recalls Big Deal. "They devoured it, and when we finished I realized it was one of the best meetings I'd ever had in my life. I was honored and I think we all clicked because John really wanted believable cars. Since I'm both an artist and a passionate 'wrenchhead,' when I draw a car it may be cartoony, but it looks like a car."

Big Deal not only contributed his fair share of conceptual artwork to the film but also held a workshop at the studio to teach the storyboard artists how best to draw an automobile.

"I had a large room filled with very talented people watching me at the drawing board," says Dave. "Most people who want to draw a car in perspective start by drawing a box and then sliding the car in so they end up with a rigid drawing. I don't approach it that way, but I had them start by drawing a Ford and a Porsche in boxes."

The resulting Fords looked like bars of soap or shoe boxes, and the Porsches certainly didn't look right. Then Dave had the artists draw the same cars inside circles. Now the Porsches appeared rounded, like mangos.

"So I drew a mango," explains Dave, "and I put in some shadow and added a couple of fenders and a windshield and made the tires hang down like they were grabbing the road. It was a wacky little Porsche, but it had gesture and correct detail. At that point everyone in that room stood and applauded. It was an epiphany. They saw it was a new way to draw."

Character Concepts: (1), (2) Dave Deal, Pencil, 14 x 11, 2000.

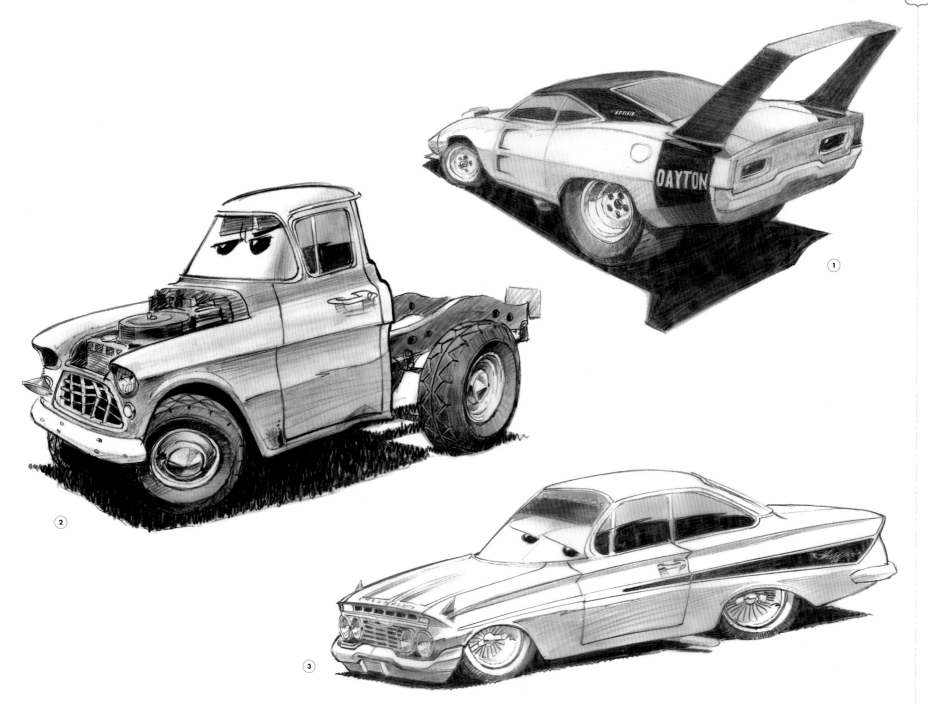

Character Concepts: (1), (2), (3) Dave Deal, Pencil, 14 x 11, 2000.

(1)

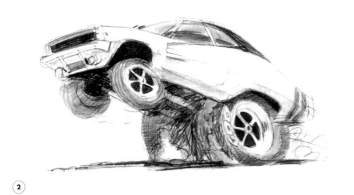

(2)

(3)

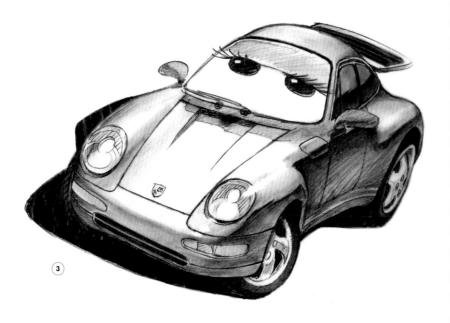

(4)

Dave Deal Class Photographs: (1) 2000. **Character Concepts:** (2), (3), (4) Dave Deal, Pencil, 14 x 11, 2000.

(1)

(2)

(3)

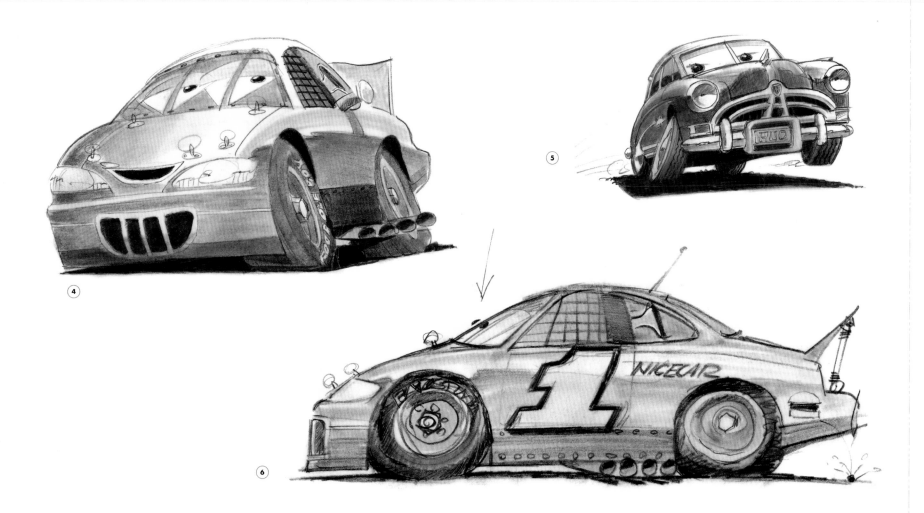

(4)

(5)

(6)

Character Concepts: (1), (2), (3), (4), (5), (6) Dave Deal, Pencil, 14 x 11, 2000.

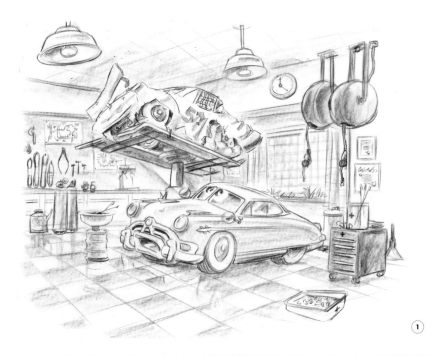

DOCTOR HUDSON
DR. OF INTERNAL COMBUSTION

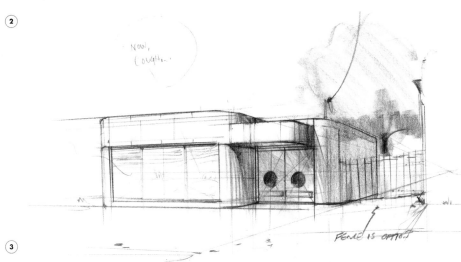

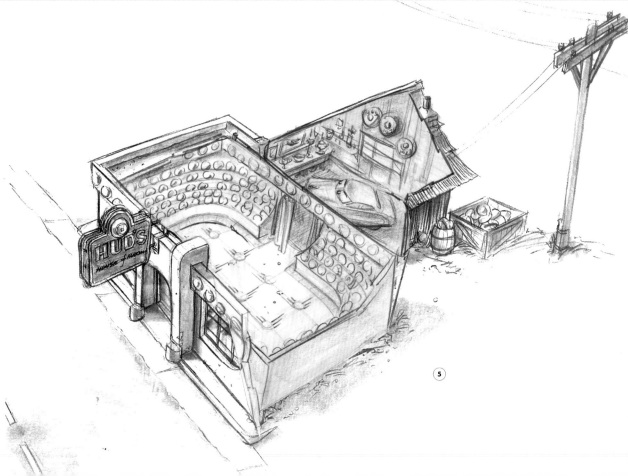

Doc's Clinic: Bud Luckey, Pencil, (1) 14 x 11, 2000; (5) 11 x 8.5, 2001.
(3) Bill Cone, Pencil, 15.5 x 9.25 [detail], 2003.
Clinic Signage and Diplomas: (2), (4) Ellen Moon Lee, Digital, 2004.

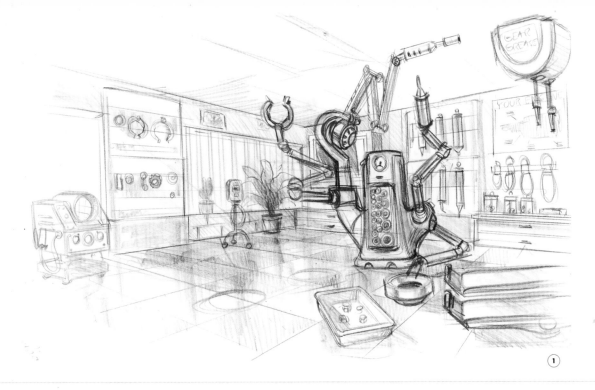

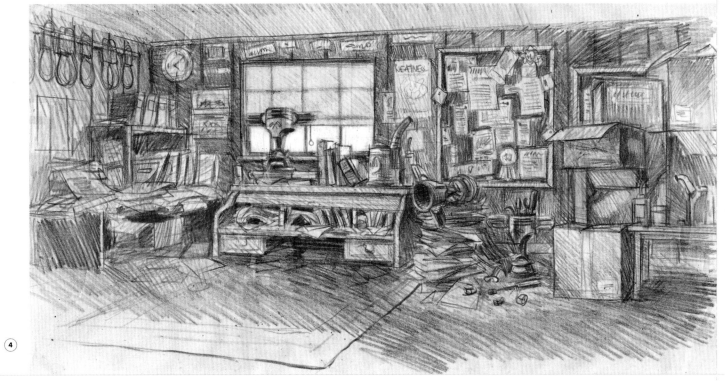

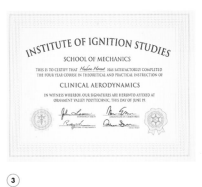

Doc's Clinic: Nat McLaughlin, (1) Pencil, 17 x 11, 2003; (2) Pencil, 15.5 x 11.75, 2004; (4) Overlay/Pencil, 14 x 8, 2003. **Diplomas:** (3) Ellen Moon Lee, Digital, 2004.

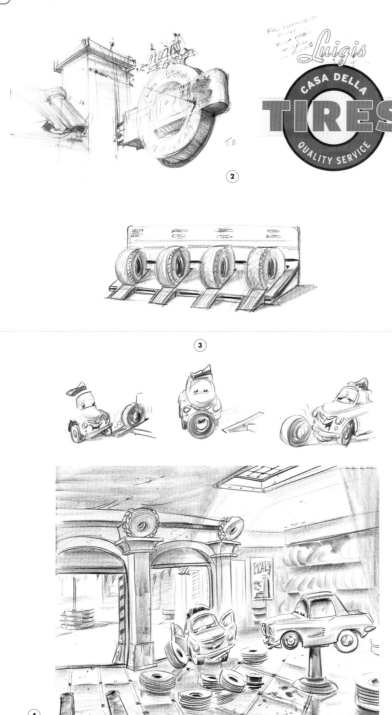

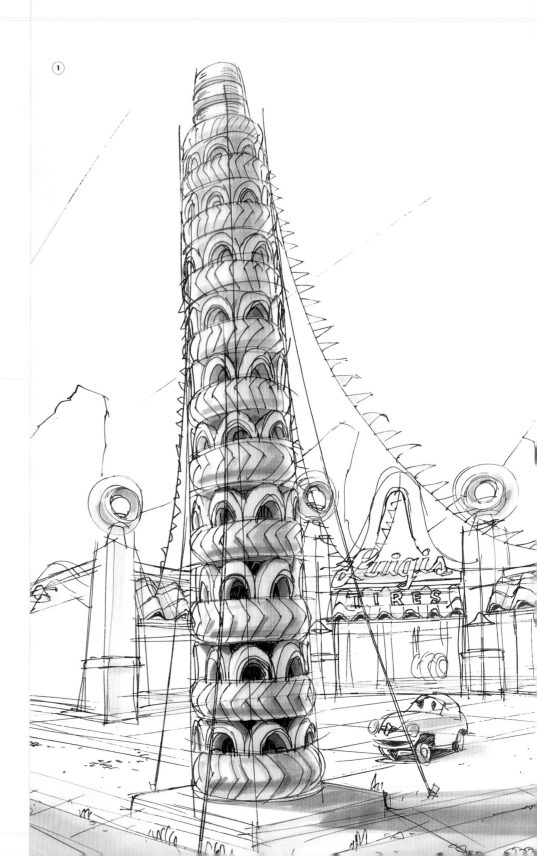

Luigi's Tire Shop: (1) Jay Shuster, Pen/Marker, 11 x 17 [detail], 2002. Bud Luckey, Pencil, (3) 11.25 x 6.5 [detail], (4) 11 x 8.75; 2001. **Signage:** Ellen Moon Lee [graphics] and Bill Cone [layout], (2) Pencil/Digital, 8.5 x 11; 2003.

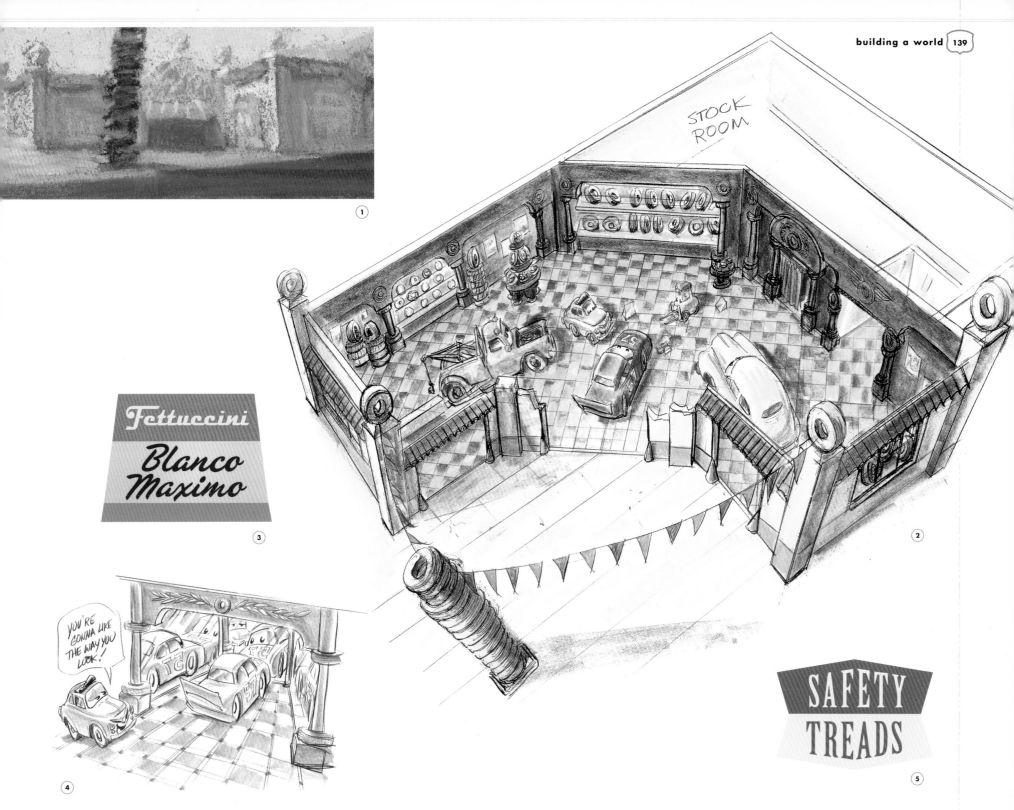

STOCK ROOM

Fettuccini
Blanco Maximo

YOU'RE GONNA LIKE THE WAY YOU LOOK!

SAFETY TREADS

Luigi's Tire Shop: (1) Bill Cone, Pastel, 18 x 8 [detail], 2004. Bud Luckey, Pencil, (2) 16.5 x 12.25, (4) 11 x 8.5; 2001. **Luigi's Signage:** (3), (5) Ellen Moon Lee, Digital, 2005.

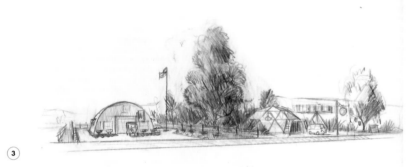

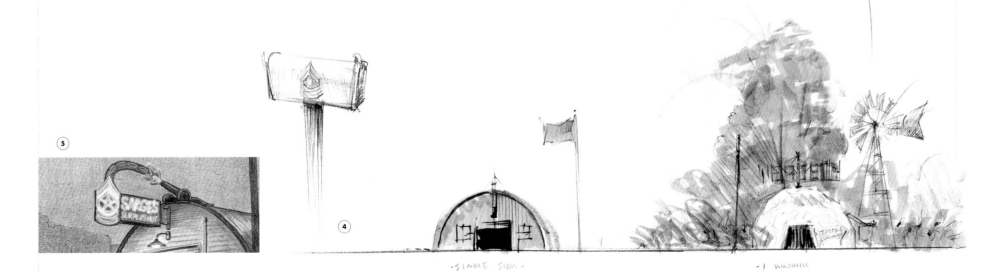

Sarge's Hut: Nat McLaughlin [overlay], Gary Schultz, Mark Adams, and Suzanne Slatcher [model], Overlay/Pencil/Digital (1) 16.25 x 11.25, (2) 15 x 10; 2004. (5) Brian Fee [art] and Patrick Siemer [effects], Pencil/Digital Effects, 2004. **Sarge's Hut and Fillmore's Dome:** (3) Nat McLaughlin, Pencil, 14 x 11, 2003. (4) Bill Cone, Pencil/Marker, 17 x 11 [detail], 2004.

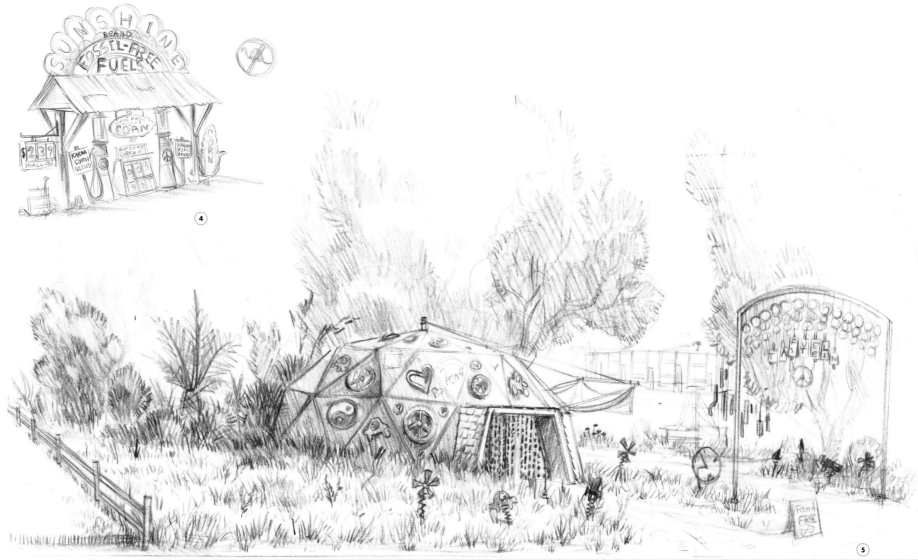

Fillmore's Dome and Property: (1) Brenda Chapman and Matthew Luhn, Marker/Pencil, 17 x 11, 2004. (2) Bud Luckey, Pencil, 8.75 x 11.25, 2001. (3) Jay Shuster, Pen/Marker, 16.25 x 10.75, 2003. Nat McLaughlin, Pencil, (4) 7.75 x 9.5, 2003; (5) 14.5 x 7.5, 2004.

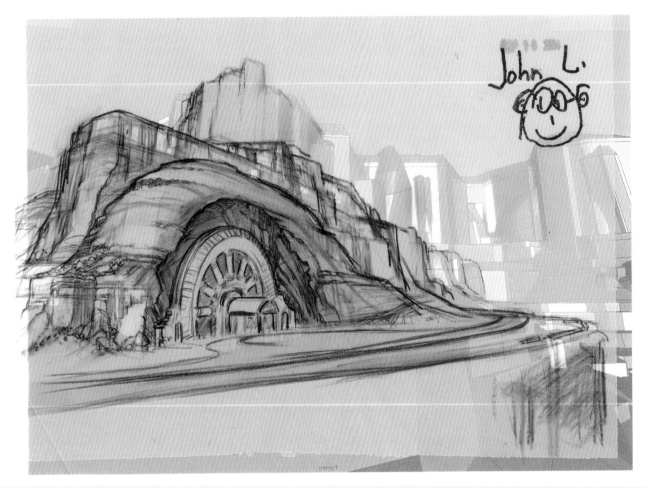

(1)

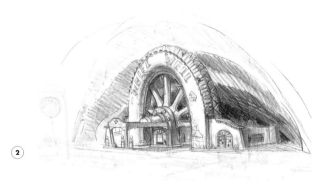

(2)

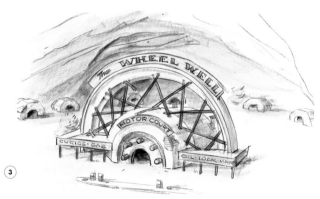

(3)

The Wheel Well Motel: (1) Anthony Christov [overlay] and Suzanne Slatcher [model], Overlay/Pencil/Digital, 11 x 7.75, 2004. (2) Nat McLaughlin, Pencil, 16.75 x 10.5, 2004. (3) Bud Luckey, Pencil, 6.75 x 11, 2001.
Frank the Combine: Jay Shuster, Pencil, (4) 13.75 x 7, (7) 14.25 x 9.75; 2003. **Tractor:** Jay Shuster, Pencil, (5) 11 x 17, (6) 10.25 x 10.25; 2003. **Tractor-tipping Storyboards:** (8) Dan Scanlon, Pencil, 9 x 5 each, 2003.

④

EVOLUTION OF THE COW-TO-TRACTOR

⑤

⑦

SHU
3 21
3

HOLSTEIN HEIFER
CHEWALL

⑥

⑧

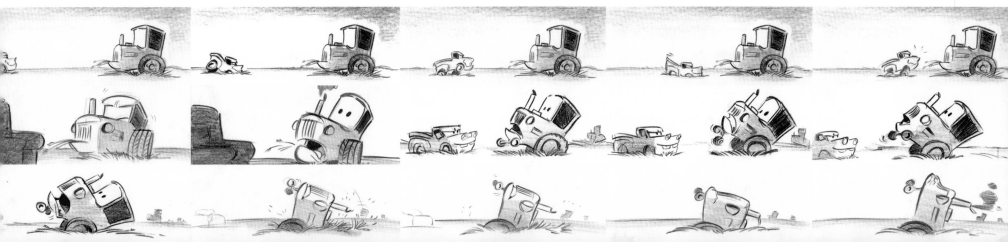

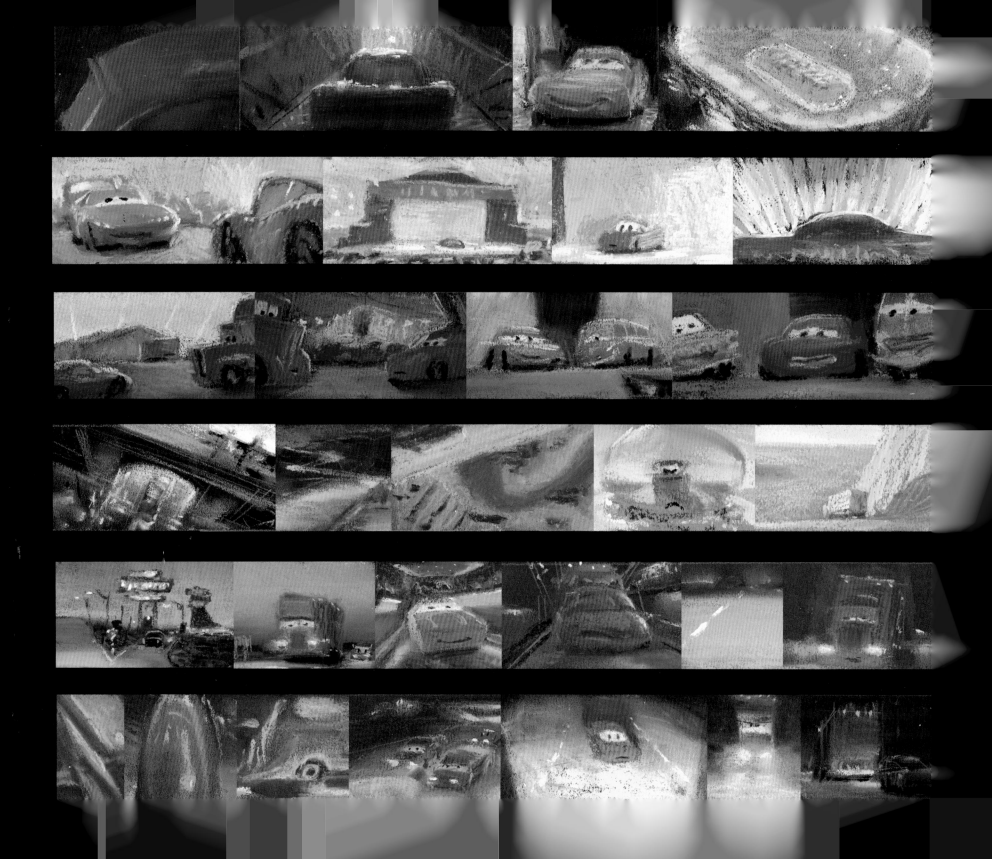

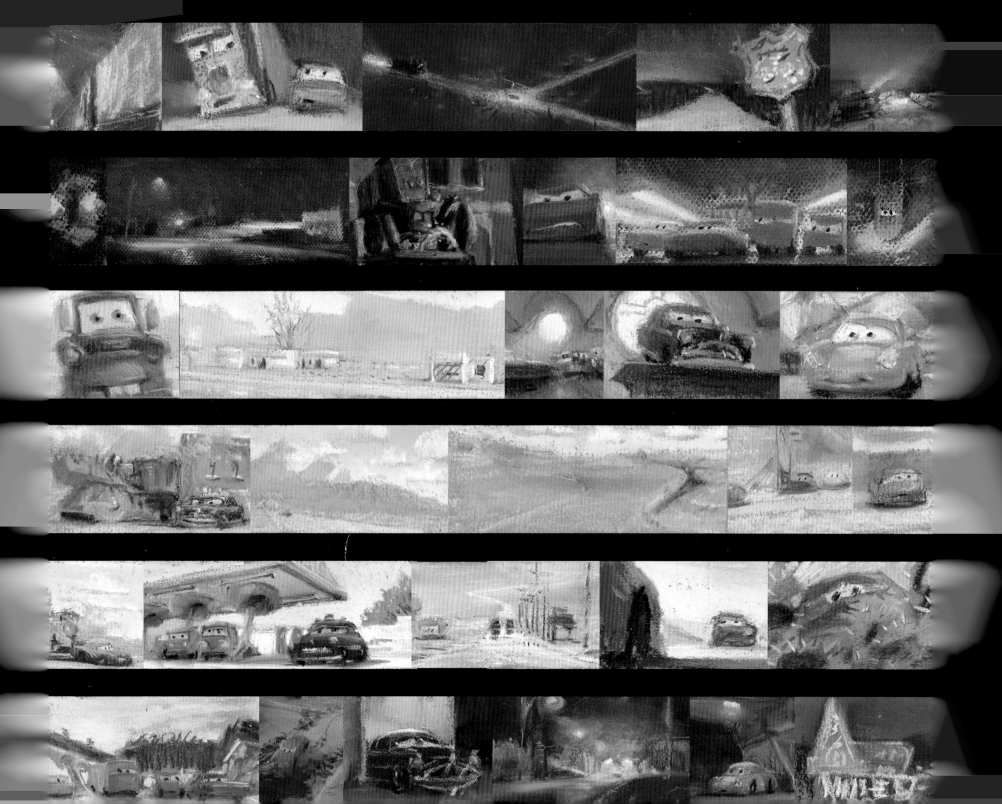

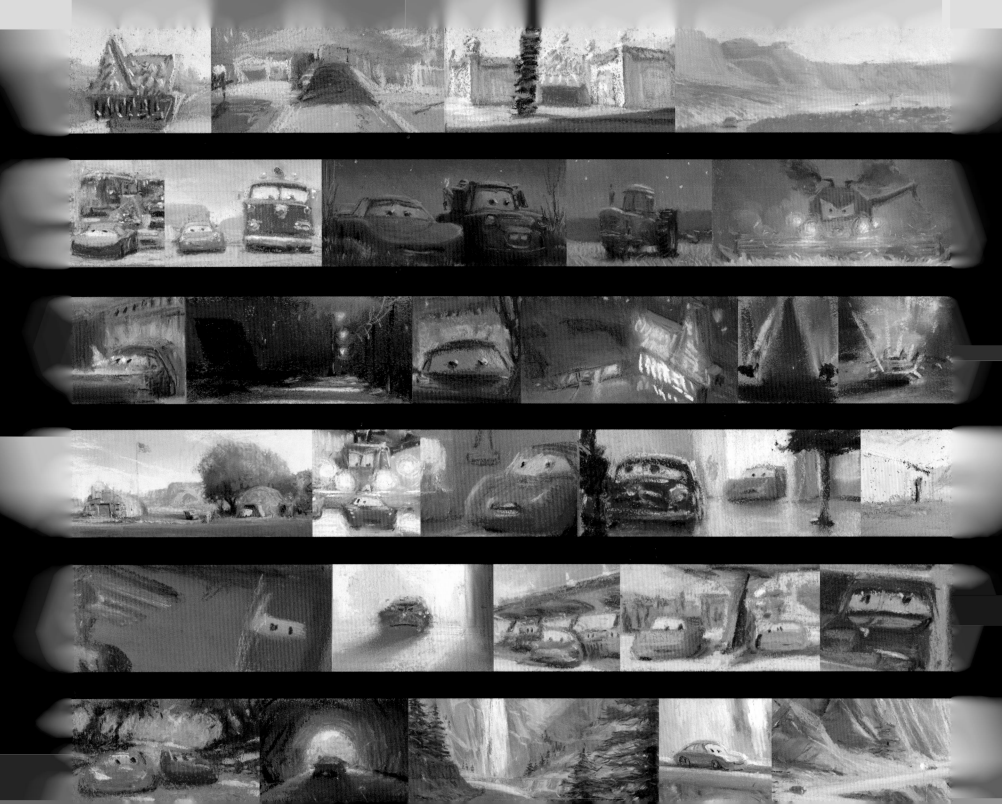

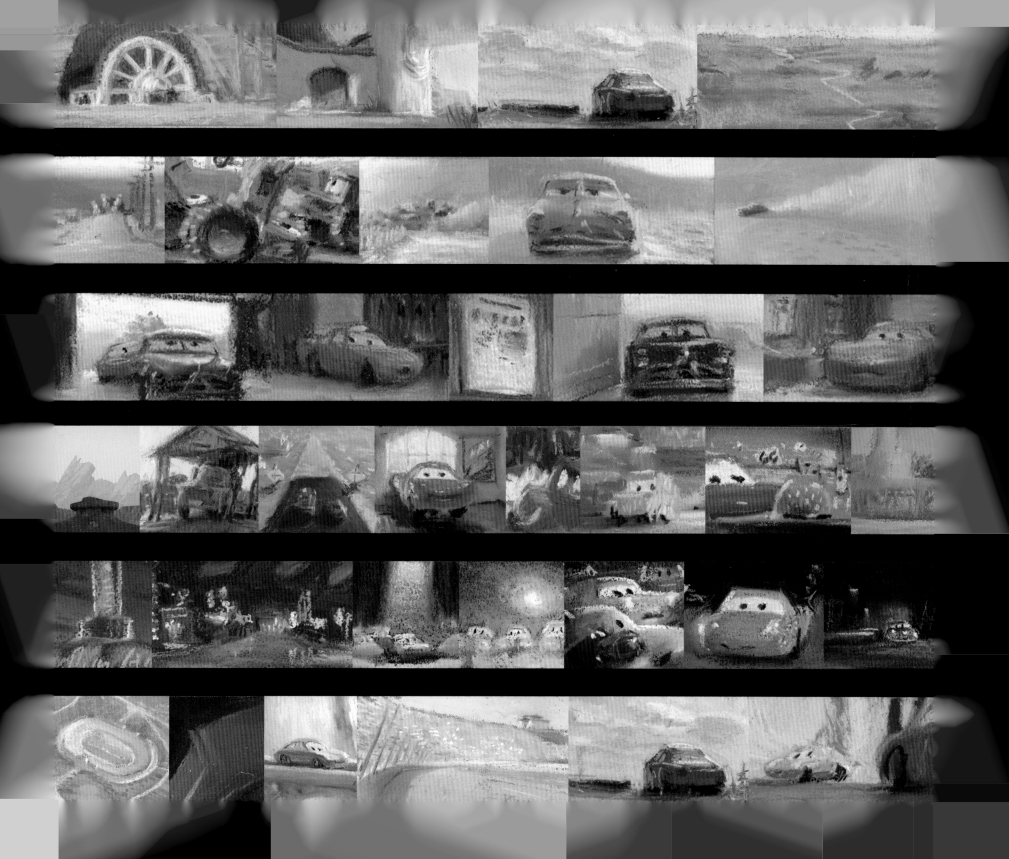

Dead Ends, Detours, and Test Rides

Throughout the development of *Cars,* the team analyzed story line, character arcs, and settings to monitor how it would all fit together. Storyboards were constantly being drawn, layouts and character models changed, dialogue rewritten, textures refined, voice talent considered and booked, and options eliminated.

"We never finish one of our films early," laughs Bud Luckey, development artist in the initial stages of *Cars.* "There's always something that can be changed and every time the film gets better and better."

That's definitely true, since several of the team's test rides ended up snarled in detours or on dead-end trails. Some characters who were dropped included Mr. Windshield, the Radiator Springs optometrist who sold windshields; a

well-meaning but ineffectual town mayor; Carl, McQueen's deceitful backup car; and a racing crew chief named Rusty Fenders. Several scenes also ended up on the proverbial cutting room floor, such as the town sheriff singing "Hot Rod Lincoln" in a "caraoke" joint, and a road race known as the Radiator Springs Grand Prix.

Characters that did make the final cut were born from the teams' encounters with the many people they met at racetracks and out on the open road. The hilarious Mater is a good example. He is a combination of a half dozen people from the fast and slow lanes, deftly blended to make a bumbling but lovable tow truck. In fact, Pixar even modeled a character named Sheriff after me. He is a 1949 Mercury police cruiser who enjoys telling stories about his beloved Mother Road.

Reworking the script and the many steps in the animation process takes lots of time, but the final product makes it all worthwhile.

"We never shortchange the story development," John Lasseter says. "At Pixar, the story drives everything. Throughout a film's production we are constantly reworking the story again and again until we have a film that we want to watch with our own families."

Early Mayor Character: Dave Deal, Pencil, 14 x 11, 2000.

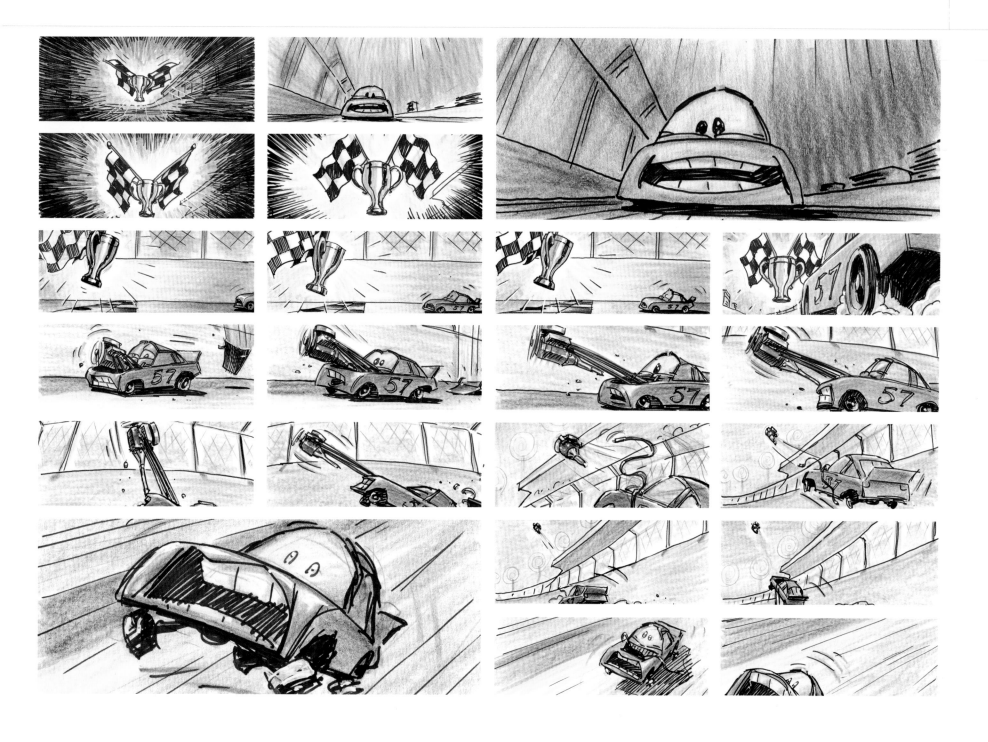

Nightmare Storyboards: Garett Sheldrew, Ink/Pencil, 9 x 5 each, 2002.

(1)

(2)

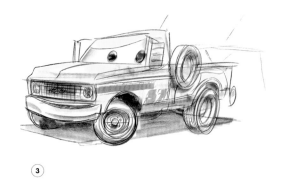

(3)

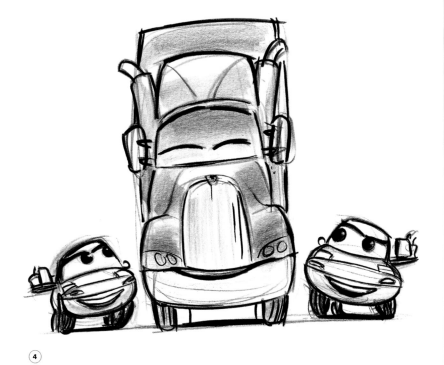

(4)

(5)

Crew Chief and Monte: Bob Pauley, (1) Pencil/Marker, 10.5 x 6, (2) Pencil, 10.5 x 6, (3) Pencil/Marker, 10.5 x 5.75; 2002. **Waitresses:** Bob Pauley, Pencil, (4) 7 x 5.75, (5) 6 x 5; 2003.

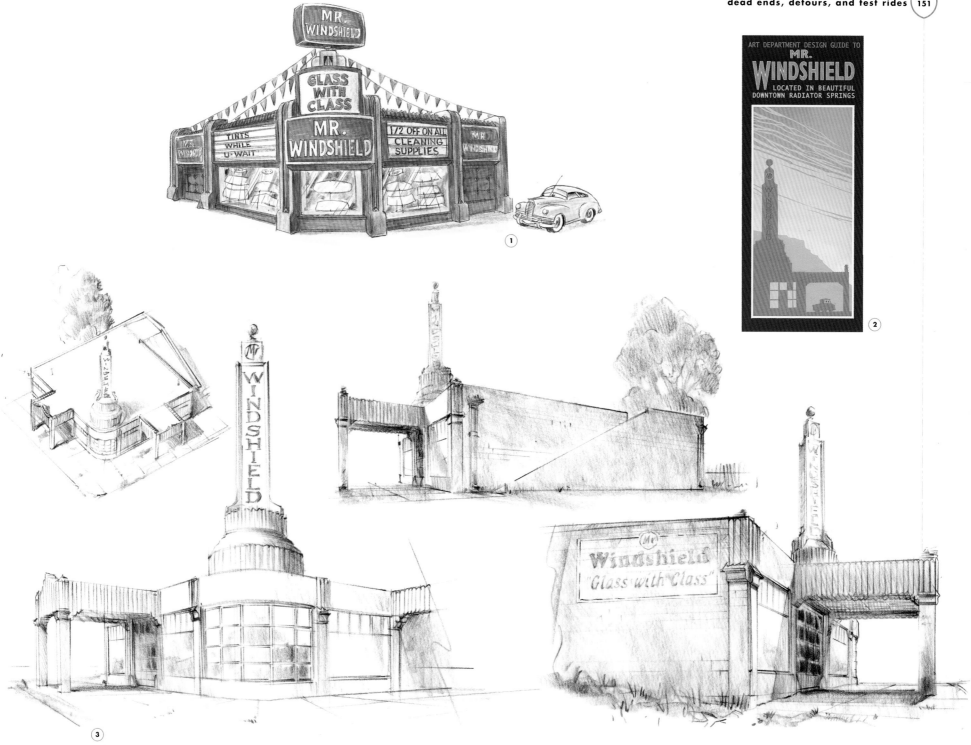

Mr. Windshield's Shop: (1) Bud Luckey, Pencil/Marker, 16.5 x 9, 2003. (3) Bill Cone, Pencil, 16.5 x 7.25, 2003. **Mr. Windshield Design Guide:** (2) Bill Cone, Digital, 2003.

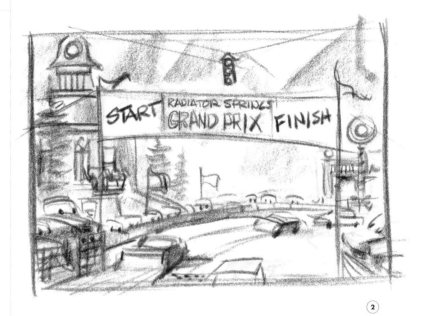

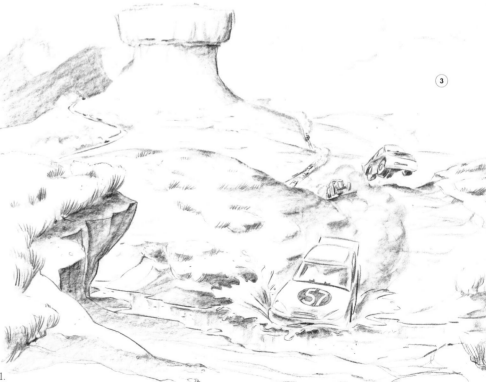

Town Race: (1) Steve Purcell, Digital, 2004. (2) Bob Pauley, Pencil, 5.75 x 4, 2001. (3) Bud Luckey, Pencil, 14.5 x 11.25, 2001.

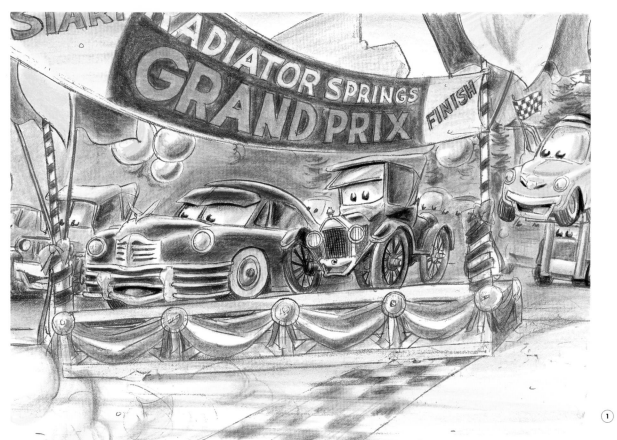

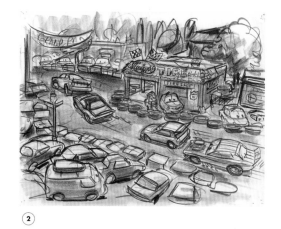

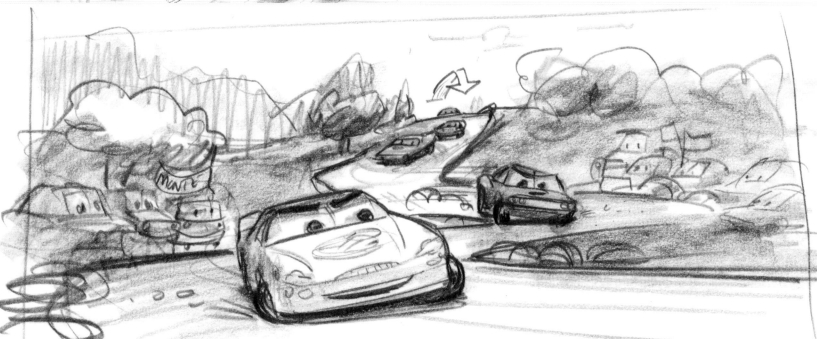

Town Race: (1) Bud Luckey, Pencil, 11.5 x 8.75, 2001. Bob Pauley, Pencil, (2) 11 x 8.5, (3) 8.25 x 3.75; 2001.

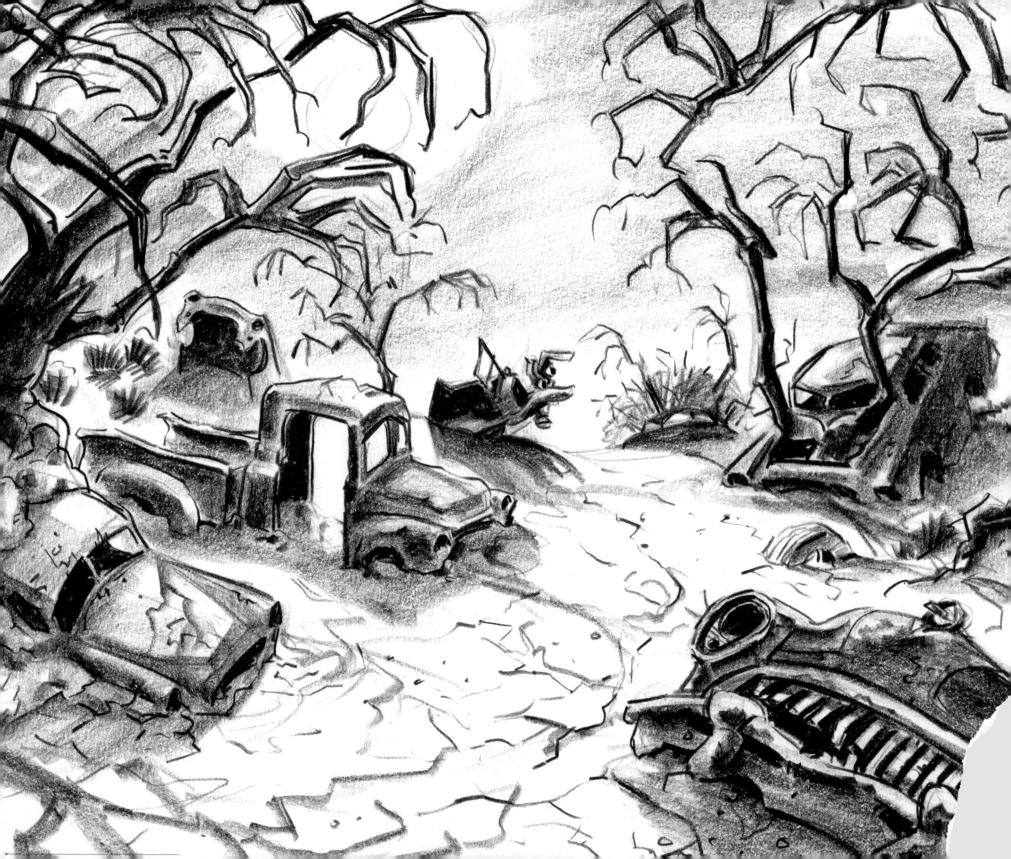

(1)

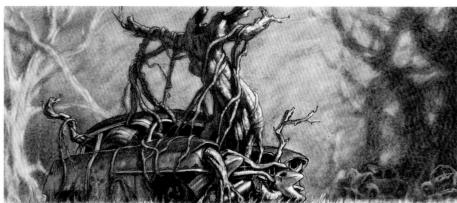

(2)

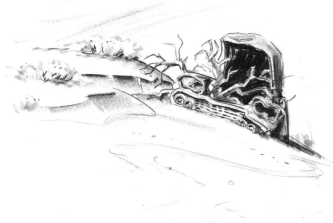

(3)

Haunted Graveyard: (Opposite) Bud Luckey, Pencil, 10.5 x 8.5, 2001. Garett Sheldrew, (1) Pencil, (2) Pencil/Digital, 9 x 5, 2002. (3) Bud Luckey, Pencil, 11 x 8.75, 2001.

The Finish Line

At Pixar, the filmmaking is a team sport. For *Cars* all of the players spent countless hours researching the worlds in which it would take place, lending to the film's detail and authenticity.

"When you see the passion to get everything right that seeps through all our different departments, it just makes everything we do even better," says Shading Art Director Tia Kratter. "Making a computer-animated film is not only challenging but also slow and laborious. So besides passion, it's good to have plenty of patience."

All of the time and research, however, only served to help them reach the ultimate goal of crafting a memorable story and believable characters. When you see this film, you don't see

the research. You feel like you are a part of the crowd in the bleachers or a member of the pit crew at the racetrack. You meet characters that are endowed with the same idiosyncrasies, foibles, fears, courage, humor, and resiliency that can be found in everyone. You get to know what it's like to be out on American's Main Street, where nothing is predictable.

"It was a long time coming, but another dream has been realized," says John Lasseter. "I believe the heart of our story is the importance of living one day at a time and making that day a masterpiece." *Cars* will appeal to fast-lane travelers as well as those who prefer the slower pace offered by roads like Route 66. No matter which path you take, make the best of your time. Enjoy the journey.

Character Lineup: Steve Purcell, Pencil, 9 x 5 [detail], 2003.

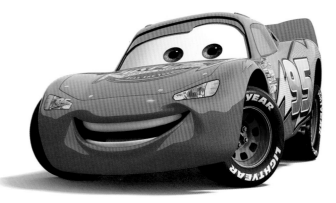

Lightning
McQueen

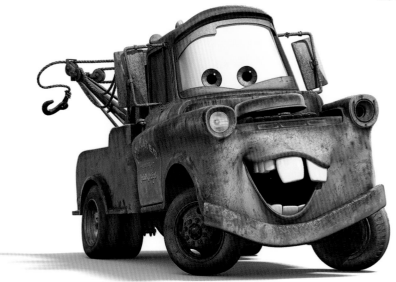

Mater

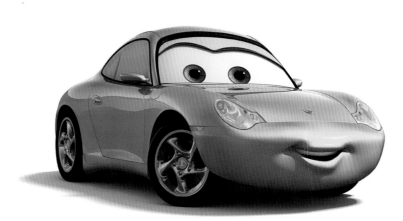

Sally

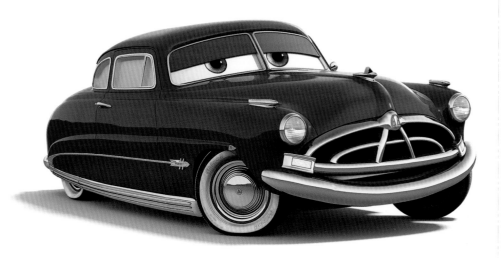

Doc Hudson

Lightning McQueen: Paul Aichele, Yvonne Herbst, Andrew Schmidt, and Colin Thompson. **Mater:** Glenn Kim, Mike Krummhoefener, Bob Moyer, and Tom Sanocki.
Sally: John Lee, Bob Moyer, Andrew Schmidt, and Sajan Skaria. **Doc Hudson:** Paul Aichele, Yvonne Herbst, Thomas Jordan, and Andrew Schmidt.

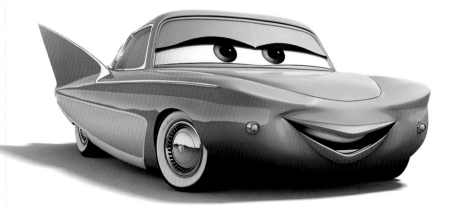

Flo

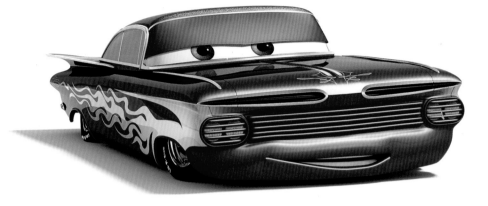

Ramone

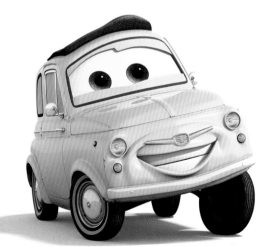

Luigi

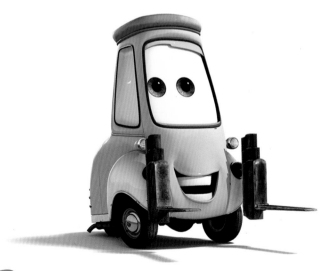

Guido

Flo: Jamie Frye, Ben Jordan, Michael Kilgore, and Andrew Schmidt. **Ramone:** Jason Bickerstaff, Glenn Kim, and Colin Thompson. **Luigi:** Paul Aichele, Jamie Frye, Ben Jordan, and Bob Moyer. **Guido:** Jason Bickerstaff, Yvonne Herbst, Guido Quaroni, and Andrew Schmidt. **Sarge:** Mike Krummhoefener, Sajan Skaria, Colin Thompson, and Bert Berry. **Fillmore:** Patrick Guenette, Yvonne Herbst, Andrew Schmidt, and Sajan Skaria. **Red:** Mike Krummhoefener, Bob Moyer, Japeth Pieper, and Tom Sanocki. **Sheriff:** Paul Aichele, Patrick Guenette, Japeth Pieper, and Andrew Schmidt.

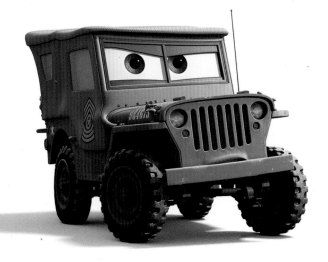

Sarge

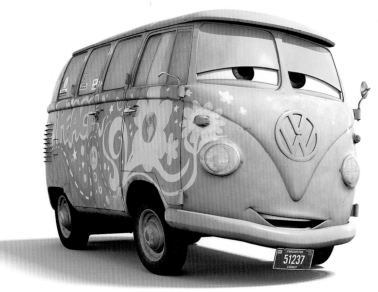

Fillmore

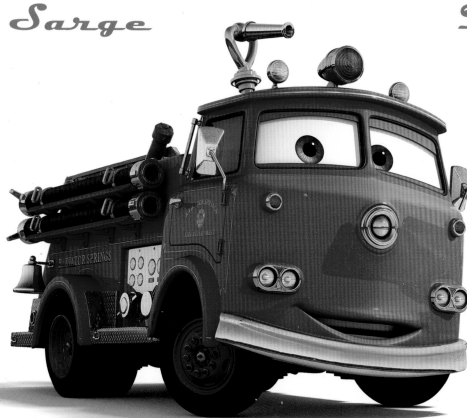

Red

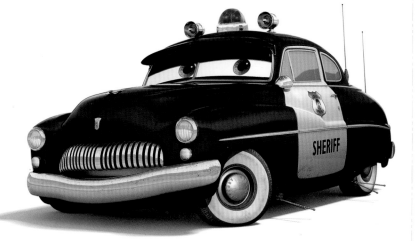

Sheriff

RADIATOR SPRINGS **Leaving So Soon?**

①

RADIATOR SPRINGS **Stop n' Stay Awhile**

②

Acknowledgments

Our "sponsor," Chronicle Books, for their continued support and belief in our films. Special thanks to our good friends Sarah Malarkey, Matt Robinson, Vanessa Dina, and Tera Killip, and our designers at Public.

The *Cars* Art & Story Departments and the Pixar Consumer Products and Creative Services teams, for all their elbow grease. Special thanks to Andrea Warren, Shane Thomas, Nick Vlahos, Russell Stough, Stephanie Hamilton, Mark Nielsen, Adrian Ochoa, Valerie Villas, Amy Ellenwood, Krista Sheffler, Michele Spane, Andy Dreyfus, Jonathan Rodriguez, Kelly Bonbright, Elisabetta Quaroni, Ed Chen, Desiree Mourad, and Karen Paik. Also thanks to the Disney Animation Research Library.

Our writers, Michael and Suzanne Wallis, whose enthusiasm for the Mother Road was infectious.

All the great people we met in our travels who so kindly shared their stories, wisdom, and passion for the world of the automobile.

My friends and driving partners, Joe Ranft, Bob Pauley, Bill Cone, and Eben Ostby. Your humor and friendship made this a truly enjoyable road trip. We finally got to make our car movie!

Tia Kratter, Jeremy Lasky, Jean-Claude Kalache, Tim Milliron, Sophie Vincelette, Steve May, Dave Munier, Chris Bernardi, Thomas Jordan, Ziah Fogel, Lisa Forssell, Jessica McMackin, and Tony Apodaca, the mechanical experts who kept our engine running smoothly.

Doug Sweetland, Scott Clark, Jim Murphy, Bobby Podesta, and their fabulous animation team, who put a soul with depth, heart, and humor behind every windshield.

Our editor, Ken Schretzmann, and his keen eye for the photo finish.

Our Producer Darla Anderson, Associate Producer Tom Porter, Production Manager Jonas Rivera, and Production Accountant and Scheduler Ali Rowghani, whose tireless efforts

made sure this film made it to the finish line. Cheers to our production crew: Heather Feng, Elissa Knight, Joan Smalley, Tricia Andres, Erik Langley, Paul Baker, Hoon Kim, Jay Ward, Deirdre Warin, Chris di Giovanni, Laura Reynolds, Jenni Tsoi, and Juliet Pokorny.

Extra-special thanks to the rest of the executive team at Pixar: Steve Jobs, Ed Catmull, Sarah McArthur, Simon Bax, and Lois Scali, who cheered us on from the very first lap.

Most importantly, thanks to everyone at Pixar who contributed to the film in ways big and small; and to my family and all of our families who support, inspire, and teach us there is more to racing than winning.

—John Lasseter, Director

③

3 1333 03322 3353

Billboards: (1), (2) Ellen Moon Lee, Digital, 2004. **Bug Fly:** (3) Bob Pauley, Pencil, 11 x 8.5, 2004.